W9-BNU-188

The Mixed Media Sourcebook

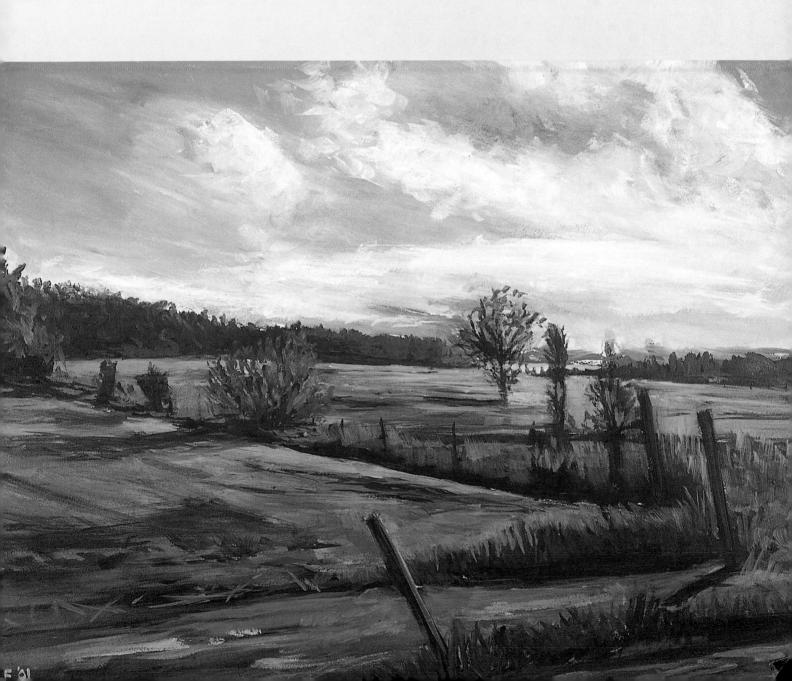

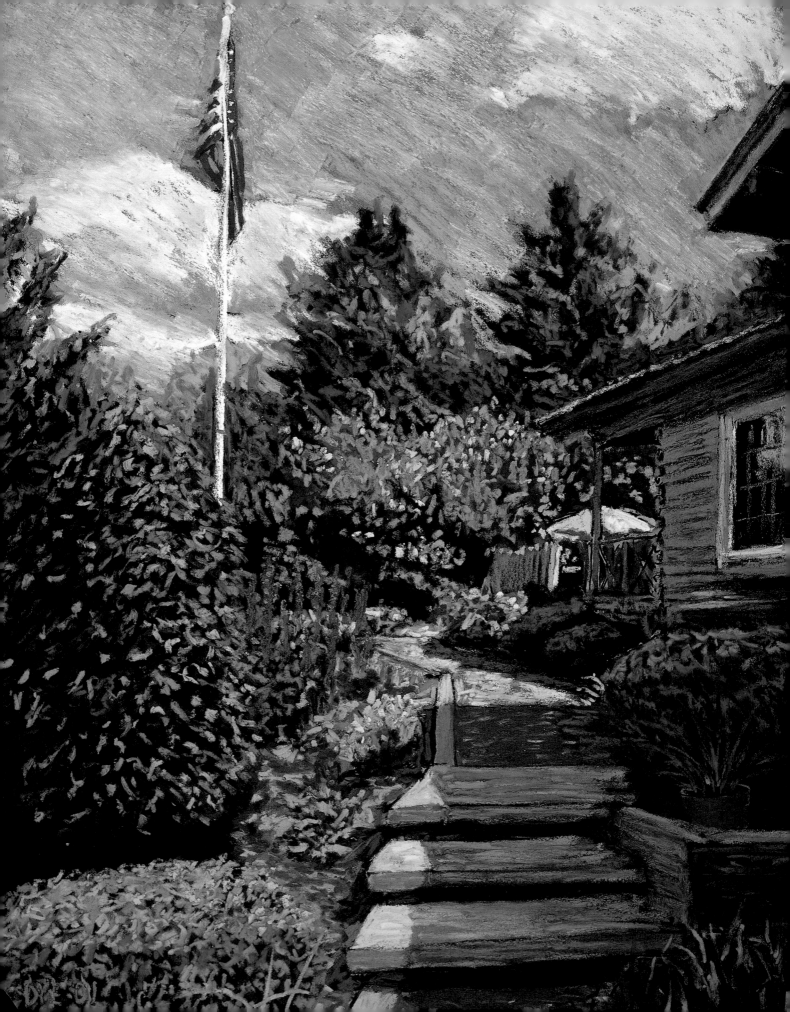

The Mixed Media Sourcebook

Techniques for Successfully Combining Painting and Drawing Mediums

Sean Dye

Watson-Guptill Publications • New York

To learn more about artwork by Sean Dye, visit his Web site:
www.seandyestudios.com

Senior editor: Joy Aquilino

Editor: Sylvia Warren

Production manager: Ellen Greene

Designer: Leah Lococo Ltd

Half-title image:

Sean Dye, *Shelburne Farms Shadows*; oil, acrylic, and charcoal on gesso-primed watercolor paper

Title page image :

Sean Dye, *The Front Garde*n *June 2001*; oil pastel, acrylic gouache, and India ink on Pastelbord

First Published in 2004 by Watson-Guptill Publications,

a Division of VNU Business Media, Inc.

770 Broadway, New York, N.Y. 10003

www.watsonguptill.com

Library of Congress Cataloging-in-Publication Data

Dye, Sean, 1963-

 The Mixed media sourcebook : techniques for successfully combining painting
and drawing mediums / Sean Dye.—1st ed.

 p. cm

Includes bibliographical reference and index.

ISBN 0-8230-3074-1

1. Mixed Media painting—Technique. I. Title.

ND1505.D97 2004

751.4'9—dc22

 2004001959

All rights reserved. No part of this publication may be reproduced or used in any form
or by any means—graphic, electronic, or mechanical, including photocopying, recording,
taping, or information storage and retrieval systems—without written permission of the publisher.

Printed in China

First printing, 2004

1 2 3 4 5 6 7 8 9 / 10 09 08 07 06 05 04

Jonathan Young
The Push, Seattle Washington (2001)
Watercolor and acrylic gouache,
10.5 x 13 in. (26.7 x 33 cm).
Collection of Sally and Sean Dye.

This book is dedicated to my wife, Sally. Without her endless support, vision, and keen eye this project would not have been possible.

Special thanks to:

My Watson-Guptill editor Joy Aquilino and my production manager Ellen Greene.

Developmental editor Sylvia Warren and designer Leah Lococo.

Sarah Neith, my assistant, who spent many hours on research, photography, editing, and surface preparations.

Ampersand Art Supply, HK Holbein, Savoir Faire for their help with artist materials.

All the artists who provided their artwork for this book: Nicholas Battis, Bill Creevy, Frank Federico, Eric Kidhardt, Anselm Kiefer, Michael Klauke, Sarah Neith, Michael Oatman, and Jonathan Young.

The Art Institute of Chicago, The Newark Museum, The North Carolina Museum of Art, The Norton Simon Foundation, The Worcester Art Museum, and Karen Hewitt, who supplied works from their collections.

My painting teacher Ted Kurahara and my teaching and color theory mentor Mary Buckley Parriott.

Frank Hewitt, who taught me that an artist's vision is more important than the means through which he gets there. Frank died in 1992, but his work and his theories have had and will continue to have a lasting influence on my work.

My parents, Betty and Joe Dye, who have encouraged me throughout my development as an artist.

My children, Katie, James, and Hender, who have been incredibly patient and helpful.

Table of Contents

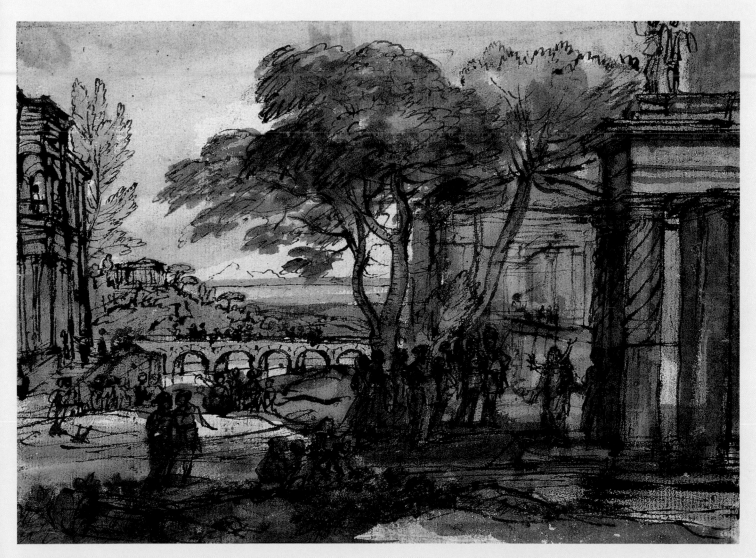

Claude Gellée, called Claude Lorrain (French, 1600–1682),

Esther on Her Way to Ahasuerus, 7 1/2 x 10 3/16 in. (19 x 25.9 cm).

Black chalk, pen, brown wash, and white heightening on paper.

Norton Simon Foundation.

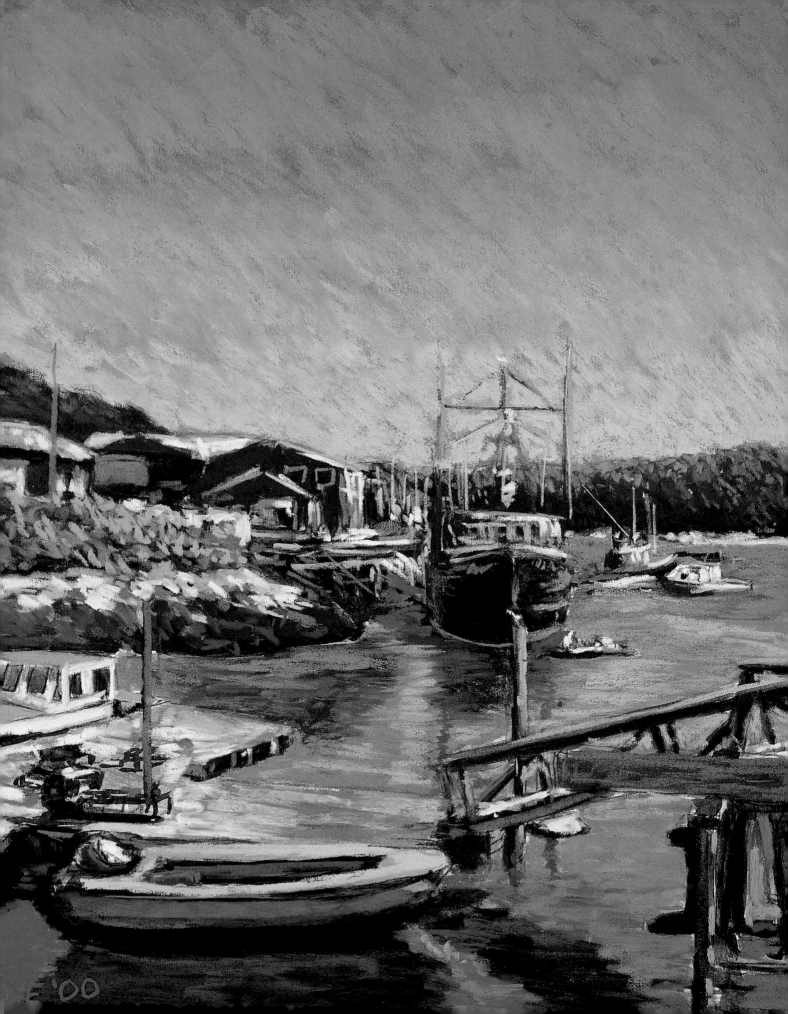

Preface

When I first started thinking about the possibility of doing a book on mixed media, I thought of some of the comments I regularly hear in my workshops. "Are you going to put all this stuff we are learning in a book sometime?" or "Should we be writing these steps down or will you be putting them in your next book?" These questions and others like them got me thinking that there was a real need for a technical and instructional guide to mixed media—and that I could do it with my own work as a foundation. I decided that the best place to start was with existing books on the subject. Guess what? They are incredibly hard to find.

Not long ago I had an exhibition at the Supreme Court of Vermont. A local art critic wrote of my work that it was "technical" and "somewhat didactic." She may not have meant those comments as a compliment, but I prefer to think of them that way. My love for and fascination with the physical materials of art making naturally leads to a concern with technical considerations. And one of the dictionary definitions of "didactic" is "intended to convey instruction and information as well as pleasure and entertainment." This book is intended to do just that.

I recently visited a gallery and was captivated by an absolutely smooth, glossy surface of an oil painting. I inquired about the artist's technique. The gallery owner told me that it was one of the artist's highly guarded secrets. After recovering from my initial annoyance, I thought to myself, "That's rather silly and self-important, isn't it?"

The good news is that I'm going to lay out all of my techniques—those not highly guarded secrets—that will start you on your way to creating innovative and exciting artwork. The bad news is that there aren't any tricks or gimmicks that you can use to make good art. The real secret lies in hard work, intense observation, endless sketches, and hours upon hours in your studio.

For the next 140 pages or so I'm going to invite you into my studio to look over my shoulder while I continue my lifelong exploration of mixed-media techniques. I hope you'll roll up your sleeves and create with me. On the way we'll take a look at some of my favorite historical and contemporary artists.

WHY MIXED MEDIA?

There is no one answer. Consider some possibilities. One medium by itself may not be sufficient to carry an artist's vision to completion. For seasoned artists, mixed-media techniques are a way to explore new mediums or reinvigorate familiar ones. For beginning artists, doing mixed media works may be a fast track way to start exploring the vast world of art materials. In either case, the artist who uses sound archival practices to make mixed-media works will be able to create a lasting record of exploration and at the same time break from some of the limiting traditions that have, historically, narrowed the range of possibilities for using art materials.

In this book, I chose the illustrations to accompany each medium as much as possible on the basis of what I perceive as the dominant medium in the illustration. There is, of course, considerable overlap, and not all viewers will respond in the same way to a given work. In some cases the surface interaction of two or more mediums will be obvious. In others the dominant medium may be all that most viewers will be able to see. That does not mean that the introduction of the other materials was superfluous. In most of the works, the early layers influenced the subsequent ones, as the demonstrations clearly show. In all cases, the works chosen for the demonstrations are representative of my most exciting and successful discoveries.

Sean Dye, **Boats Near Pemaquid Maine, Detail** (2000)
Pastel, watercolor, and graphite on Wallis paper, 18 x 24 in. (45.7 x 61 cm).
Collection of Cindy and Gary Hazelton.

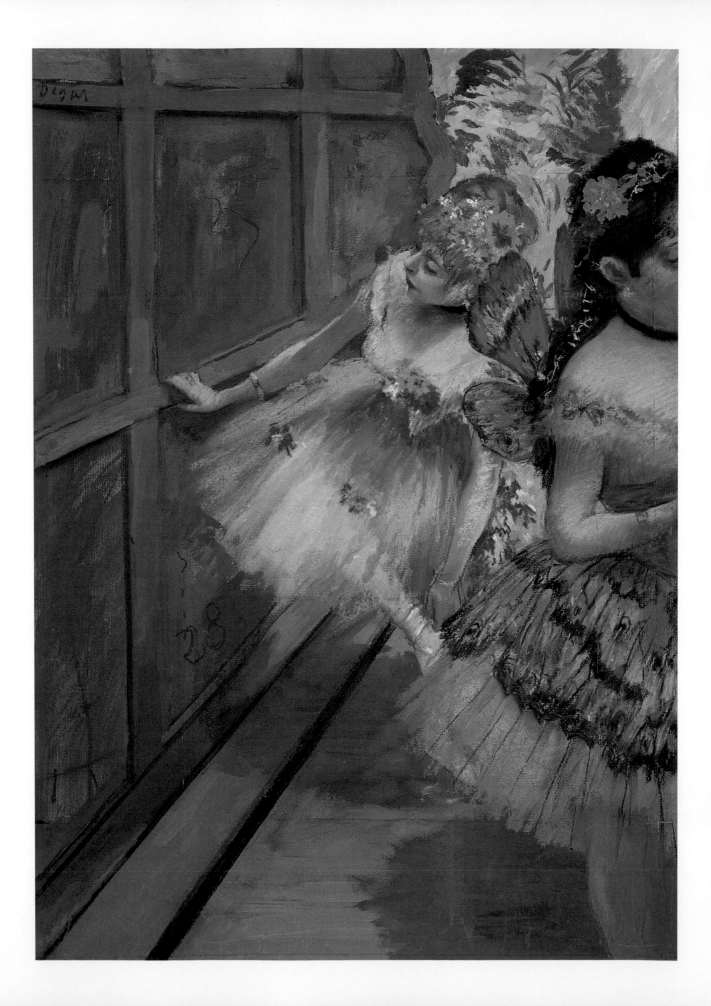

1

AN INTRODUCTION TO MIXED MEDIA

Although many of the truly ground-breaking mixed-media combinations were made possible only by relatively recent developments in paint and support technology, and by a sea change in what the art world regards as legitimate art, artists have been using mixed-media techniques for centuries.

Edgar Degas,
Dancers in the Wings (1880)
Pastel and tempera on paper,
mounted to paperboard,
27 ¹/₄ x 19 ³/₄ in. (69.2 x 50.2 cm).
The Norton Simon Foundation.

The composition of this mixed-media painting is daring. A crop of the figure such as the young woman in the foreground was considered revolutionary at the time. Degas often used extreme angles in his perspective, as seen here in the floor and wall. The bright pastel passages sit comfortably on the more muted layers of tempera. The grain of the paper, virtually obliterated in the tempera areas, shows dramatically through the pastel strokes.

Historical Art and Mixed Media

Giotto di Bondone (Italian, c. 1266/76–1337) was one of the first modern European painters to create mixed-media works. At the age of ten, Giotto began apprenticing for the great Florentine master Cimabue (Italian, c. 1240–c. 1302), from whom he learned the technical details of fresco, mosaic, and tempera. He later broke with the old traditions of Roman and early Gothic painting that often represented full figures with stiff, unnatural poses and stylized, almost expressionless faces. He used his knowledge of perspective, contour, foreshortening, and anatomy to take the art of figure painting to new heights. In one of his well-known works, the *Peruzzi Altarpiece*, which depicts Christ, the Virgin Mary, St. John the Evangelist, St. John the Baptist, and St. Francis of Assisi, Giotto and his assistants beautifully combined the satin luster of tempera paint with the metallic sheen of gold leaf to create a dynamic and highly spiritual effect.

Piero della Francesca (Italian, 1420?–1492) painted a double portrait, *Battista Sforza and Federico da Motefeltro*, some time after 1475 using oil and tempera on panel. It hangs at the Galleria delgi Uffizi in Florence. Oil was not widely used in Italy at the time but had been popular in northern Europe since the early 1400s. Fifteenth-century Flemish artists such as Jan van Eyck (1390?–1441) are also known to have used oil and tempera together. Van Eyck's *Man in a Red Turban* (oil glaze over tempera on board) at the National Gallery in London is an excellent example. The tempera provided an absorbent ground for the oil to adhere to. The combination of oil and tempera, as well as his highly developed sense of light and shadow, may help to explain why van Eyck's luscious, fluid realism can be distinguished so easily from the relatively flat, rigid representations of nature painted by his predecessors.

Drawing mediums, which are often grouped together as a

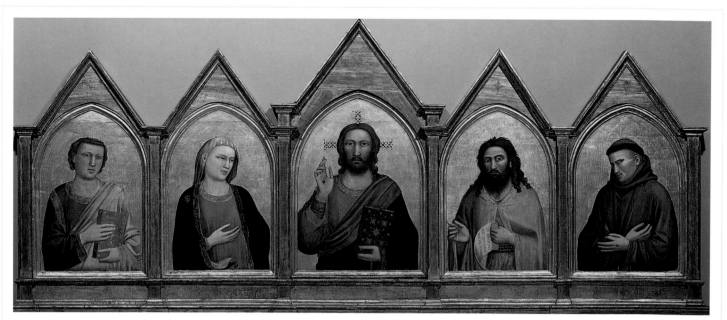

Giotto di Bondone and assistants, **Peruzzi Altarpiece** (c. 1312)
Tempera and gold leaf on panel, 41 5/8 x 98 1/2 in. (105.4 x 250 cm).
North Carolina Museum of Art, Raleigh. Gift of the Samuel H. Kress Foundation.

For a time during the nineteenth or early twentieth century, the central picture was separated from the other four. In 1947, Samuel H. Kress bought all five, and restored the altarpiece to its original configuration.

single medium, were an obvious and natural group of materials for artists to mix. For centuries, drawing materials were used for sketches, studies, or preliminary works, and issues of permanency and rules for their application did not apply. Rembrandt van Rijn (Dutch, 1606–1669) drew *Head of an Oriental with a Dead Bird of Paradise,* now at the Louvre in Paris, using pen, bistre washes, and gouache. Bistre is a brown pigment made from the ash of the beechwood that was used from the fourteenth through the nineteenth centuries. It was eventually supplanted by inks with more light-fast pigments. Italian artist Giovanni Battista Tiepolo (1696–1770) used pen, brown ink, and brown wash over black chalk for *Apollo with Lyre and Quiver, His Arm Upraised,* now hanging at the Pierpont Morgan Library in New York City.

Perhaps the most well-known and tragic mixed-media disaster is Leonardo da Vinci's fresco *The Last Supper* (c. 1495–98) in Milan. Leonardo used oil and tempera on plaster. Because of his meticulous technique he could not keep up with the fast drying of the plaster. The plaster and pigment did not fuse properly, and to his great disappointment the paint quickly began to flake off the surface of the masterpiece.

French Artist Antione Watteau (1684–1721) did several portraits and figure studies using red, black, and white chalk with gray ink washes.

In the 1870s and 1880s Massachusetts-born artist Winslow Homer (1836–1910) created many exquisite paintings using watercolor, gouache, graphite, and sometimes charcoal on various papers. His paintings were usually dramatically lit and depicted people at leisure or work in settings such as the New England coast and the Adirondack region of upstate New York.

French artist Edgar Degas (1834–1917) is considered by many experts to be the greatest pastel artist in history. His superb draftsmanship combined with a lifelong exploitation of the medium's possibilities make the claim hard to argue with. What may not be as widely known is that he spent much of his career exploring the possibilities of mixed-media techniques, working mainly with monotype, gouache, pastel, essence, oil, charcoal, and tempera on paper.

Degas's contemporary Henri de Toulouse-Lautrec (1864–1901) also experimented with mixed media, including pastel with drained oil color with spirits on cardboard and various combinations of colored pencil, pastel, and graphite.

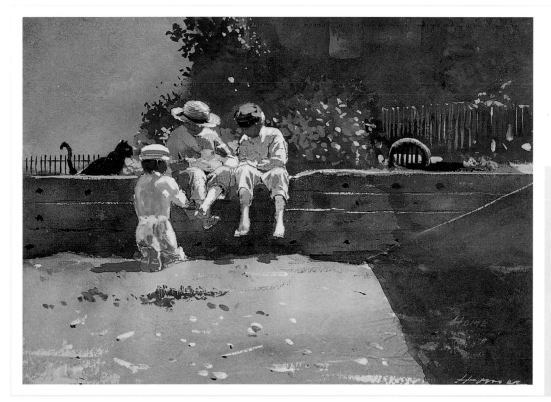

Winslow Homer

Boys and Kitten (1875)
Watercolor and gouache over graphite on medium-textured cream wove paper, 9 ⁵/₈ x 13 ⁵/₈ in. (24 x 34.3 cm). *Worcester Art Museum, Worcester, Massachusetts. Sustaining Membership Fund.*

Winslow Homer seems to capture the light effortlessly here. The boys' curiosity is mirrored by that of the black cat. It peers at the group inquisitively, or perhaps protectively, from the side. The transparent watercolor, opaque gouache, and pencil lines make distinct, individual statements. Using cream paper allowed Homer to add bright highlights with the gouache.

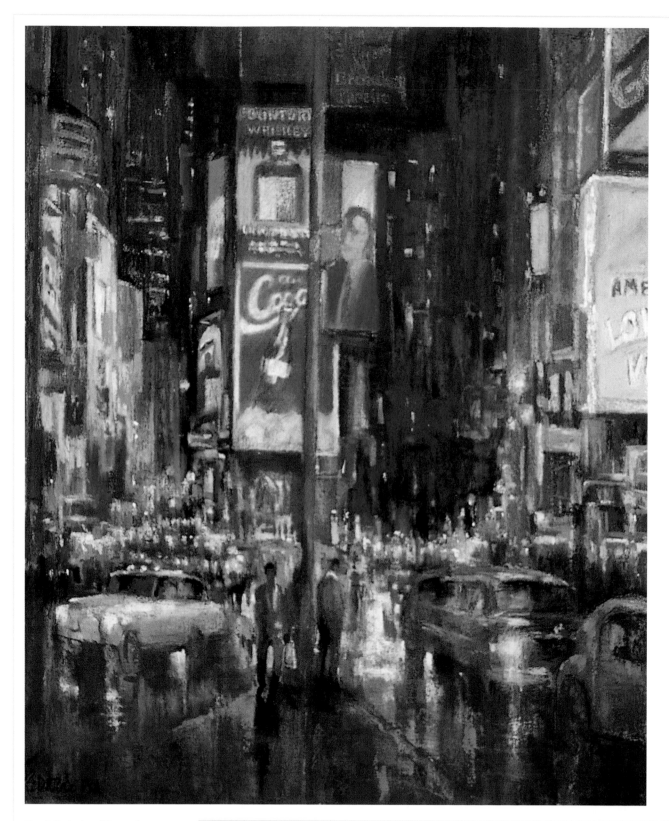

Frank Federico, Times Square

Pastel over gouache underpainting on canvas, 32 x 26 in. (26 x 66 cm).

Connecticut artist Frank Federico has almost magically transformed the dry pigment of pastel and gouache layers into this incredible scene of New York's Times Square at night. The repetition of vertical strokes enhances the feeling of height in the buildings. The warm reds, yellows, and oranges thrust the people and automobiles forward, helping the cool colored buildings to recede.

The Modernists and Beyond

Over the course of the twentieth century, mixed-media techniques were adopted by an increasing number of well-known artists, and the combinations became ever more complex. Perhaps one of the most interesting twentieth-century artists who experimented with mixed media was painter and printmaker Paul Klee (Swiss, 1879–1940). Klee's body of work doesn't fit neatly into any category, but many of his paintings can be classified as mixed-media works. The combinations used by Klee include gauze mounted on paper; casein and oil on canvas; oil, oil transfer, and opaque water-

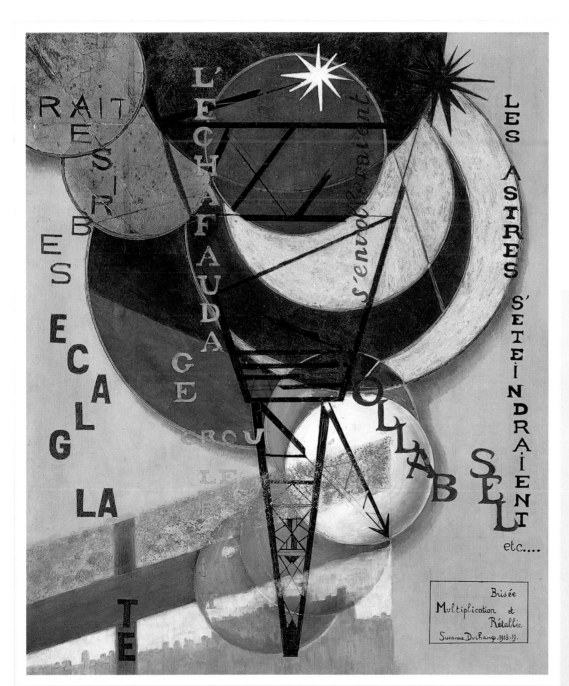

Suzanne Duchamp

Broken and Restored Multiplication (1919)

Oil and silver paper on canvas, 24 x 19.7 in. (61 x 50 cm).

Gift of Mary P. Hines in memory of her mother, Frances W. Pick; through prior acquisitions of Mr. and Mrs. Martin A. Ryerson, II. J. Willing, and Charles and Mary F. S. Worcester. 1994.552 reproduction. The Art Institute of Chicago. © Artists Rights Society (ARS), New York/ADAGP, Paris.

Suzanne Duchamp first exhibited cubist works in 1912 but soon after became one of the leading Dada artists. Along with the other Dada artists, Duchamp was influenced by the poems of Guillaume Appollinaire, in which he arranged the word pictorially. This painting makes references to the work of her contemporaries Robert and Sonia Delauney. The text in this work mentions such things as balloons, scaffolding, stars, and a shattered mirror (perhaps one reason for the silver paper). There is an upside-down Eiffel Tower, a window overlooking a city skyline, and assorted disks.

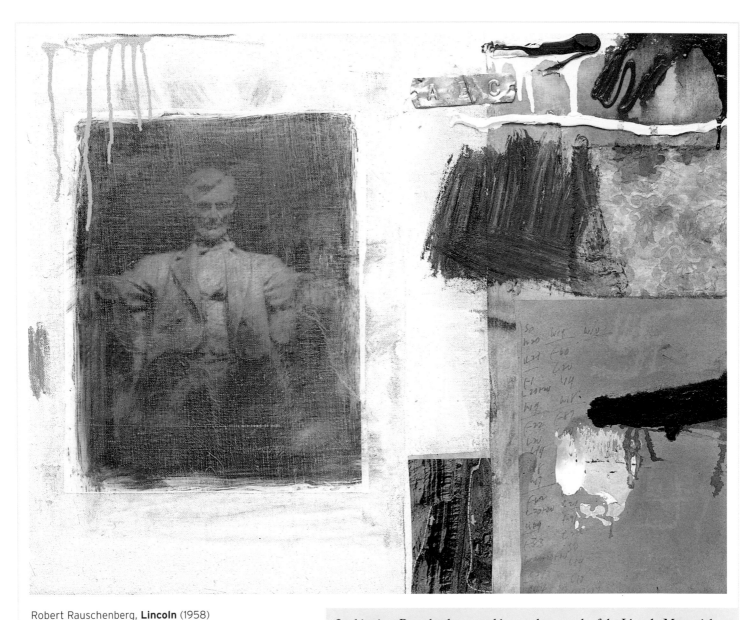

Robert Rauschenberg, **Lincoln** (1958)

Printed paper and stamped metal, with oil paint, fiber-tipped pen, and silkscreen ink on fabric, 17 x 20.8 in. (43.2 x 53 cm). *Gift of Mr. and Mrs. Edwin E. Hokin. 1965.1174 reproduction. The Art Institute of Chicago. © Robert Rauschenberg/Licensed by VAGA, New York, NY.*

In this piece Rauschenberg combines a photograph of the Lincoln Memorial in Washington, D.C., with thick and thin layers of paint; a rectangle of brown wrapping paper with lists of numbers and letters; a metal tag stamped with the letters A, B, and C; a scrap of damask; and an illustration of an eroded cliff turned on its side. It is likely that Rauschenberg included the image of Lincoln, the president who helped to free the African American slaves in the 1860s, as a commentary on America's civil rights struggles in the late 1950s and early 1960s.

color on plaster-coated gauze on painted board; oil on oil-primed muslin mounted on gold foil mounted on painted board; and tempera and oil on canvas. Among his famous mixed-media works is *Dance You Monster to My Soft Song* (1922), a watercolor and oil transfer drawing on plaster-primed gauze bordered with watercolor on paper mount.

COLLAGE

Among the many well-known artists who created memorable mixed-media works in the first half of the twentieth century are Pablo Picasso (Spanish, 1881–1973), Georges Braques (French, 1882–1963), Suzanne Duchamp (French, 1889–1963), Max Ernst (German, 1891–1976), and Kurt Schwitters

(German, 1887–1948). All of these artists, beginning with Picasso and Braques, experimented with the genre known as collage. Collage is generally described as any two-dimensional or low-relief work executed by gluing or otherwise attaching paper, fabric, printed materials, photographs, or other natural or manufactured materials to paper, panel, or canvas. Collages are not necessarily mixed-media works—a work consisting entirely of objects and materials glued onto a flat surface would not be considered mixed media—but the examples in this section all combine pasted elements with one or more of the traditional drawing and/or paint mediums.

Picasso and Braques were the first to elevate the nineteenth-century craft of *papiers collés* ("glued papers"), a decorative craft in which designs were developed with cut colored paper, to the level of fine art. They began to paste newspaper clippings, tickets, and other materials onto paintings and drawings. Two early examples are Picasso's *Still Life with Chair Caning*, where the artist incorporated oil cloth, newspaper, and rope into the painting, and Braque's *Fruit Dish and Glass*, onto which were glued bits of wallpaper and newspaper.

From the second half of the twentieth century and into the twenty-first, collage has continued to be a compelling means of expression for major artists, and the range of materials that can be incorporated into the works is seemingly limitless.

Starting in the mid-1950s American artist Robert Rauschenberg (b. 1925) introduced a method he called "combine paintings." He started by gluing photos, paper, and clippings to his paintings, and eventually began adding bulkier objects to the works, giving them a more three-dimensional quality. At the same time, another American, Jasper Johns (b. 1930), was introducing the art world to his encaustic and collage works on canvas. In the 1990s Johns began adding autobiographical collage elements to his paintings, including family photographs and even a floor plan of his childhood home.

In the early 1980s a Brooklyn-born artist, Julian Schnabel (b. 1951), created unique, monumental collages that started with reinforced wood layered with plaster into which Schnabel embedded broken plates and crockery along with

ADHESIVES

If you search the Internet for information on what adhesives work well for collage and other mixed-media works and are at the same time archival, you will find that different artists offer different advice. In general, you want a pH-neutral adhesive that dries clear. Many artists use one or more adhesives known as acrylic mediums, which dry to a waterproof finish. For a dull, paperlike finish acrylic matte medium or acrylic matte gel work well; however, the matting agents sometimes cause the medium to dry slightly cloudy. Always test a new medium by letting it dry thoroughly before you use it for your permanent work. Gloss gel has the strongest adhesive properties, but dries to a shiny finish. Golden Paints makes a variety of top-quality acrylic mediums, and their properties are described on Golden's Web site: www.goldenpaints.com

There are a number of pH-neutral archival PVA (polyvinyl acetate) adhesives that are suitable for gluing collage elements to a support, for gluing linen and paper onto panels, and as an alternative for animal glues for sizing canvas and panels for oil painting. They are more fluid than many acrylic mediums. I use a pH-neutral PVA glue made by Light Impressions, a Rochester, N.Y., company that makes an entire line of archival materials (for a free catalog, call 800 828-6216 or visit their Web site: www.light-impressions.com).

Do not use Elmer's Glue All, which has cornstarch in it, for anything you want to last.

other objects such as twigs and Bondo, an auto body filler. Then he worked oil paint in and out of these uneven surfaces.

At about the same time in Germany, Anselm Kiefer (b. 1945) was creating what art historian H. H. Arnason called "great black, apocalyptic paintings." These paintings, which were sometimes 12 feet long or larger, employed many unusual combinations of varied mediums, materials, and techniques, such as, oil, woodcut, shellac, acrylic, straw, lacquer, canvas cardboard, and lead. Kiefer's collages are, essentially, historical works. In the scorched and decimated landscape of *The Order of the Angels,* which is meant to represent the postwar Germany of Kiefer's childhood, a chance of rebirth for the German people comes in the form of a miracle. The Order of

the Angels, which Kiefer applies with small labels at the top, is the nine heavenly ranks of angels based on the writings of the first-century Athenian, Dionysius the Areopagite. With his combination of unusual materials and unique look at German history, Anselm Kiefer creates a world full of mystery and spiritual hope.

Modern Arts, on the opposite page, owes much to twentieth-century collage technique. To create this piece, Kidhardt first made a collage from printed materials he had saved from *Popular Mechanics* and *Popular Science Magazine* during the period from about 1930 to the 1950s. Next, he enlarged the images onto plywood using woodburning as a drawing tool. Finally, he added color using acrylic polymer paint.

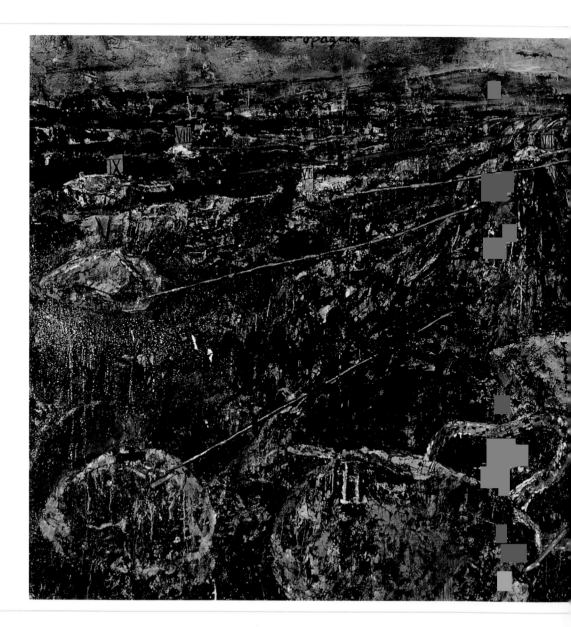

Anselm Kiefer, **The Order of the Angels** (1983-84)
Oil, acrylic, emulsion, shellac, and straw on canvas with cardboard and lead, 10.8 x 18.2 ft. (330 x 555 cm).
The Art Institute of Chicago.
Courtesy of Anselm Kiefer.

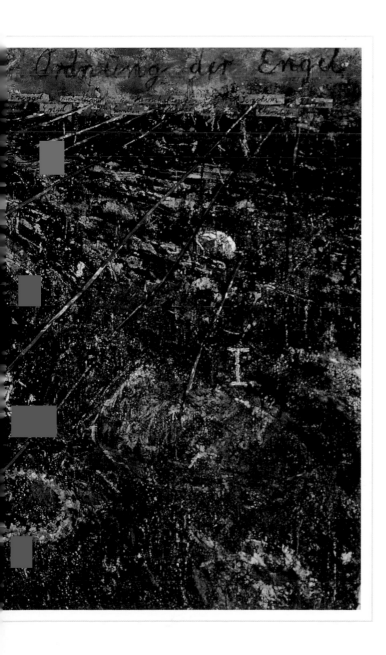

Eric Kidhardt, **Modern Arts** (2001)
Woodburning and Acrylic on Plywood, 40.5 x 28 in. (102.9 x 71.1 cm).

The woodburning, the wood grain, the color scheme, and the vintage images all add to the nostalgic, retro feeling of this piece. The work is much more than a simple memory piece, however, and there is an offbeat and even sinister undertone to the imagery.

Michael Oatman, whose studio is in Troy, New York, is a multitalented artist, and many of his most compelling works are dominated by collage techniques. Oatman's attention to detail and the sheer complexity of his work are astonishing. All of his works, many of which are filled with social and political messages (often accompanied by a healthy dose of irony), are intellectually challenging. They are also visually compelling. He uses images that he hopes will lead us to re-examine our society's unhealthy tendency to consume "institutional versions of human history."

Michael Oatman,

Anaximander (2002)

Collage on paper, 300+ components; wood frame with brass-framed micro-collages, 4.6 x 6.3 ft. (139.7 x 190.5 cm).

Photograph by Arthur Evans.

Anaximander was an early Greek philosopher who was among the first to articulate that all matter is somehow connected. Oatman believes that Anaximander was referring both to atomic structure and to divine design. When confronted by this piece in person, the viewer is overwhelmed not only by the complexity and precision of the work but also by its implications that we live our lives in the context of a constant information overload. His choice of collage elements, which includes natural materials and images from children's illustrators of the 1940s through the 1970s, was shaped by the texts he encountered as a child.

Study for **The Birds**

Collage on paper, 300+ components; wood frame with brass-framed micro-collages, 18 x 24 in. (45.7 x 61 cm). *Photograph by Arthur Evans.*

One of the many preparatory studies for *The Birds,* this collage shows a nearly seamless coupling of two vastly different sets of images: birds and modern weaponry.

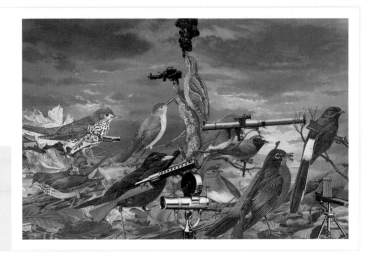

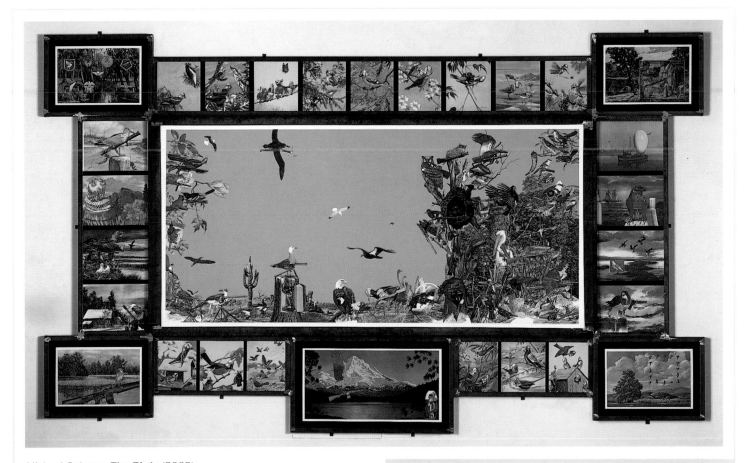

Michael Oatman, **The Birds** (2002)

Collage on paper, 400+ components; frames of main piece and 28 micro-collages are predella, welded steel, 12 x 7.3 ft. (368.3 x 223.5 cm). *Photograph by Arthur Evans.*

Among the antecedents of his monumental collage are the works of Hieronymus Bosch and Peter Brueghel the Elder, as well as Alfred Hitchcock's 1963 horror film of the same name. In the large central image it appears that the tide has turned against humanity as birds of all varieties are armed to the teeth. It could be that nature is making a stand against its own destruction. Seeing these creatures armed in this manner points out the absurdity of the human desire for self-destruction. The smaller collages depict birds in armor, dressed as hunters posing as decorated military heroes.

2

SUPPORTS

A *support* is any surface on which a work of art is made, and the preparation of surfaces for mixed-media works is often an integral part of the creative process, affecting how the different mediums chosen for a particular work will look. This chapter first gives an overview of the major support types, then discusses surface preparation in the context of mixed media.

Sean Dye
**Entrance to Hogan Pond III,
Oxford, Maine** (2000)
Water-soluble oil color, acrylic
gouache, India ink on Gessobord,
24 x 18 in. (61 x 47.5 cm).
Private Collection.

From Paper to Claybord

PAPER

The earliest documented support for painting was cave walls, followed by parchment, usually made from sheepskin or goatskin, and vellum, made from calfskin. Paper, which was probably first made as early as 200 BCE, appeared in China about 300 years later. By the middle of the eighth century, Chinese paper-manufacturing methods had reached Samarkand in Central Asia. Muslim traders brought paper to the Islamic empire and, in the twelfth century, to the Iberian Peninsula. Christian Europeans of the middle ages were at first reluctant to replace the much sturdier parchment with paper, but increasing demand and the popularity, with artists, of flexible yet sturdy rag-based paper inevitably broke down resistance.

Today, the raw material for all paper basically consists of cellulose fiber from a variety of plant sources. The fiber is reduced to a pulp and all toxic components are removed. Next, it is felted, or pressed together in sheet form. The microscopic weblike mass of interlaced fibers abrades pencil, charcoal, crayon, or pastel applied to the paper surface, and particles of the medium remain in the tiny interstices.

Artist-quality paper is made from linen or cotton and is 100 percent pure rag. Non-artist-quality paper is usually made from acidic wood pulp. Most paper is sized with alkyl ketene dimer before being pressed. Paper that is not sized is called blotter or filter paper. Paper may be hot-pressed, which leaves a smooth surface; rough, or not-pressed; or cold-pressed, which leaves a coarser texture than hot pressing.

Paper for watercolor is priced according to weight, ranging from 70-pound paper to 300- to 400-pound paper. The lighter-weight papers require wetting and stretching before use. An alternative to stretching is to buy the paper in blocks, where the sheets are glued together at the edges.

Sean Dye, **After the Shower at Shelburne Farms**

Watercolor, gouache, and graphite on Arches 140-pound cold-pressed watercolor paper, 9 x 12 in. (23 x 30 cm). *Collection Louis and Joline Drudi.*

I captured most of this scene in watercolor and pencil on site. Back at the studio, I reworked the painting from memory using the more opaque gouache.

Michael Oatman, Blanket (2002)

Collage and spray paint on paper, 200+ components with clear pushpin border, 12 x 7.3 ft. (145 x 88 cm). *Photograph by Arthur Evans.*

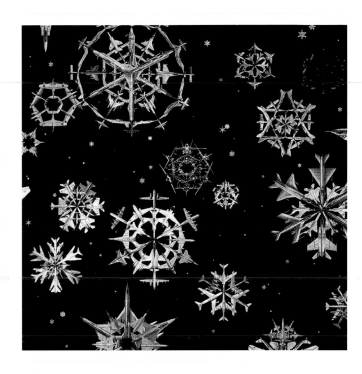

This work was partly inspired by the paintings of Italian mannerist painter Giuseppi Archimbaldo (c. 1530–1593), whose thematic portraits appear to be constructed from fruits, vegetables, plants, fish, or other objects. It also owes a debt to the microphotographs of Wilson A. "Snowflake" Bentley (1865–1931), the Vermont pioneer of subzero photography. At first glance, the collage seems to be a delightful collection of falling snowflakes on what may be a child's blanket or comforter. As the viewer looks closer, however, it becomes apparent that the snowflakes are constructed from hundreds of military aircraft. Of the work, artist Michael Oatman says, "It calls to mind the state of war readiness I experienced growing up in Vermont in the 1960s and 1970s."

Frank Hewitt, Gallery Series/NYC (1977)

Watercolor, glued paper, dirt, and acrylic medium on paper, 88 x 120 in. (223 x 304 cm). *Courtesy of Karen Hewitt. Photo by Ken Burris.*

The paintings in this series were meant to work individually or in groups. Frank Hewitt used pieces of watercolor paper (each piece is 22 by 30 inches and each has a unique color scheme) as a resist in some places and glued them to the surface in others. He used dirt to add color and texture, with acrylic medium as an adhesive.

Sean Dye,

The Return of Stolen Money

Oil, graphite, white charcoal pencil, India ink, and powder pigment on Lenox Superfine paper, 8.5 x 11.5 in. (21.6 x 29.2 cm). *Collection of the artist.*

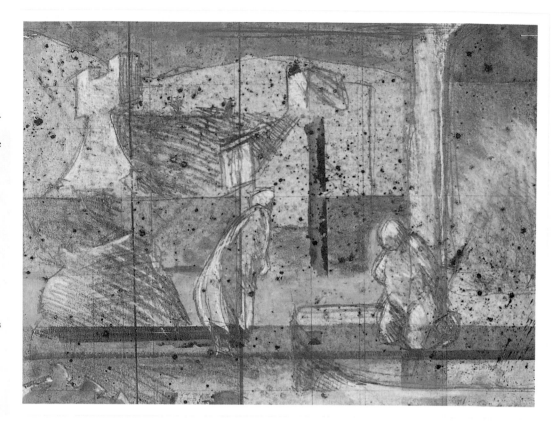

The two figures and archway were inspired by Rembrandt's *Judas Returning the Thirty Pieces of Silve*r; the distant buildings by his *Farmhouse in Sunlight*. I prepared the paper with liquefied matte medium and sprinkled it with dry powder pigment while it was still wet to get an ancient look. The gridwork was rendered in graphite and India ink, the figures and architecture in graphite and charcoal pencil. I added color with a layer of oil thinned with mineral spirits.

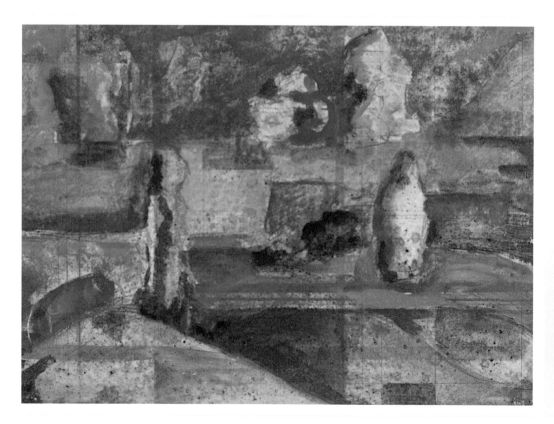

Sean Dye

Study for Timid Request

Oil, graphite, India ink, acrylic, and powder pigment on Lenox Superfine paper prepared with acrylic matte medium, 8.5 x 11.5 in. (21.6 x 29.2 cm). *Collection of the artist.*

This was a study I made for a large 4- by 6-foot painting. The title refers to the figure on the left, who has come to make a difficult request of his superior represented by the figurelike form on the right. In this work I wanted a balance between creating an interesting two-dimensional surface and suggesting three-dimensional pictorial space.

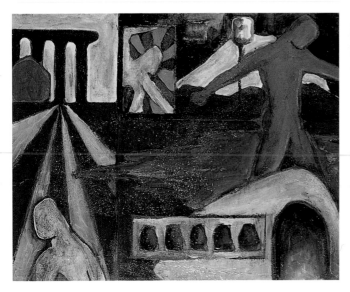

Sean Dye, **Twist and Turn Away**
Oil, acrylic, charcoal, and powder pigment on rice paper mounted on canvas, 22 x 26 in. (55.8 x 66 cm). *Collection of the artist.*

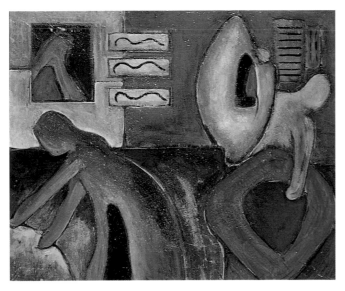

Sean Dye, **What Were You Hoping For?**
Oil, acrylic, charcoal, and powder pigment on rice paper mounted on canvas, 22 x 26 in. (55.8 x 66 cm). *Collection of David P. Morency.*

CANVAS

Canvas is the general term for all stretched fabric used for artists' supports. Canvas may be made from linen, cotton, linen/cotton blend, and synthetic materials like polyester. The most ancient and archival of these materials is linen, and painting on linen dates back to pre-Columbian times in the Western Hemisphere and to 2000 BCE in Egypt. The use of linen as a support in Europe probably started in the Netherlands in the fifteenth century, with Dieric Bouts and Pieter Brueghel. In Italy, Andrea Mantegna (1431–1506) painted many of his works on linen, and was instrumental in popularizing its use. Historians believe that the use of stretched canvas in Italy was sparked by the influx of painted Flemish cloths, which could be hung in place of tapestries. Whatever the reasons, canvas has clear advantages over wood panels: it requires less extensive preparation, doesn't crack, and is relatively light and flexible, making it easy to transport.

Linen is made from the long fibers of the flax plant. After the seeds are removed, the fibers are left to decompose so the binding pectins break down, either naturally outdoors or after soaking in tanks of water. The fibers are dried and separated from the woody waste matter. Then they are combed to remove the long flax lines from the short ones. The short lines are then pulled into slivers of flax fiber that are spun wet or dry and then woven into fabric. Wet spinning creates a smooth surface and dry spinning a rough surface.

Cotton has been cultivated for thousands of years, but it has only been popular for use as artists' canvas since the 1930s. Cotton canvas is less expensive than linen canvas, but linen remains the surface of choice for most professional artists. Linen is stronger, lighter, and longer-lasting than cotton. Its texture is more irregular, and its weave looser, than cotton, which gives added interest and depth to any work created on a linen surface.

Cotton fibers stretch more readily than linen fibers. The stretching techniques for both linen and cotton depend on whether they are primed or unprimed. Care should be taken when stretching linen. Too much tension will weaken the structure while too little tension will yield an unresponsive surface. It is important to put staples or tacks not only on the back of the stretcher but on the sides of the stretcher bars as well. This helps to distribute stress and thus extend the life of the linen canvas. Most experts do not believe that the extra staples are necessary for cotton canvas. If the stretching of any fabric is too tight, small cracks will appear at the corners of the canvas.

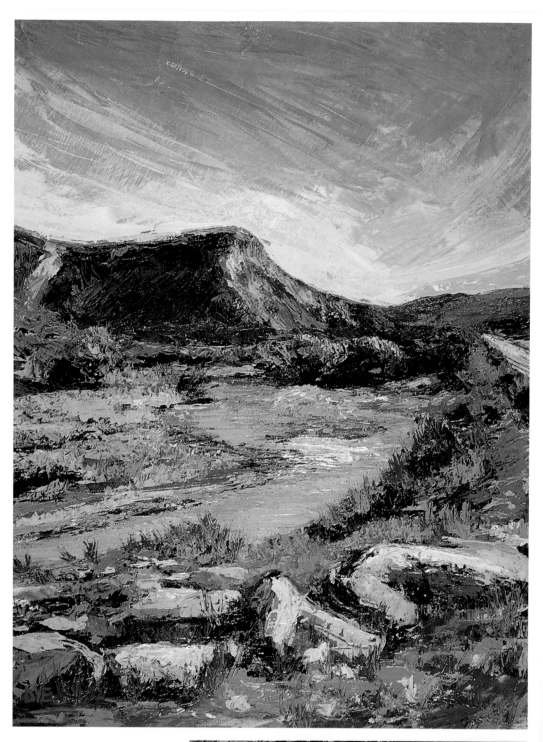

Sean Dye
On the Way to Taos, (2003)
Oil and acrylic gouache on canvas,
18 x 24 in. (45.7 x 61 cm).
Collection of the Artist.

For this work, I used painting
knives, pushing and scraping
the paint into thick impasto
layers. The acrylic gouache
dries quickly to a slightly toothy
matte surface that has great
adhesive properties for oil color.
The texture of the canvas holds
much of the paint. Scraping
exposes earlier layers, but the
recessed areas of the weave hang
onto initial layers even after
aggressive scrapes.

On the Way to Taos, Detail

Frank Federico, **Navajo Moon**
Gouache, ink, coarse pumice gel on
canvas, 24 x 30 in. (60 x 76 cm).

**Frank Federico uses collaged,
blocky shapes to build the
structure of this abstract
nightscape. The loose, splattered
application of pigment helps
build the complex surface.**

PANELS

For centuries, natural hardwood was the most commonly used
material for panels; the wood species used varied from region to
region depending on tradition and availability. Historically, the
preparation of wood panels has been long and tedious. Wood
panels must be well seasoned to remove resin and gum; other-
wise they will warp. In his book *The Craftsman's Handbook*
(c. 1390), Italian master painter Cennino Cennini (1370–1440)
advised that small panels be boiled to prevent splitting. Large
panel pieces of antiquity had to be fitted together perfectly and
glued with casein glue, which often proved to be a difficult oper-
ation. Any wood to be used as a support had to be meticulously
prepared with sizing and layered with gesso, both because nat-
ural wood is highly absorbent and because the pigment of the
wood would otherwise taint the paint.

Today, the preparation of panels doesn't have to be so tire-
some. Since the nineteenth century, the commercial manufac-
turing of prepared boards and processed wood has made life
easier for artists who want to work on panels. Good furniture-
grade plywood is relatively inexpensive and can be prepared sim-

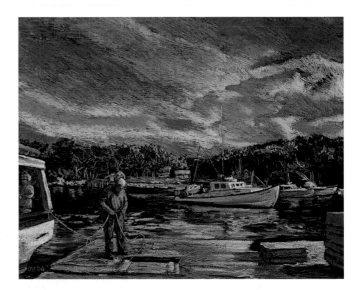

Sean Dye, **Fisherman at New Harbor Maine** (2000)
Pastel and India ink on MDO board prepared with Holbein's Gray V-5
gesso and pumice, 24 x 30 in. (61 x 76.2 cm). *Collection of the artist.*

ply with gesso. Alternatives that have the same practical advan-
tages as plywood over natural wood are hardboard (Masonite),
medium density fiberboard (MDF), and medium density over-

lay (MDO) board. MDO board is sign painter's plywood that is paper-faced and impregnated with resin. The surface does not absorb or release moisture and resists warping. Artists can also buy prepared wood panels in an assortment of tinted finishes from companies such as Artboard, Panelli a Gesso, J P Stephenson, and Ampersand. Panelli a Gesso is an absorbent gesso-coated panel made in Italy from a strong, natural wood called *pioppo* (poplar). It comes in two finishes: smooth and cold-pressed.

Ampersand Art Supply makes a variety of panel types. The absorbent Claybord works well for ink, watercolor, egg tempera, encaustic, and airbrush. Claybord Black may be used as a scratchboard. The less absorbent Gessobord is suitable for oil and acrylic. Pastelbord has a toothy finish that holds many layers of pastel. Hardbord, an unprimed panel, is available for those who like to prepare their own surfaces. Gessobord, Claybord, and Hardbord may also be purchased in cradled and deep-cradled versions, so they can be displayed unframed.

Supports that fall somewhere between paper and panel include illustration board, Bristol board, and museum board. Museum board comes in one-, two-, four-, six-, and eight-ply versions and, like Bristol board, has a smooth surface.

Hinesburg Hill View, Details
Both of these details show how the areas of the acrylic gouache that remain unpainted contribute warm accents that add a glow to the completed painting.

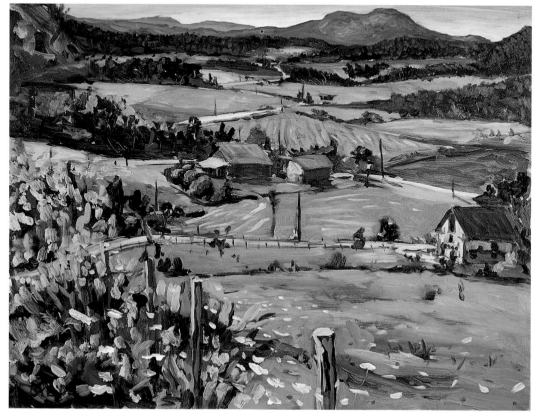

Sean Dye
Hinesburg Hill View (2002)
Oil, charcoal, and acrylic gouache on Gessobord, 14 x 18 in. (35.6 x 45.7 cm). *Collection of Gary and Susan Stewart.*

I toned the panel with a layer of yellow-orange acrylic gouache. Next I did a complete value study in vine charcoal. I painted the oil layer wet-on-wet using small amounts of fast-drying medium.

Eric Kidhardt,
Knocked Out (2002)
Woodburning and furniture stain on
plywood, 16 x 25 in. (40.6 x 63.5 cm).

This work is based on an
American photograph of a
German bunker taken during
the Normandy Invasion of
World War II. It is part of a
series that grew out of Eric
Kidhardt's interest in what he
refers to as "American militia
and obsessive survivalists."
It is drawn on plywood with
a wood burner and colored
with furniture stain to create
a "wood scale" as a substitute
for the grayscale of the original.

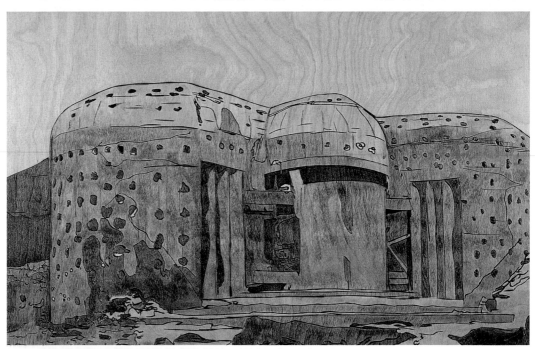

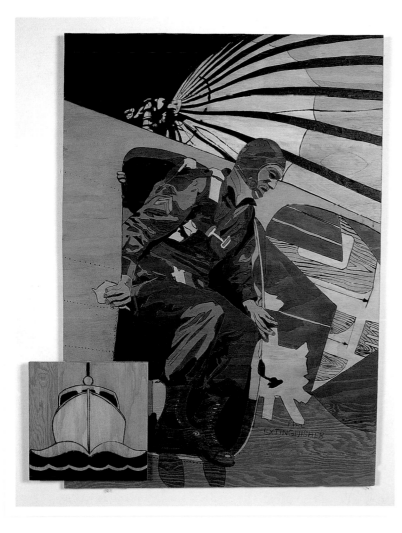

Eric Kidhardt, **Cut Plunge** (2001)
Woodburning and gouache
on plywood, 38.5 x 26.5 in.
(97.8 x 67.3 cm).

This work is based on a very
small collage that Eric
Kidhardt made from vintage
magazine cutouts. He seam-
lessly combines the image of
a skydiver with that of a dirigi-
ble and a cruise ship. The color
scheme is somewhat reminis-
cent of mid-twentieth-century
three-color publications popu-
lar before four-color printing
became widely used.

OTHER SUPPORTS

The structural integrity of a building is highly dependent upon the quality of its foundation. The support of a drawing or painting is the foundation of the piece. This first decision by the artist will affect all of the others. The oil painter who chooses a smooth, commercially sprayed gessoed panel will certainly have a different experience from the artist who decides to stretch and prime his or her own 12-ounce Belgian linen. Before beginning a mixed-media work, artists need to take into account *all* of the materials that may be placed on the support. Thus, the decision-making process is somewhat more complicated than it is when using a single, traditional medium.

Since the beginning of the twentieth century, it has been common practice for artists to try new surfaces for painting

Sean Dye, **Arrogant Virtue or the Relative Sizes of Artists' Egos**
Oil, acrylic, powder pigment, and charcoal on acrylic gel, sand, collage, fabric, rubber, leather, jute twine, jute, drywall screws, and pine, 42 x 48 x 2.5 in. (106.7 x 122 x 6.4 cm).

I built the support for this quintessential mixed-media work by screwing together small pieces of pine boards in various widths and lengths. Many of these had twine, rubber, fabric, or jute already attached to them. (As a materials specialist at a large architectural firm, I had a large collection of industrial fabric and leather samples). Next, I added collage elements and sand mixed with matte gel medium. I sketched out the composition using vine charcoal. I washed in early color using diluted acrylic paint. While the paint was still wet, I sprinkled on powder pigments. I finished the piece by adding layers of oil color in varying degrees of thickness from thin washes to thick layers applied with a knife. The shape on the right represents the young artist developing the self-confidence to enter the dog-eat-dog art world. The title suggests that the central figure wonders what one must do to achieve success.

Arrogant Virtue, Details

and drawing, and experimentation both with surface materials and with the methods of preparation of those materials is characteristic of artists working in mixed media.

Many materials if prepared properly can make exciting supports. Metals should be degreased and if rust-prone protected from oxidation with varnish.

Plastics are often used as supports for mixed-media works, and perhaps the most popular of these is Plexiglas. This clear, less fragile alternative to glass comes in varying degrees of thickness. It can be drilled, glued, sanded, and hinged. It accepts acrylic paint easily.

Just as found objects of many kinds can be used to create new and exciting art, found objects can also be combined in unusual ways to make one-of-a-kind supports.

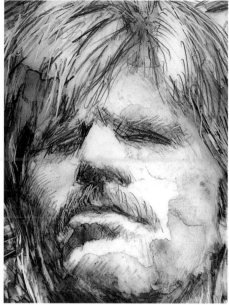

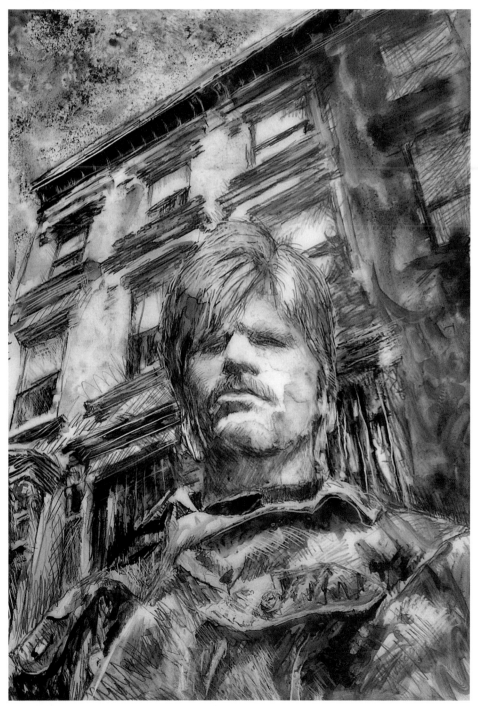

Sean Dye,
Self-Portrait, Fort Green, Brooklyn
Pencil, water-soluble pencil, lithographic tusche, and powdered graphite on frosted Mylar, 9.5 x 14 in. (24 x 35.6 cm).

I made this self-portrait several years ago, at a time when I had a fascination with juxtaposing the human figure with architecture. This piece was originally created to expose onto a lithographic plate. Many of the subtle grays were lost in the lithograph so I prefer this original drawing.

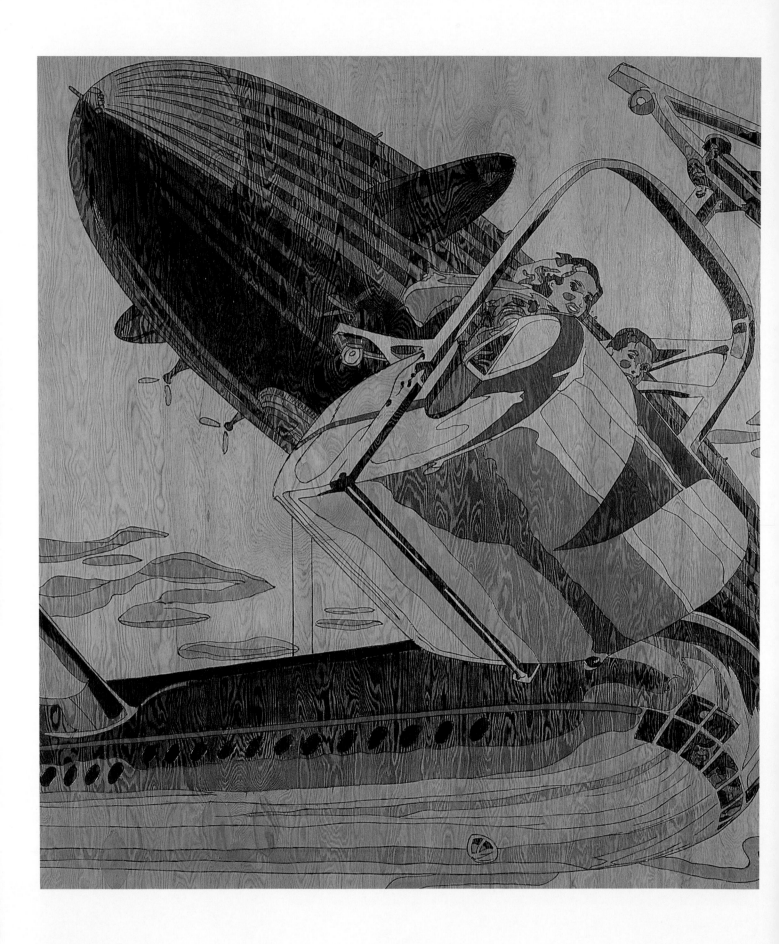

3

DRAWING MEDIUMS

Eric Kidhardt, **Airlifts** (2001) Woodburning, acrylic, and gouache on plywood, 68 x 46 in. (173 x 117 cm).

Using a woodburning tool as a drawing medium, artist Eric Kidhardt made swift, sure lines, and the result is a dynamic sense of movement. The gouache color is applied thinly enough to allow much of the natural wood grain to be visible.

Over the past 150 years, the notion of what qualifies as a drawing has evolved. Most experts agree that when a wet or dry medium is used to create a primarily monochromatic delineation of shapes and forms on a surface, the picture can be called a drawing. A contour drawing or value sketch that is painted over is no longer a drawing. In a mixed-media work, any of the drawing mediums can play a dominant role.

Drawing Mediums

A HISTORY OF VERSATILITY

Drawing is a major fine art in itself, but it is also known as the foundation of art, and is used as preliminary stages in painting, sculpture, and architecture. It is also the mode most used for sketches and studies, capturing the flowing ideas of an artist. From the imagery preserved in prehistoric caves of France and Spain to linear design on Etruscan vases, drawing is the oldest surviving art technique in the world.

The drawings of ancient times were most often used to document belief systems, for example, the Egyptian *Book of the Dead*. During the early Middle Ages in Europe, many manuscripts were illustrated with hand-drawn images, but most of the illustrated texts were religious in nature. In the fifteenth century, the cost of paper dropped dramatically, and sketchbooks became widely available. This gave professional and amateur artists alike the freedom to experiment and to set down on paper spontaneous, original responses to one's surroundings rather than rely on the numerous pattern books containing copyable drawings of thousands of objects and animals.

In the sixteenth century, Leonardo da Vinci (Italian, 1452–1519) emphasized spontaneity in drawing, and used preliminary drawings as a way to solve artistic problems. Da Vinci was a strong influence on Raphael (Italian, 1483–1520), one of the greatest draftsman of all time. Michelangelo Buonarroti (Italian, 1475–1564) was one of the first masters to regard drawings as works of art in their own right. During the seventeenth century, Michelangelo's high opinion of drawing came to be almost universally accepted in the art world, regardless of the original purpose of the drawing. Rembrandt often used an etching needle as a drawing medium, and his etchings and bistre drawings were sold at high prices during his lifetime.

During the nineteenth century, technological advances, including the invention of synthetic graphite and new processes for the mass production of different kinds of paper,

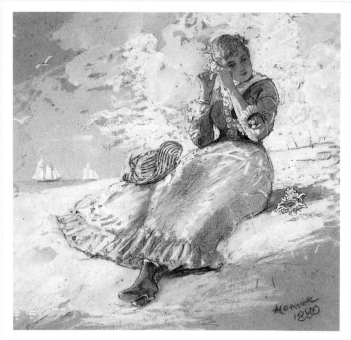

Winslow Homer, **Girl with Shell at Ear** (1880)
Graphite, charcoal, and white gouache on paper, 11 7/8 x 11 3/16 in. (30.2 x 28.5 cm). *Worcester Art Museum, Worcester, Massachusetts. Bequest of Grenville H. Norcross.*

Winslow Homer spent much of his career painting the North Atlantic coast. Here he depicts a young girl listening to the sound of the ocean in a seashell. Homer used the white gouache on the warm paper to create the sun-drenched beach. He used blended charcoal as well as charcoal and graphite lines to create folds in the textiles and to model the figure.

led to further advances in drawing techniques. The invention of photography was a significant force for change not only for painting but for drawing. It was impossible for artists to match the realism of a photograph, so they were forced to develop new means of expression through drawing.

CHARCOAL

There are many mediums that can be used as drawing tools, including woodburning guns (see Eric Kidhardt's piece on the opening page of this chapter). Probably the one that has been

around the longest is charcoal. Charcoal, available in vine, compressed stick, or pencil form, is a carbon residue obtained from charring wood sticks. It provides the artist with a variety of textures and subtle values. Like pastel, charcoal is easily manipulated by smudging, blending, or erasing.

GRAPHITE

Graphite is a crystalline form of carbon that produces a more permanent, and grayer, line than charcoal. Graphite was discovered in about 1500 near Keswick, England, but it wasn't quarried until the mid-1500s. The first wooden holders for graphite were developed in Italy, but the hardness or softness of each "pencil" varied with the characteristics of the graphite, which in turn depended on where it had been quarried. In 1795, French inventor and chemist Nicolas-Jacques Conté developed a process for mixing powdered graphite with finely ground clay particles and then shaping the material into sticks and baking it. Using the Conté process, manufacturers produced pencils with varying degrees of hardness (the more clay, the harder the pencil), and the hardness and quality were

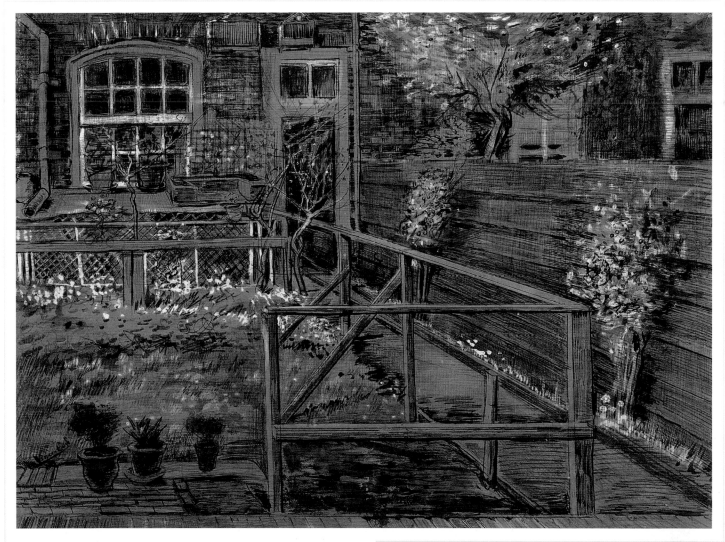

Vincent van Gogh
Back Garden of Sien's Mother's House, The Hague (1882)
Graphite, black ink, and white gouache on brown-toned paper mounted to paper, 18 1/4 x 23 7/8 in. (20.9 x 60.8 cm). *The Norton Simon Foundation, Pasadena, CA.*

Here van Gogh carefully records the perspective and creates a deep space using size change and overlap. The ink, graphite, and white gouache provide just enough values to give form to his objects. The brown paper acts as a mid-tone on which both the darks and lights can be easily seen.

relatively consistent from batch to batch. Today's pencils are labeled according to hardness: 9H to 2H are the hardest; H, F, and HB are in the middle of the range; and 2B to 9B are the softest. There is, however, no official standard for pencils, and an HB pencil from one manufacturer may not be the same as an HB pencil from another company.

INK

India ink, a highly permanent and stable medium, also known as drawing ink, is made of carbon pigment finely dispersed in a binder (usually shellac and borax) with a wetting agent and a preservative. Chinese ink is similar to India ink, but with a few minor ingredient changes making it more suitable to the subtle gradations of tone desired in Chinese painting. Ink can be applied with a brush or pen, and the artist can obtain a great variety of widths and intensities depending on the tool used, the pressure applied, and whether or not the ink has been diluted and by how much. There is an almost bewildering array of pens on the market, including Speedball pens, crow-quill pens, and technical pens, such as the Rapidograph. There is also a hybrid product called a brush pen, whose manufacturers claim offers the advantages of both pen and brush. If you plan to use ink extensively as a drawing medium, you'll need to try a variety of different brushes and pens.

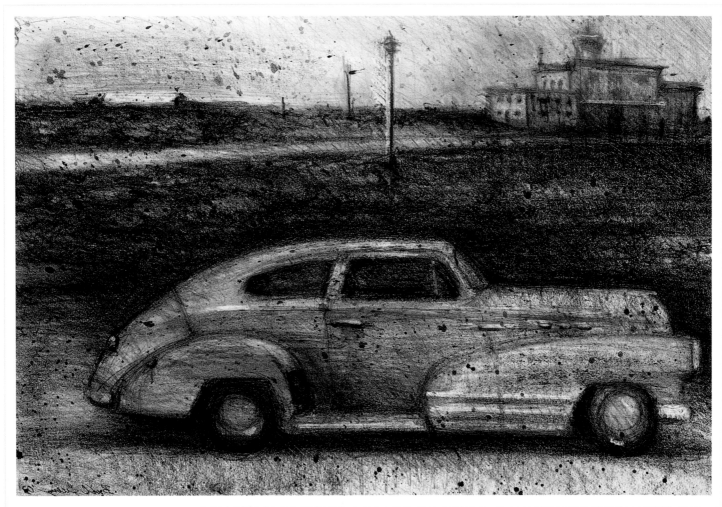

Bill Creevy, Torpedoback
Graphite, erasers, lithographic crayon, and watercolor on 140-pound hot-pressed watercolor paper, 12.5 x 18 in. (31.8 x 45.7 cm). *Photograph by D. James Dee.*

Well-known New York artist and writer Bill Creevy has mastered many mediums, including oil and pastel, but he says that his favorite medium is pencil drawing. This is a drawing of a 1946 Pontiac Streamline Coupe "Torpedo Back" resting on the outskirts of an abandoned airfield. Bill Creevy did not set out to create a typical vintage car picture here, but rather a surreal, somewhat mysterious image—a mood piece, not passive documentation. In Creevy's words: "No 'Sha Na Na' or 'Happy Days' with this baby. 'Torpedoback' is more like 'Desolation Row' via the 'Twilight Zone.'"

Michael Klauke,
From A to B # 12 (1996)
Pen and ink, gold leaf, and
watercolor on paper, 21 x 23 in.
(53.3 x 58.4 cm).

North Carolina artist
Michael Klauke appropriates
imagery from art historical
sources and combines them
with technical industrial
diagrams and text. His works
often employ clever plays on
words and multiple meanings.
The precision and attention
to detail of his work convey
a timeless message to the
viewer. The combination
of ink, gold leaf, and water-
color in this work feels natural,
yet ordered.

From A to B # 12, Detail

MIXING DRAWING MEDIUMS

Drawing mediums are very versatile mixed-media tools. There are very few chemical or physical restrictions governing how you can mix them. The most important consideration is the relative visual strength of the mediums being used. A 9H pencil, for example, could not stand up visually to straight India ink or soft vine charcoal, but would be an appropriate choice to combine with highly diluted ink or highly compressed charcoal.

When most people think of drawing, they think of works executed with pencil or charcoal. In fact, artists can draw with colored chalk, colored pencils, and different colored inks, and various colors can be used in the same drawing. Visual matches are important here as well. For example, the saturated color produced by a colored pencil is likely to be overwhelmed by the visual intensity of the lines made with a Conté crayon or pastel stick.

In general, wet drawing mediums such as India ink or black watercolor or gouache work best if applied before dry or powdery mediums like charcoal or pastel. The water-solubility of a drawing medium to be used in a mixed-media work should be tested before beginning the drawing, as the effectiveness of any layering sequence will depend on the relative water-solubility of the different mediums being used and the order in which they are applied.

Nearly all artist-grade papers are suitable for drawing and require no special treatment. Panels of various compositions may also be prepared for drawing mediums with gessoes as well as absorbent or abrasive finishes.

Nicholas Battis,

Gold Reflection, Black Pool

Ink, iridescent gouache, and bleach on paper, 9 x 12 in. (22.9 x 30.5 cm).

In this drawing, Nick Battis maintains a relatively monochromatic palette yet achieves a great deal of variety by employing a wide range of opacities and luster. He added bleach to the ink to bring back white from the paper. The bleach caused the ink to separate, revealing previously invisible hues. It is possible that the bleach will have negative archival effects over the long term, but meanwhile the piece is a wonderful combination of experimental materials and traditional, deliberate drawing techniques.

DEMONSTRATION

GRAPHITE, WALNUT INK, INDIA INK, OIL PENCIL, AND WHITE CARBON ON BUFF-COLORED PAPER

The model for this piece was comfortable assuming a pose and this one happened quite naturally. I positioned myself just below his eye level and asked him to look at me straight on. I saw in his eyes the serene confidence of a young man with his whole future ahead of him.

The pose and the expression were the most important elements of this piece. Normally, I feel compelled to fill the paper or any other surface I am working on. In this case leaving much of the background untouched placed dramatic focus on the model. It also meant that white paper would not be suitable for the surrounding space, so I chose buff-colored printmaking paper, which I felt would add a warm, natural, antique quality to the work.

In portraiture I like to have the option of making corrections, so although ink is a wonderful drawing medium, I decided to use graphite for the initial sketch.

1. I sketched the portrait in lightly with a 2H pencil on the soft, absorbent Lana Gravure 250-gram paper. Even at this early stage I am starting to think about value. This detail from the sketch shows some light cross-hatching I've included to indicate the shadow areas.

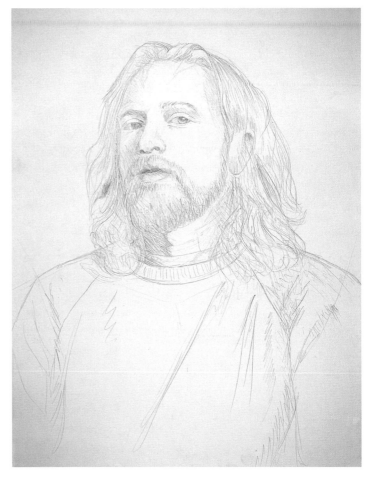

2. With a 2H and a 2B pencil, I have added more information to my sketch. I have modeled the shape of the skull and added more shadow to the eyes and neck. I have erased most of my guidelines from the early sketch.

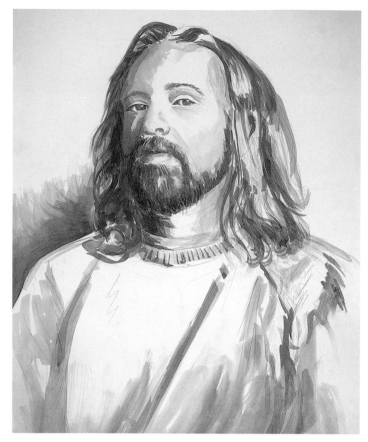

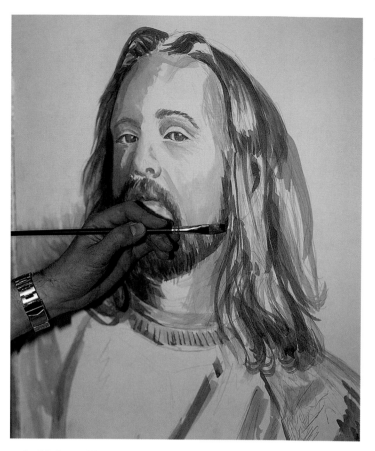

3. For the initial washes, I used walnut ink, which is essentially a more saturated version of the paper color, and thus a good visual fit. I placed a shadow behind the model's right shoulder to push the figure forward. The ink has several different densities here, providing a variety of values. The face is now more sculptural. The paper color appears lighter in the untouched areas, making the skin seem illuminated.

4. I added an additional thin layer of black India ink to deepen the shadows. Inks are absorbed quickly into printmaking paper because it is not heavily sized, so I had to use a lighter hand than I would have on drawing or watercolor paper.

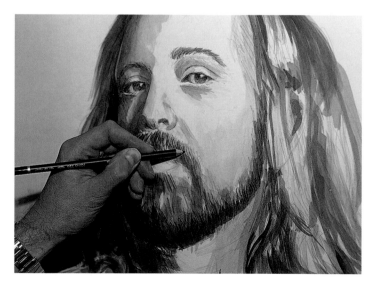

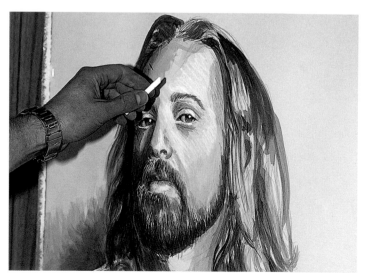

5. Here I am reintroducing pencil work with a #3 Nero pencil by Cretacolor. These soft, oil-based pencils provide a rich, smooth, dark opaque line that sits on the surface of the paper, helping to expose its subtle texture.

6. To exaggerate the highlights, I used Holbein's white carbon crayons. The white carbon adds a final, cool highlight that would not have been possible on white paper.

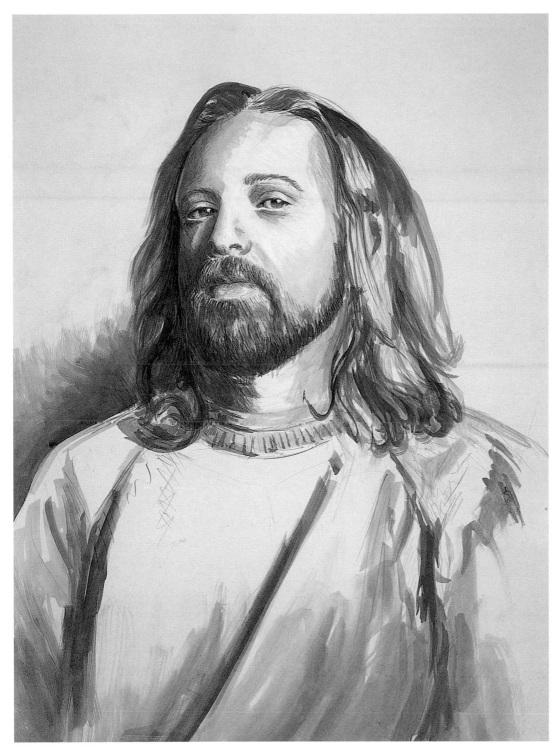

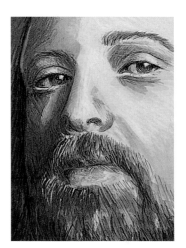

Sean Dye, **The Confidence of Youth** (2003)

Graphite, walnut ink, India ink, oil pencil, and white carbon
on buff-colored paper, 30 x 22 in. (76.2 x 55.9 cm).

Collection of the artist.

This detail clearly shows the white carbon in the eyelids, mouth, and facial hair. You can also see that the eyes have been darkened, which I did with the black pencil to intensify the stare.

DEMONSTRATION

GRAPHITE, OIL PENCIL, AND PRISMACOLOR PENCIL ON GRAY PASTEL PAPER

My wife, Sally, and I were looking for interesting subject matter near Taos, New Mexico, when I took a snapshot of her near this old pickup truck. I took a narrow crop from the center of my color photo and translated the colors into values for the drawing that was the basis for the work. I did the drawing on textured, middle-value pastel paper because I knew that both light and dark colors would show up well on it and that I wanted the texture of the paper to contribute to the final effect. I also knew that if I worked the surface too hard at any stage, the pebble-like surface would disappear, so I consciously maintained a light touch throughout the process.

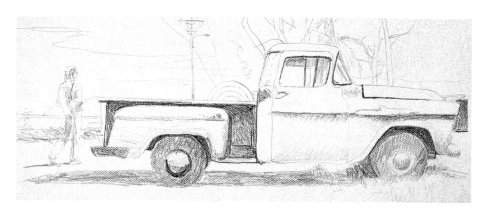

1. I chose to use the rough side of a piece of Warm Gray Canson paper. I sketched out the composition with a 2H pencil. When I was happy with the sketch, I added my first round of shadows with a #3 Cretacolor Nero pencil.

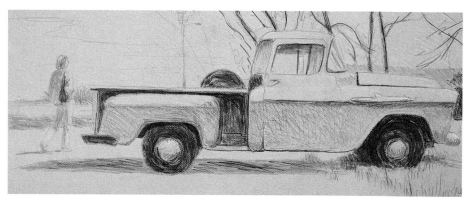

2. Using the Nero, I established most of my deepest darks, such as the tires, wheel wells, and tree trunks. I used an ordinary 2B drawing pencil to expand my middle tones. To introduce lighter colors, I added warm and cool, light gray Prismacolor using a very light touch. My main focus here is still value.

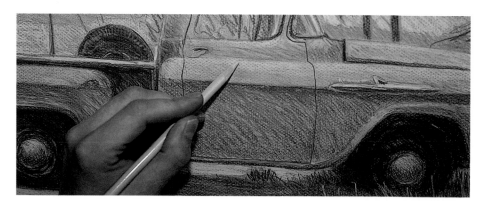

3. All of the colors that were lighter than the paper color were rendered with Prismacolor pencils. Here I am adding a warm, light gray to the side of the pickup. I used a variety of different grays, ranging from creamy yellow to steely blue. These additional color changes go beyond value, creating subtle variations in temperature and hue.

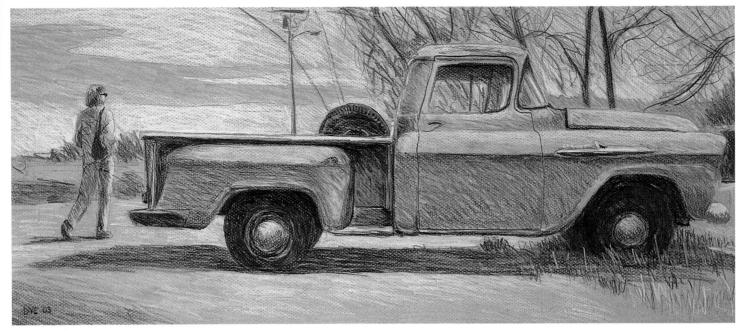

Sean Dye, **Sally and the Old Truck, Taos, New Mexico**
Graphite, oil pencil, and Prismacolor on gray paper, 10 x 24 in. (25.4 x 61 cm).
Collection of the artist.

The horizontal format accentuates the horizontal shape of the truck, and at the same time the placement of the vertical figure near the tailgate slows the horizontal flow of the drawing.

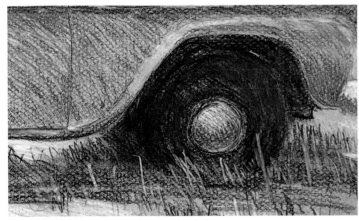

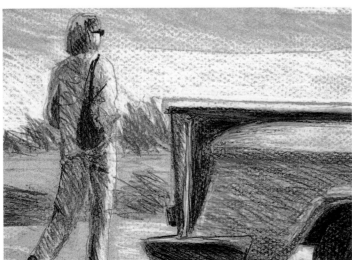

Sally and the Old Truck, Details
Top left: I added detail to the foreground vegetation to help create a three-dimensional space for the truck to sit in. Some of the strokes follow contours of the sheet metal to help describe the curves of the vehicle. *Bottom left:* Sally is a few feet behind the vehicle, so less detail was needed to describe her. The loose strokes help to make the figure feel less static. *Above:* Sometimes sharp, thin lines are helpful when depicting manmade objects. Here the thin lines are complemented by the overlapping cross-hatching on the surface areas.

DEMONSTRATION

CHARCOAL, INDIA INK, AND GRAPHITE ON PAPER

My wife's parents recently built a house not far from us on the same unpaved country road. As they were preparing the grounds for the house they took down dead trees in the surrounding woods. Several beautiful old oak trees such as the one central to this drawing flank the house. The woodpile stacked against the right side of this great tree, which is perhaps 200 years old, is a testament to its own survival. I like to find a little slice of nature—like this tree—that others might not notice.

Any ordinary subject can be made into an extraordinary image.

I decided to use an HB pencil, which is softer than the ones used in the previous demonstrations, for the initial sketch. I chose vine charcoal as the second drawing medium because I wanted this to be a moody, impressionistic piece. Vine charcoal is perfect for capturing tonal subtleties without sacrificing spontaneity. Vine charcoal comes in thin, medium, and thick sticks. I use the thin ones for more detailed areas. The thick sticks can be broken into short pieces and used on their sides to make broad strokes for covering large areas.

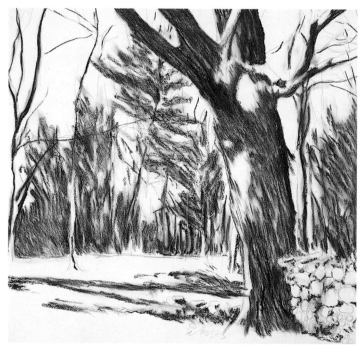

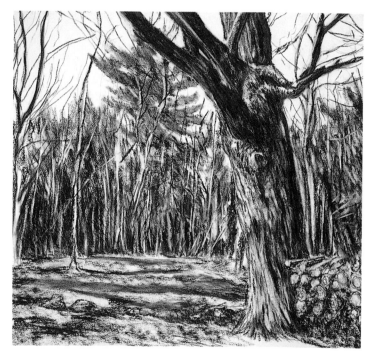

1. At this stage the pencil sketch is mostly covered up with light vine charcoal strokes to begin indicating the light and dark areas. I find that a square format often helps me to focus on composition. Here I was trying to find a balance between the many verticals of the trees and the nearly horizontal shapes of the ground. The diagonals of the branches help to break off the many verticals in the top half of the picture.

2. I used the vine charcoal again to better define the relative values. I used a kneaded eraser to soften some of the shadow areas and the distant evergreen tree. A 100 percent rag paper such as Arches has very long cotton fibers; it is a rugged surface that can withstand many erasures without serious degradation.

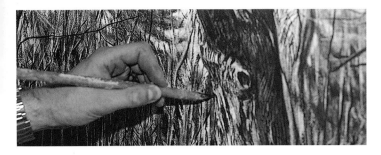

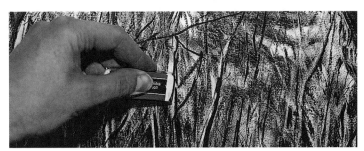

3. Here I am applying India ink with a hand-carved stick pen. I make these by breaking dry sticks, with about a finger's diameter, into pieces 10 to 12 inches long. With a sharp utility knife, I make a pen point with three cuts: a slightly curved cut on the underside of the tip and two cuts on the sides to make a sharp tip.

4. Most people think of an eraser only as a tool for correcting mistakes. Here I am using it to add white or light gray strokes to the drawing. Never use colored erasers for this purpose, as they can transfer their color to the paper. Here I am using a white plastic eraser. The firm texture and square edges make it very suitable for this purpose.

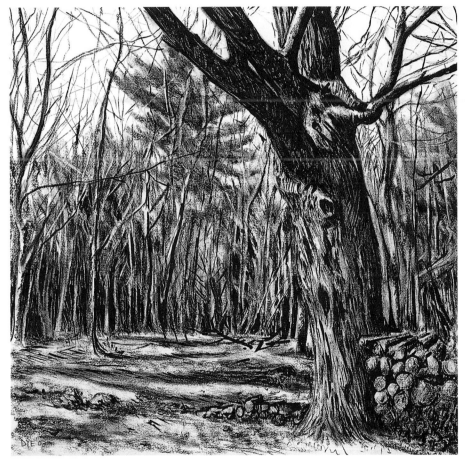

Sean Dye, **The Survivor** (2003)

Charcoal, India ink, and graphite on Arches 140-pound cold-pressed paper, 20 x 20 in. (50.8 x 50.8 cm). *Collection of the artist.*

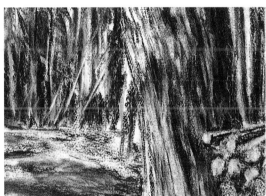

The Survivor, Details

Top: In this close-up one can see the way the ink and charcoal work in harmony to perfectly capture the atmosphere of the wooded scene. The eraser marks have brought out the highlights on the trees and logs. *Above:* I left much of the white of the paper showing to create a brightly lit sky. The coarse texture of the paper is an important element in the drawing, as can be seen in the distant tree as well as the deep shadow areas of the foreground oak.

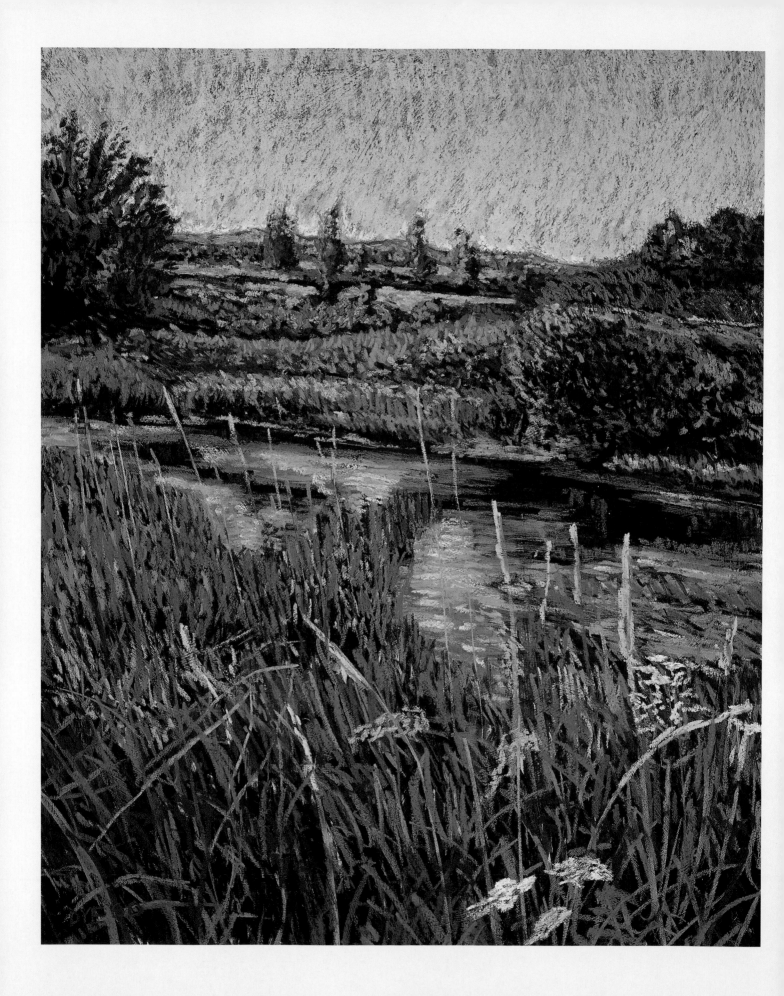

4

PASTEL

Sean Dye, **St. George, Vermont, Pond**

Pastel, water-soluble pastel, and acrylic gouache on Lana 300-pound cold-pressed paper primed with Holbein's Yellow Gesso and pumice, 30 x 22 in. (76.2 x 55.9 cm). *Collection of Tom and Nancy Carlson.*

In late summer, I painted this small pond at the end of the dirt road that leads to my house. The reds and oranges peeking through in the foreground came from the warm acrylic gouache underpainting.

Pastel, both soft pastel and oil pastel, is ideally suited for mixed-media works. Pastel is easily manipulated and offers a broad range of textural and dramatic possibilities when mixed with other mediums, such as egg tempera, gouache, and oil.

Soft Pastel

Most soft artist-quality pastel today is made by creating a paste of pure pigment in powdered form; a binder, usually gum tragacanth; and water. The mixture is formed into sticks and allowed to dry. The hardness or softness of the stick is a function of the relative proportions of pigment, gum, and water. Because the amount of binder needed to hold pastel sticks together is minimal, soft pastels are closer to being pure pigment than are most other mediums, and pastel colors are particularly brilliant.

The forerunners of today's pastels probably appeared sometime in the fifteenth century when painters made "crayons" of pigment supported by filler and binder or bound with gum Arabic. Among the important characteristics of pastel is its fragility, giving artists the ability to blend, smudge, and manipulate areas of pigment. Pastel is also good for rendering reflections and iridescence in fabric.

Pastel developed into a serious art form in Italy and France in the seventeenth and eighteenth centuries. In eighteenth-century France probably the most influential proponent of pastel was Maurice-Quentin de La Tour (1707–1788). Known for his insightful portraits in pastel and pastel and gouache, he developed a realism that fully exploited the spontaneity and brilliance of the medium.

As the popularity of portraiture waned toward the end of the eighteenth century, the use of pastel also declined, only to come back full force by the middle 1800s. Nineteenth-century masters such as Mary Cassatt (American, 1845–1927), Edgar Degas, and Odilon Redon (French, 1840–1916) made brilliant use of pastel's intense colors and infinite textural and dramatic possibilities. With the passing of European Impressionism, pastel once again declined in popularity and was not again seen as a serious medium by critics and the gallery world until the last two decades of the twentieth century.

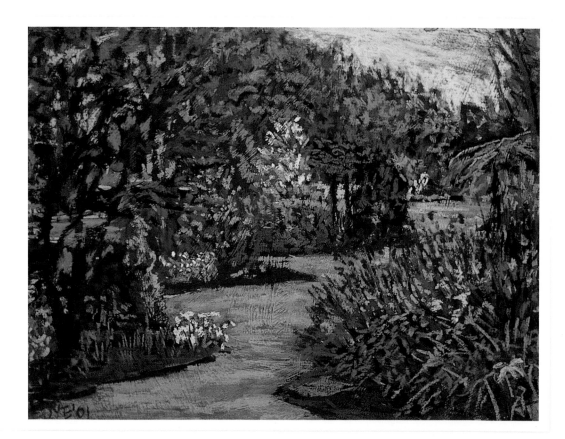

Sean Dye, **McNall-Pierce Garden, Hinesburg, Vermont** (2001)
Pastel, watercolor, and India ink on gray pastel paper prepared with acrylic ground, 12 x 16 in. (30.5 x 40.6 cm). *Collection of the artist.*

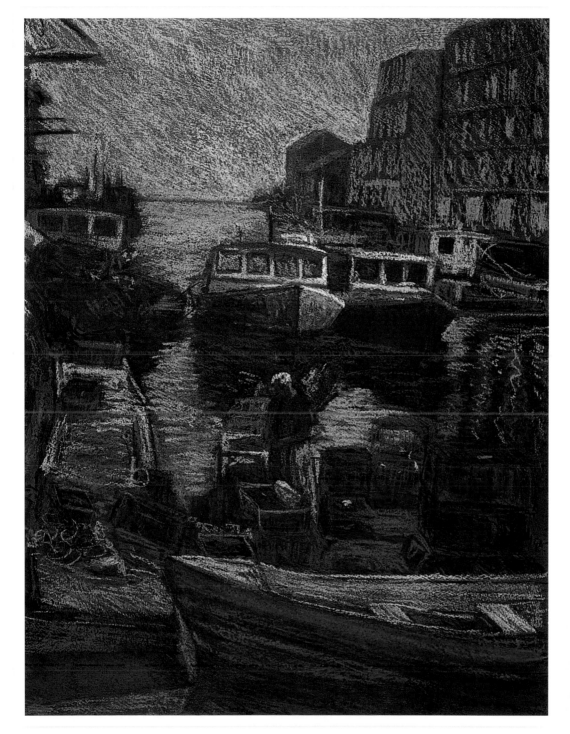

Sean Dye, **Fisherman at Portland Harbor**
Pastel, gouache, India ink, and acrylic airbrush color on 300-pound cold-pressed paper primed with colored gesso and pumice, 30 x 22 in. (76 x 55 cm). *Collection of the artist.*

I began this painting as a workshop demonstration. I wasn't happy with an early version, so using a small spray bottle, I misted the entire painting with a sepia acrylic airbrush color. This threw the entire image into the darkness, allowing me to reintroduce the light areas.

AIRBRUSH COLOR

The airbrush color that I use is Holbein's Aeroflash. The pigment is very finely ground so as not to clog airbrushes or technical pens, then suspended in an inklike, fluid acrylic solution with added alcohol for fast drying. I spray the paint on with a small, very inexpensive pump-style spray bottle. This technique adds tiny, water-insoluble speckles that add visual texture and an aged look to the piece. And, because the spray covers only some of the paper, the delicate pastel strokes maintain their presence in the finished work.

PASTELS AND MIXED MEDIA

Most beginning art students, and even some well-known professionals, fail to exploit the potential of this uniquely versatile medium. They will stick with one brand (one hardness) of pastel and use it to draw on pastel paper, often the inexpensive kind that is prone to fading. This combination is fine for sketching, but not for work that enhances one's experience and stretches one's imagination.

When I was first introduced to pastels—hand-held sticks of dry pigment that have the look and feel of charcoal or Conté crayon—I thought of them primarily as a drawing medium. Yet pastel is at its best when it is used as a painting

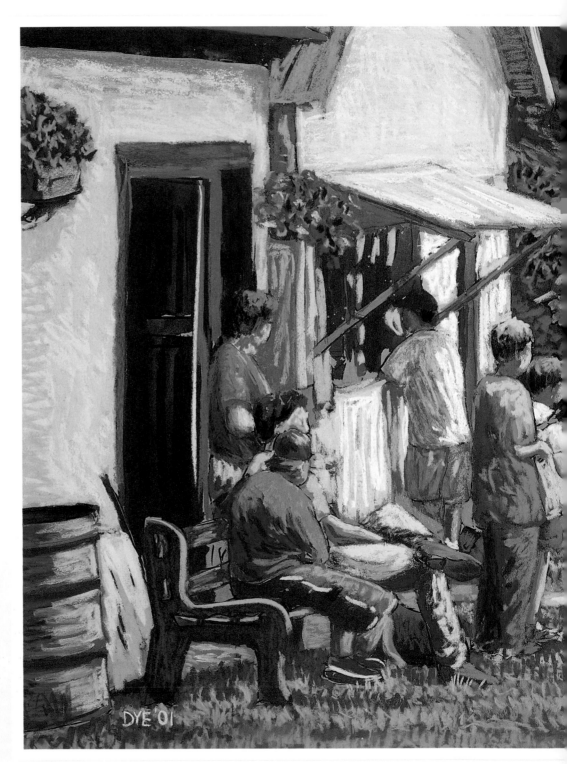

Sean Dye, **Waterford Fair** (2001)
Pastel, gouache, and India ink on
sand-colored Pastelbord, 18 x 24 in.
(45.7 x 61 cm). *Collection of the artist.*

I knew a strong use of line and bright color would help unify the different parts of this complex piece. Using gouache, I painted in each shape with the complements of the colors to be used in the final version. I applied the pastel with many tiny strokes of broken unblended color. I left much of the underpainting untouched, and the resulting areas of vibrant color give the painting an exciting, active surface.

medium, to explore color, shape, and form in the same way one might use oil or watercolor to achieve those goals.

My early experiments with pastel in mixed media involved using them over watercolor paintings, creating "enhanced watercolors" that were more pastel than watercolor. I started to wonder what other materials would work under-

neath pastel. This led to experiments with gouache, acrylic gouache, acrylic, oil, and tempera. It also occurred to me that white watercolor paper might not be the best support for pastel. When I tried to apply wet mediums such as watercolor or gouache on pastel paper, it buckled and rippled. I decided to make my own surfaces, using high-weight watercolor paper as well as museum board. I added a variety of gessoes and abrasives to create interesting and sturdy surfaces.

Today, a wide variety of prepared surfaces are available which were designed with mixed media artists' requirements in mind. These surfaces will accept wet materials and numerous, often aggressive, applications of pastel.

The choice of support for a mixed-media pastel work depends on the effect you want. The first consideration is how much pastel pigment you want to remain. For example, a coarse, abrasive surface, such as Wallis paper, will chew into the pastel stick so that it leaves thick, colorful, expressive strokes. On the smoother Bristol board, your pastel strokes will be controlled, light, smooth, and soft.

If you use watercolor to stain a surface to be painted with pastel, it will not change the tooth of the support. Gouache has more covering power than watercolor, and if applied too heavily, it will begin to fill in the tiny interstices necessary to hold the pastel color. Both watercolor and gouache may be affected if water is to be used with the pastel for blending, spattering, or other effects. A waterproof, acrylic version of gouache is an option, although there are fewer color choices with that medium.

DEMONSTRATION

PASTEL AND ACRYLIC GOUACHE ON PASTELBORD

I painted *Hay Barn* in autumn, in early morning light. It is located on a farm in Hinesberg, Vermont, one of the small towns that borders the town where I live. I chose this image because I liked the way the buildings were nestled in the landscape. The various planes of the architectural surfaces with their range of angles and textures offered me exciting visual opportunities. The fall foliage provided me with a more rounded palette than early spring or summer could offer.

One of my favorite ready-made surfaces is Pastelbord: it has a rough but predictable surface and almost unlimited layering possibilities. The handcrafted clay surface with its granular marble dust is porous enough to absorb all types of paint. Its unique texture will hold many layers of pastel if the artist applies the hardest sticks first and gradually moves to the softest. The gray color allows light and dark values to show up well and it enhances the intensity of the pastel strokes, especially the warm fall colors needed for this painting.

I chose to sketch with India ink because it dries quickly, in a very thin coat, and doesn't use up the tooth of the board. Because ink is so quickly "permanent" and thus difficult to change, I am forced to be freer and less nitpicky in my sketching process.

Acrylic gouache is a great underpainting medium because it has dense color even when applied thinly enough so that it won't affect the basic integrity of the surface. At the same time, its slightly textured matte finish will actually add tooth to surfaces that would otherwise be too smooth for pastel. The bright passages of acrylic gouache will eventually peek through the pastel strokes, adding visual excitement and sparkle to the finished piece.

Acrylic gouache—unlike its traditional gum Arabic–based counterpart—dries perfectly waterproof, which is important if there is a possibility that the pastel layer may be manipulated with water. The underpainting thus provides a fixed layer of color that will not be altered by later applications of pigment.

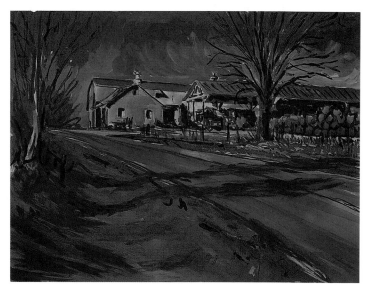

1. I designed the composition so that there would be a long foreground and the building would be pushed up close to the sky. Here I have established the structure and the general value range of the painting.

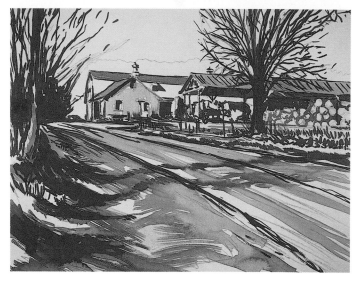

2. For the underpainting I chose Holbein's Acrylic Gouache, which dries to a waterproof matte finish and comes in exceptionally vivid colors. I used warm colors in the sky and grass, which I knew would contrast nicely with the pastel layers. The shadows are painted with violet and blue-violet.

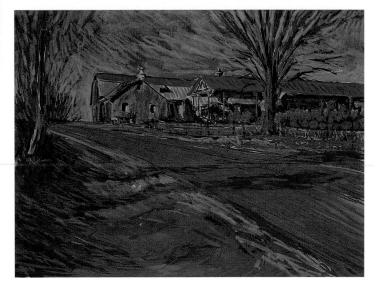

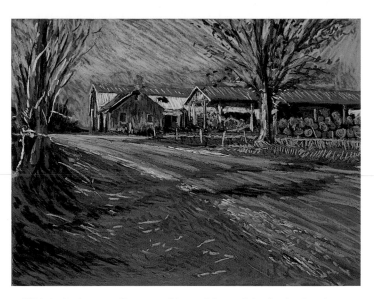

3. For the first pastel layer, I used the firmest of my pastels and added color to all parts of the painting. To get the transparent effect I wanted, I needed to let the sky fall in behind the trees that cross the horizon line into the sky. Notice how blue the shadow areas are. Purely black or gray shadows would look flat and dull.

4. This is the intermediate pastel layer. Many of the final colors have been established. I have introduced mid-tones and numerous light values to give the painting form and depth.

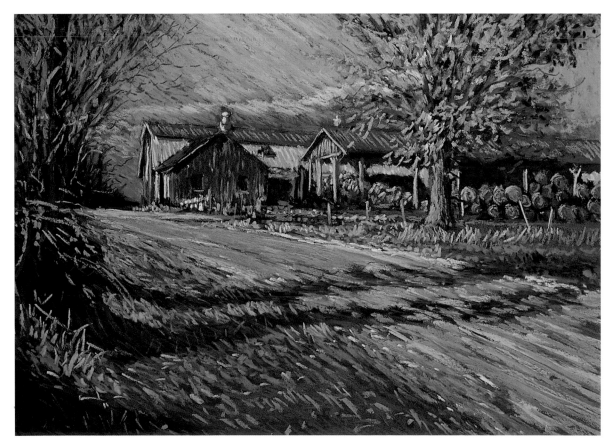

Sean Dye, **Hay Barn** (2003). Pastel and acrylic gouache on Pastelbord, 18 x 18 in. (45 x 45 cm). *Collection of Chris and Leslie Titchner.*

To finish the painting I varied the size of my pastel strokes depending on how far from the viewer I wanted the objects to appear. I reworked the sky and added foliage to the large maple tree in front of the hay barn. I lightened the road and added more greens to the grass. The thin, wispy branches in front of the sky were added last. It is still possible to see some of the underpainting coming through the sky, tree, and road.

DEMONSTRATION

PASTEL, INDIA INK, AND WATERCOLOR ON PAPER MOUNTED TO BIRCH PLYWOOD

These old trucks are still active vehicles on a working farm. The farm was a large country estate for many years. My great-grandfather was a foreman there in the early twentieth century.

I chose this composition because the trucks look like they are ready to go at a moment's notice. My focus was the vehicles in the foreground. I decided from the beginning that the landscape elements in the painting would be looser than the rest of the painting.

I made my surface by gluing 300-pound cold-pressed paper to 1/2-inch furniture-grade birch plywood. I used PVA (polyvinyl acetate) glue and applied pressure. Pressure should be applied overnight. For this 22- by 30-inch piece, I used about 60 pounds of cinderblock. If there is even a slight bow in the plywood, a heavier weight should be used. Any warp-

ing in a wood support will cause problems later. Next, I applied Golden's Acrylic Ground for Pastel. This is a translucent ground that seals the paper and has a fine grit to hold onto the pastel. Sealing the paper makes it possible to remove unwanted ink and water color passages later. This would be impossible on untreated watercolor paper, as these mediums would penetrate the surface too quickly.

Brushstrokes from the pastel ground, which was applied with a gesso brush, are eventually exposed by early pastel skimming over its bumpy surface. The feltlike surface of the cold-pressed paper also appears at this time. The raised bumps catch the pastel while the small crevices of the paper retain much of the pigment from the watercolor.

When using a support like the one I prepared for this piece, you'll need to use a hard pencil because the abrasive surface will wear down the tip of a soft pencil rapidly. For the preliminary sketch, I used a 7H.

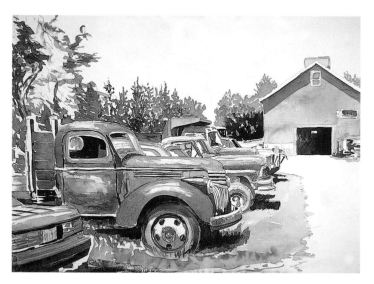

1. After doing the pencil sketch, I decided to do a full-value study in India ink. Ink is a good choice for abrasive surfaces. It holds a thin line and can be used for gradual washes.

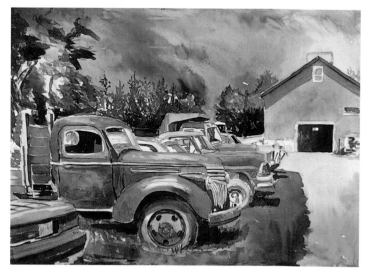

2. Because my final painting would be dominated by cool colors, I chose a warm palette for the watercolor underpainting. The watercolor does not obliterate the waterproof ink. I kept my strokes large and loose.

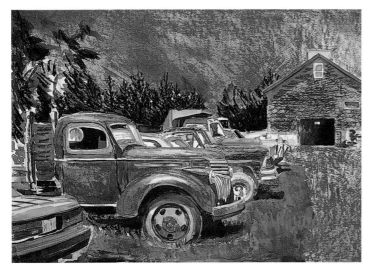

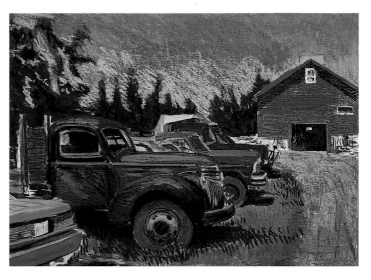

3. The first pastel layer is complete. I used firm Holbein pastel right from the beginning, so that later layers would adhere. The texture of the pastel ground is still evident in many places. It is very important not to fill the tooth of the paper too soon. Many artists who start with pastel feel compelled to cover every bit of the paper. If you leave open areas, it will be easier to add additional layers.

4. This is the intermediate pastel stage. The underpainting has started to take a back seat. I finished adding all of the dark shadow areas and then introduced the mid-tones.

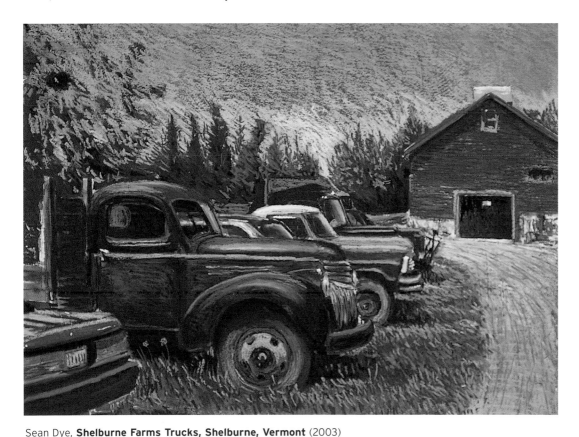

Sean Dye, **Shelburne Farms Trucks, Shelburne, Vermont** (2003)
Pastel, India ink, and watercolor on paper mounted to birch plywood, 22 x 30 in. (55.9 x 76.2 cm). *Collection of the artist.*

In the final painting, the multitude of pastel strokes are part of a unified whole. All the highlights are in, and the "center of interest" (a term I dislike, but here it is appropriate) is the black truck. The textures and shapes of that vehicle pull the viewer into the scene.

Finished Painting, Detail
In a multilayered piece like this one, it is important not to over-work the final layer. Here it is possible to see how maintaining a light touch allows each of the previous layers to speak for itself. The pastel layers have not completely covered the warm watercolor washes; some of the ink passages are also still visible. This allows for a layered inter-play of color and texture.

Oil Pastel

By the middle of the nineteenth century almost all of the pigment-binder combinations available today were being produced, giving artists a wide range of available colors, textures, and fluidities to choose from. Oil pastel, however, is a twentieth-century invention. In 1949, Pablo Picasso came to the famous art materials manufacturer Sennelier and asked them to develop a medium in the form of a durable stick that was of true artistic quality and could be used on a variety of surfaces without fading, cracking, or losing color. Picasso wanted the qualities of vivacity, radiance, and oiliness in one medium and, due to his habit of drawing on anything and everything, wanted them in an easy-to-apply form. At the time it was thought that wax-based binding mediums, which date back to ancient Egypt, had evolved as far as they could, but Sennelier developed a new medium having a perfect balance of oil, wax, and pigment. Such was the birth of oil pastel, a medium that meets all of Picasso's criteria.

The best oil pastel is manufactured by combining raw, high-quality pigment with a pure acid-free binder of microcrystalline petroleum wax and nondrying chemically inert oils, then molding the mixture into oil-soluble, water-resistant sticks. Their buttery, smooth consistency gives them a paintlike effect; they don't dry, crack, or peel; they are dust-free; and they never lose their vibrant color. Artists can build up oil pastel into thick layers of impasto as well as combine them with oil for wash or glaze techniques. Also notable is the relative translucency of the medium as compared to soft pastel.

Because artist-grade oil pastel is a relatively new medium, there are no hard-and-fast guidelines for its use, and there is wide latitude for artists—both amateur and professional—to experiment. But, despite the fact that Picasso himself was instrumental in introducing oil pastel to the art world, it has yet to be accepted in some circles as a serious art medium. As of 2004, many societies and juried exhibitions were still excluding oil pastel.

Sean Dye, **Geprag Barn, Hinesburg, Vermont** (2003) Oil pastel and gouache on Pastelbord, 18 x 24 in. (45.7 x 61 cm). *Collection of the artist.*

This painting of an old barn not far from my home in Vermont is part of a series of "Barn Portraits" that I am making as a way to explore value. I started with white Pastelbord and painted the entire surface with burnt sienna gouache. Next I sketched my composition in with a middle gray oil pastel. I put the rest of the values in: white, black, and three grays. I left much of the gouache coming through to add warmth to the composition.

OIL PASTEL AND MIXED MEDIA

Artist-quality oil pastel is a truly versatile medium for mixed-media work. It can be used as a drawing tool or manipulated like paint. It adheres to almost any support or underpainting.

There are a few simple rules for using oil pastel. The most important is to plan for it to be the final layer, as oil pastel never truly dries, and other mediums will not adhere. The chemical composition of oil pastel never changes. It can be scratched or dissolved with mineral spirits many years after a painting has been completed.

Some artists sketch with oil pastel before painting with oil. I believe this to be an unsafe practice for the reasons stated

above. If the oil pastel is thinned with spirits before the oil color is applied, there is less risk that the oil color will fall off—but why risk it?

One exception to the "oil pastel is last" rule that I will make occasionally is gouache. If you run a thin layer of diluted gouache over an oil pastel layer, most of the paint will be resisted. The gouache will, however, add color to all areas missed by the oil pastel. Usually, a few spots of gouache will bead off slightly on top of the oil pastel and dry, providing an interesting effect.

Oil pastel should be treated like oil color in terms of sur-face preparation. A size such as gesso, acrylic paint, acrylic mediums, rabbit skin glue, or PVA glue should be added to all surfaces to which you plan to apply oil pastel unless the manufacturer (not the retailer) says that it is safe for oil pastel. Without surface preparation, the oil and any solvents used can soak into the support, leading to destruction of the surface.

Because oil pastel never really dries, works done in this medium need to be covered with glass. Thus paper and smooth panels, which are easily covered with glass, rather than canvas, which is not, are the best support choices for oil pastel paintings.

Detail, Ethan's Bog
The red ochre ground shows through the cool green, blue, and violet oil pastel strokes.

Sean Dye, **Ethan's Bog**
Oil pastel, watercolor, and India ink on 300-pound Gemini cold-pressed paper primed with Holbein's red ochre colored gesso and pumice, 30 x 22 in. (76.2 x 55.8 cm). *Collection of the artist.*

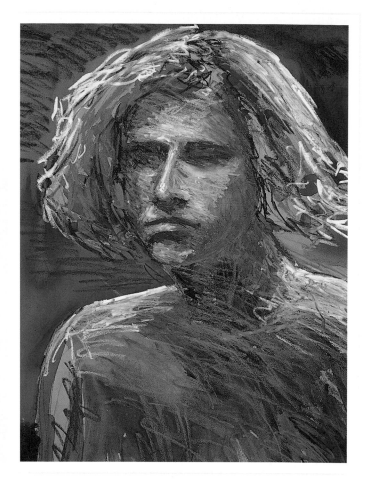

Sean Dye, **Portrait of a Young Woman: Melancholy**

Oil pastel, gouache, and India ink on gray Pastelbord, 18 x 14 in. (45.7 x 35.6 cm). *Collection of the artist.*

I made this portrait from life as part of a demonstration for my students at the University of Vermont. I asked the model to think of something very serious. After my ink sketch, I applied very loose washes of gouache. For a panel that begins as dark as this one, gouache shows up better than watercolor. I left most of the oil pastel strokes open and sketchy. On the face, I worked in many layers. The blended effect of the oil pastels on the face makes that part of the painting look as if it had been painted with traditional oil color; other areas of the painting retain their pastel-like appearance.

Sean Dye, **Getting the Message** (2003)

Oil pastel, acrylic polymer, and acrylic airbrush color on panel, 24 x 30 in. (61 x 76.2 cm). *Collection of the artist.*

The mixed-media combination used for this painting, in order of application, was acrylic polymer washes; fine mists of Aeroflash airbrush color in mixtures of sepia, pale yellow, and brownish red; thin layers of oil pastel, local colors only (no subtleties); Holbein oil pastel; Sennelier oil pastel (slightly softer than the Holbein); Sennelier giant oil pastel sticks. The orange gesso and many of the airbrush color speckles show through the oil pastel. In this painting, it was important for me to create interesting edges. Some of the edges in this painting are defined by line, others by an abrupt color change.

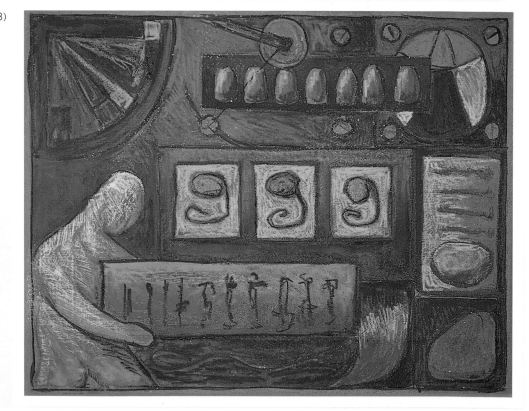

DEMONSTRATION

OIL PASTEL AND CASEIN ON GRAY PASTELBORD

Many people in our region head south during the winter months to get away from the cold. Not long ago we took a January trip north instead to Canada's beautiful capital city, Ottawa. This painting is of a street scene at the time of day when there is still a bit of natural light left. The streets were wet from a late afternoon shower, and oil pastel seemed the right choice to capture the reflective quality I wanted. I knew

from the beginning that I wanted to use casein, which works well on Pastelbord if it is wet enough, for the underpainting, and I planned to let some of it show through to capture the subtle light of the sky. Pastelbord is also rigid enough to be able to hold the many layers of oil pastel I planned to apply. I chose gray because it seemed right for this gray winter afternoon and because I wanted the bright colors applied later to "pop" the same way a bright yellow umbrella or red jacket does on gray, rainy days.

1. For this painting, I decided to start right away with color. I used casein for the sketch/underpainting, which works well on Pastelbord if enough water is added; also its matte finish holds the oil pastel well, and if applied in thin layers, it will not cover the sanded tooth of the panel. Note that thin casein paint dries very quickly and there can be a lot of drag on the brush if it is not moist enough.

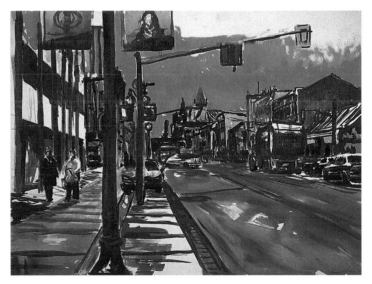

2. The last of the casein paints have been applied. I used bright orange along the horizon to create the warm glow of a winter sunset. To help define the compositional structure, I used the analogous colors of blue, blue-violet, violet, and red-violet.

This detail shows how loose and suggestive the early casein strokes are. All of the details will be defined with oil pastel.

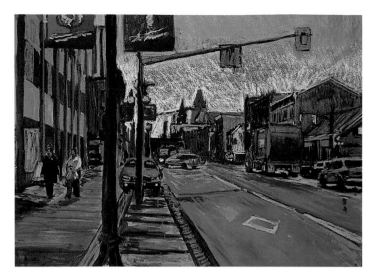

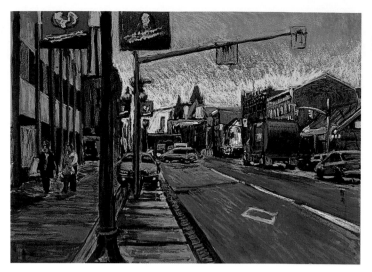

3. This is the first oil pastel layer. The oil pastel glides smoothly onto Pastelbord. At this early stage, for a painting this complicated, I find it best to block in the big shapes with one color—the color that dominates in that area, a local color—rather than try to render all the subtle colors that are actually there and that will be added with later layers.

4. In the intermediate layers, the suggestion of detail is achieved by a collection of fine strokes of different hues, values, and intensities, rendered with many colors. I lightened the sky with progressively lighter values. There is more light from the sky shining on the vehicles and the buildings have more texture.

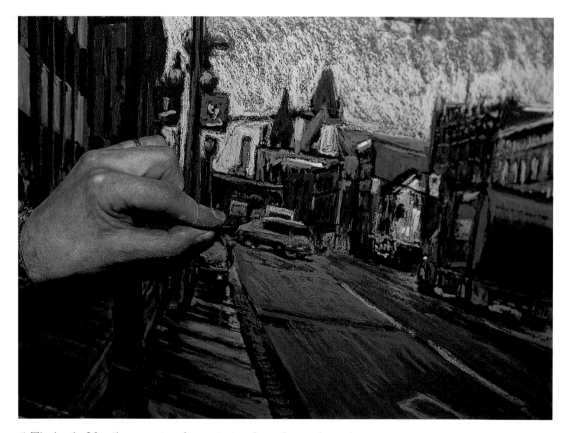

5. The level of detail appropriate for a painting depends greatly on the tool being used. Here I am using a Holbein oil pastel with a ³/₈-inch square tip. Anything that I cannot render with this size stick does not belong in this painting.

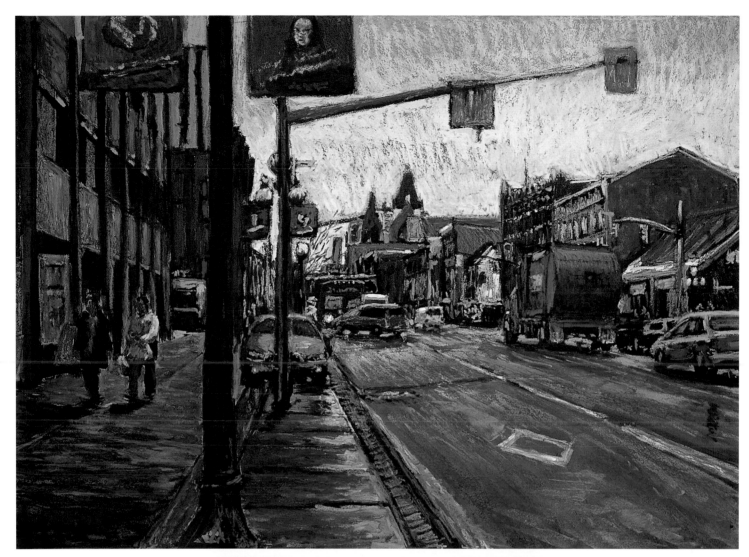

Sean Dye,
Ottawa Street at Dusk (2003)
Oil pastel and casein on Pastelbord,
18 x 20 in. (45.7 x 50.8 cm).
Collection of Annie Kirby.

To finish this painting I focused
on sheen and reflection. I want-
ed the street and sidewalk to
appear wet. Many of the vehi-
cles had glowing headlights
or taillights, and the sky was
reflected on the cars and street.

It is nice not to have to search
too far for the right color. Here
I've laid out the complete 225-
color set of Holbein oil pastels
on my easel's tab tray.

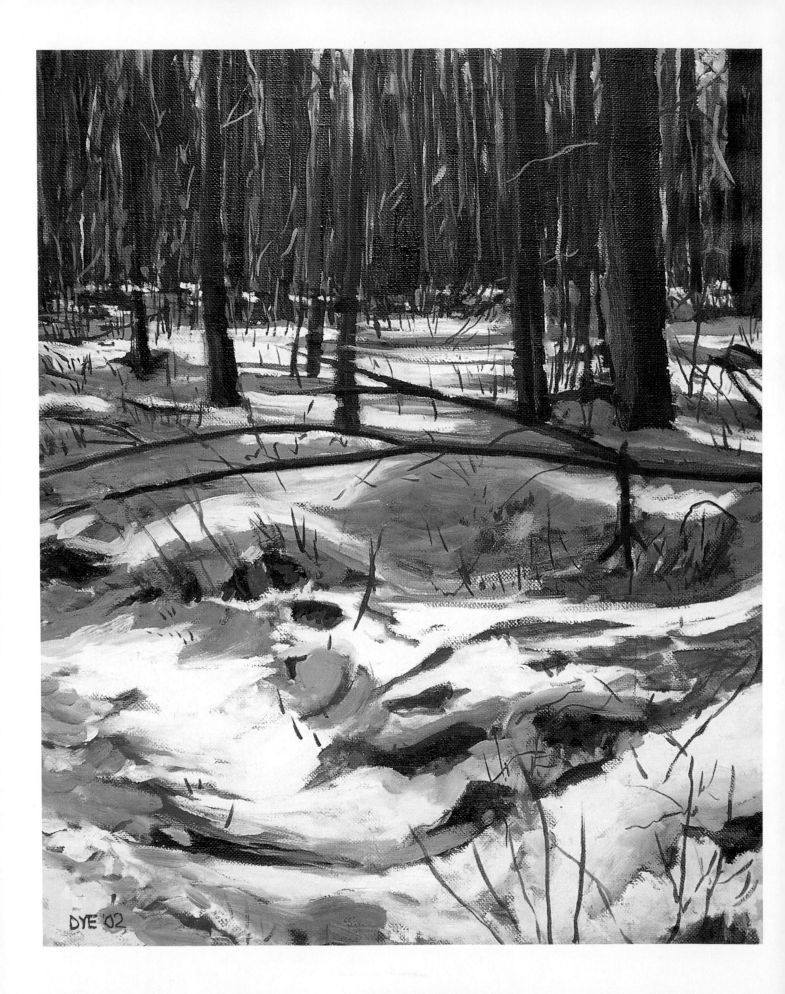

5

OIL: TRADITIONAL & WATER-SOLUBLE

Sean Dye, **Our Back Woods**
Oil, acrylic gouache, and charcoal
on linen, 20 x 16 in. (50.8 x 40.6
cm). *Collection of David Kirby
and Barbara O'Connor.*

Oil paint has several characteristics that make it a good choice for mixed media. It is easy to apply; it can be built up, scraped, and reworked many times without peeling or cracking; and it can be applied in thin, transparent layers, allowing earlier passages in another medium to show through.

Traditional Oils

The use of oil as a painting medium dates back at least to the thirteenth century in England, but early oil paints were highly viscous and dried very slowly and were used primarily as decorative paints. Northern Flemish painter Robert Campin (c. 1375–1444) was probably one of the first artists to recognize the potential of oil for creating highly realistic and dimensional paintings. Jan van Eyck (1390?–1441) developed techniques for increasing the fluidity of the medium, and by the end of the fifteenth century oil was in widespread use by artists throughout Northern Europe and Italy.

Oil paint's slow drying time allows artists to apply the paint in layers, achieving subtle changes in lighting that create a very effective sense of form. Oil paint can also be thinned with turpentine or another oil medium and applied in very thin, almost transparent layers called glazes.

The flexibility of oil allowed artists to paint on canvas set up on easels in their studios, instead of traveling to sometimes distant fresco sites. By the seventeenth century oil painting materials and procedures had been fine-tuned and oils had become the medium of choice for both Italian and Flemish masters.

The ability of oil painting to create the illusion of reality on canvas made it a natural medium for portraits, landscapes, and still lifes, and oil painting was immensely popular in the eighteenth and nineteenth centuries. At the end of the nineteenth century the French Impressionists, led by artists such as Claude Monet (1840–1926), Edgar Degas (1834–1917), Camille Pissarro (1830–1903), Berte Morisot (1841–1895), and Edouard Manet (1832–1883), as well as American Mary Cassatt (1845– 1897), were using oil to change the way people looked at color and light in paintings. They allowed separate, painterly strokes to show and experimented with using bright, unmixed color on the canvas in a technique referred to as "broken color" that conveys an impression of a visual memory. Vincent van Gogh (Dutch, 1853–1890) built up the oil

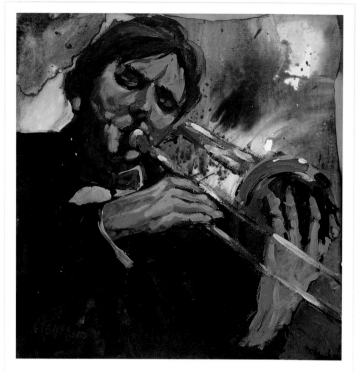

Frank Federico, **Trombone Man**
Oil over acrylic wash on paper, 20 x 24 in. (50.8 x 61 cm).

Frank Federico's *Trombone Man* is a beautiful example of how an accomplished artist can let two strong mediums do their own thing in the same work. The acrylic wash, which was freely applied to the background, has remained fresh and untouched in many places. The oil, used to depict the musician and his horn, is an independent, controlled, and modulated statement.

paint on many of his canvases so heavily that it has a palpable physical presence. When you see one of these amazing canvases, the thick, bright paint looks as though it had been applied very recently.

During much of the twentieth century, artists who had broken with realist traditions still worked primarily in oil. In 1907 Pablo Picasso (Spanish, 1881–1973) turned the art world upside-down when he presented *Les Demoiselles d'Avignon,* a work which had little in common with works by

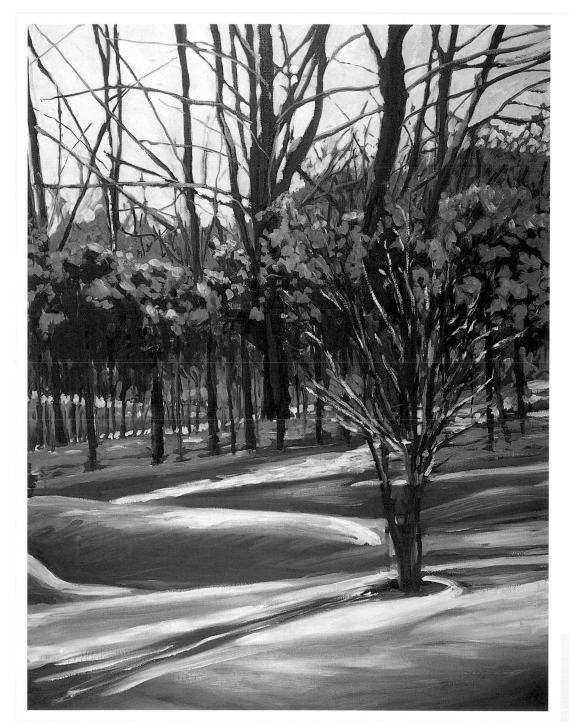

Pear Tree and Winter Garden, Detail

The detail shows that most of the value changes in this painting were achieved during the India ink stage.

Sean Dye, **Pear Tree and Winter Garden**

Oil, India ink, and acrylic gouache on linen, 48 x 36 in. (122 x 91.4 cm). *Collection of David Kirby and Barbara O'Conner.*

This painting depicts afternoon winter light filtering through the trees onto my sleeping vegetable garden.

earlier masters other than its subject matter (female nudes) and the medium in which it was painted (oil). The abstract expressionists such as Willem de Kooning (Dutch/American, 1904–1997) used oil paint to create energetic works with little reference to visual reality. Georgia O'Keeffe (American, 1887–1986) is best known for her floral works, but she also created large, dramatic abstractions in oil that had a close connection to their inspirations in nature. Oil continues to inspire many contemporary artists, and oil paintings still go for premium prices in the commercial art world.

TRADITIONAL OIL AND MIXED MEDIA

Traditional oil color has deep roots in the history of mixed media, from early experimental glazes over tempera in Italian and Flemish art to twentieth-century cubist collages.

Oil color sits well on heavy paper, panels, linen, and canvas. It has been used on metal supports, such as copper, as well. All of these surfaces need to be prepared carefully to prevent the oil from leaching into the surface, causing rot. Metal surfaces need to be cleaned and varnished to keep the oxidizing metal from reacting with the oil color.

Oil works beautifully with many types of drawing materials. Artists should be aware that graphite used under oil color is chemically safe but may pose future problems visually. As the oil color ages, it sometimes becomes more transparent, allowing the graphite to show through. Some experts feel that graphite may actually bleed through the oil and migrate to the surface over time. India ink and charcoal have been successfully used for centuries under oil. Charcoal has a tendency to mix with the first layer of paint, darkening it slightly; this first layer normally seals the charcoal,

preventing further degradation of the oil color.

There are many underpainting possibilities for oil, but the general rule is that it needs to be absorbent. The practice of painting oil over acrylic polymer emulsion, common in the second half of the twentieth century, is no longer considered sound practice. Most experts feel that the "closed" semigloss surface of acrylic paint does not allow a good mechanical bond between the acrylic and the oil. There are two exceptions. Acrylic gouache, which has an absorbent, waterproof matte surface that the oil will adhere to, is one. Acrylic gouache colors were created with designers and illustrators in mind, so fine artists need to check the label of each color for lightfastness. Another medium that works with oil is colored acrylic gesso, which has been formulated to be a suitable ground for oil and acrylic polymer emulsion colors. Safe underpainting mediums for oil include casein, egg tempera, watercolor, and gouache. Of these, only egg tempera may be used safely on oil-primed panels and oil-primed linen or canvas.

Traditional oil sticks, which are oil color in stick form, may be used under, combined with, or used on top of oil color safely.

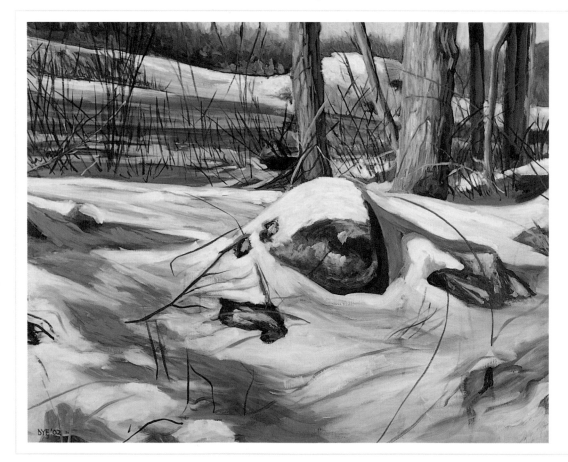

Snow Rock and Trees, Detail

Sean Dye
Snow Rock and Trees (2002)
Oil, charcoal, India ink, and acrylic gouache on linen, 24 x 30 in. (61 x 76.2 cm). *Collection of the artist.*

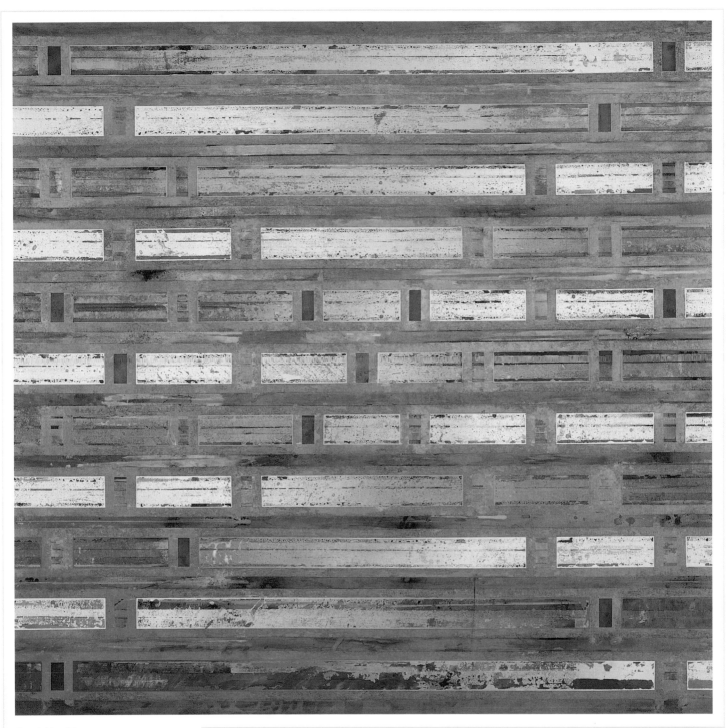

Frank Hewill

Orange Field and Dirt (1974)

Oil and dirt on linen, 72 x 72 in.
(182.9 x 182.9 cm). *Courtesy of Karen
Hewitt. Photo by Ken Burris.*

Frank Hewitt's connection to nature "was visceral, sensual, intellectual, and spiritual" according to his wife, Karen Hewitt. This was especially true of Frank's feelings about the couple's land in remote East Corinth, Vermont, where the artist created many of his most important works. Starting in the 1970s, he began to incorporate colored earth into his paintings, and the physical characteristics of the dirt, such as color and grain size, affected the look of the finished work. In *Orange Field and Dirt* Hewitt has created an orderly repetition of horizontal shapes that flow rhythmically on and off the canvas. He used tape as a resist, and when the tape was removed, much of the light from the orange underpainting came through. The textured rectangles on the top layer vary greatly in opacity, creating a strong sense of depth.

OIL COLOR, CASEIN, AND CHARCOAL PENCIL ON PASTELBORD

On one of my painting trips to New Mexico, I came across a big-sky scene that fascinated me because of the fluffiness of the huge clouds and their relationship to the hills. I did an on-site study in oil pastel and gouache on Pastelbord, a mixed-media work in its own right. I did the final painting back in my studio. The oil pastel sketch was 18 by 24 inches, but I decided to change the dimensions to 12 by 24 inches, to emphasize the panoramic quality of the scene.

For the underpainting, I decided to use casein. A milk-based paint, casein dries with a vibrant, matte, slightly porous finish, and, because of its adhesive properties, makes an excellent ground for oil color. It is correctable for a while before it becomes water-insoluble.

1. For the casein underpainting I used a simple combination of red, violet, and yellow. The violet established all of my shadow areas early on.

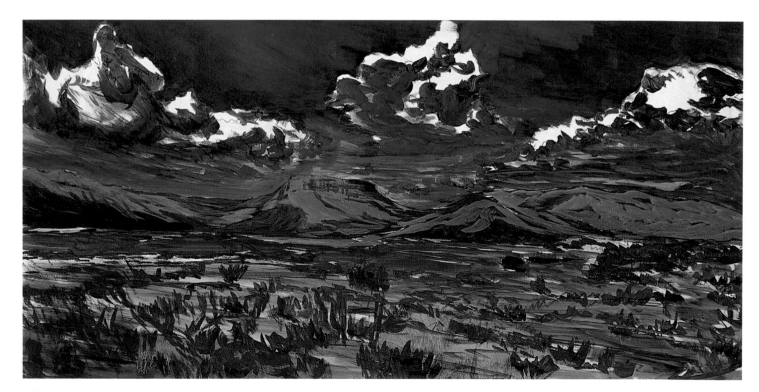

2. This is the initial oil layer. For early layers, I like to thin the oil with a solvent, such as Turpenoid (an odorless turpentine substitute) or Gamsol, which accelerates drying time. If you plan to thin your oil color to a wash, it is wise to add a few drops of damar varnish to increase film strength. Traditional oil painting moves from darker values to light ones. In this layer I have painted the correct hues but the values are darker than they will be when the painting is finished. I left open spaces in the sky to mark the bright areas of the clouds.

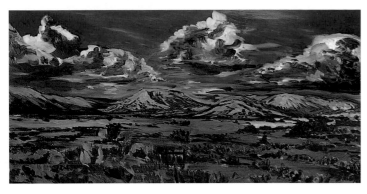

3. In this stage I have added middle values. I have also added many dark greens to create a solid base for the vegetation. I put some yellowish near-whites in the clouds and shadowed them with cool grays.

Intermediate oil layer, detail
In a painting such as this, I find it important to vary the brushstrokes according to what I am describing. The brushstrokes in the foreground are, in general, broad. They get smaller and smaller as objects recede into the distance.

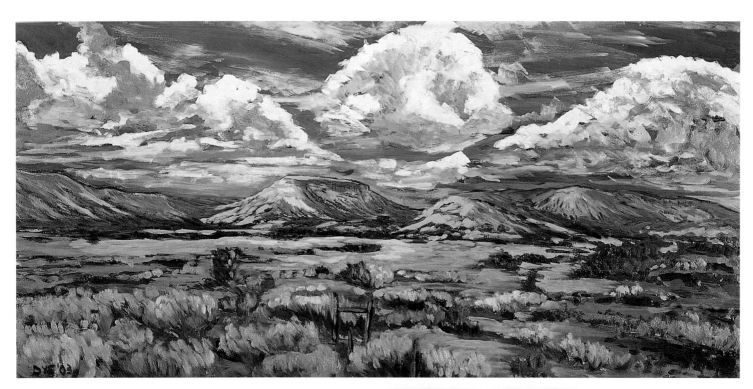

Sean Dye, **Big Clouds near Los Alamos, New Mexico**
Oil, casein, and charcoal pencil on Gessobord, 12 x 24 in. (30.5 x 61 cm).
Collection of the artist.

To complete the scene, I added a lot more light to suggest a Southwestern landscape flooded with mid-day light. I added more detail to the vegetation and hills. I felt the clouds had too much contrast, so I reworked them using lighter shadows.

Big Clouds Near Los Alamos, detail
The light values in the middle ground of the painting suggest sun coming through an opening in the clouds.

DEMONSTRATION

OIL, INDIA INK, AND ACRYLIC ON LINEN

I had lived in Vermont for nearly 30 years when I realized that I had only done two winter paintings. Since winters are very long here it seemed only natural that I explore the subject more carefully. At first I thought that I would be doing primarily monochromatic work. After I had spent some time hiking the woods and staring out of my studio window, I realized that our winters are full of beautiful color.

The focus of this painting from my winter series is a large, old tree. Trees in their dormant stage have a lot of personality: the skeletal forms reveal the trees' individual asymmetry.

I knew what I was going to call the painting, *An Old Tree's Secret Wish*, before I began painting. Perhaps, in this fast-growing community, the tree wishes that urban sprawl will be arrested and the environment will retain its rural quality.

I decided to work on Claessen's Acrylic Primed Medium Textured Linen, which has a distinctive yet natural texture. It

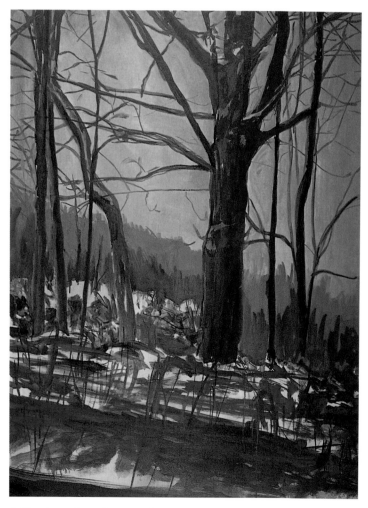

1. I created an India ink value study using both undiluted ink and ink thinned with water to make a wash. I began the sketch with a 1-inch flat watercolor brush, eventually moved to a ½-inch brush, and finished with a #10 round sable brush for the thin branches and twigs. The ink study created a structure on which to build the oil layers.

2. For the early and intermediate oil layers, most of my work was done with filbert hog-bristle brushes, #18, #12, and #8. I started the oil layer by warming up the sky. To keep the paint layer thin and to increase flow, I mixed in small amounts of Turpenoid. The oil and ink strokes work beautifully together.

is also fairly absorbent. I chose the acrylic-primed canvas rather than an oil-primed one because I knew I was going to use acrylic for an initial wash, and acrylic will not adhere properly to oil, whether it is an oil primer or regular oil color.

I almost always use a wash as an underpainting for my work, and this was no exception. Painting a wash over a support is one way to provide unity to a painting because the places where this underpainting comes through—either areas that subsequent layers have not covered or where these layers were relatively transparent—will all be the same color. For this wash I used burnt sienna and permanent yellow deep thinned with a lot of water. I applied it with a 3-inch house painting brush.

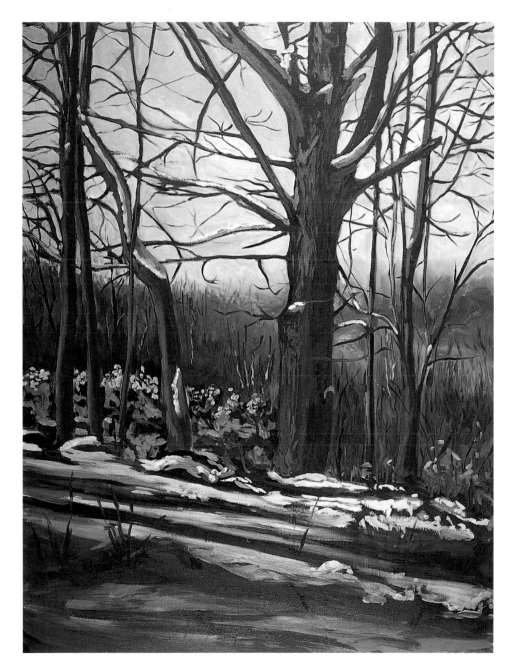

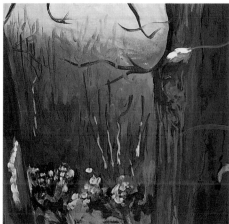

An Old Tree's Secret Wish, Detail
As this detail shows, the pronounced texture of the linen allows for an interesting effect. The final layer of paint, which was less fluid than the earlier layers, sits on top of the raised parts of the canvas while the early layers remain in the indentations.

Sean Dye, **An Old Tree's Secret Wish** (2002) Oil, India ink, and acrylic on linen, 48 x 36 in. (122 x 91.4 cm). *Collection of the artist.*

For the final layer of the painting I used just enough thinner on the brush to allow the oil paint to spread. First, I lightened the sky using various pale yellow–orange mixtures that gradually blend with a gray blue-violet near the horizon. This area is meant to suggest distant trees and hills without being too specific. For the final snow mid-tones and shadows I used mixtures of white, cerulean blue, and gray-violet. I painted the light areas of the snow using near-whites. Snow is never pure white in nature, and it shouldn't be painted with pure white.

DEMONSTRATION

OIL, AIRBRUSH COLOR, AND ACRYLIC GOUACHE ON LINEN

I travel each year to New Mexico to teach and paint. This scene is just outside of Taos. It is a great spot to paint because of the combinations of reds and greens that are unique to this region. As with *An Old Tree's Secret Wish,* I needed to use an acylic-primed support because I planned to use acrylic gouache for the underpainting. Acrylic gouache dries rapidly and permanently to a consistent matte finish. A disadvantage to this medium is that once it dries, it is not possible to make corrections by removing it, as you can do with casein or tempera. An advantage is that it flows more smoothly on the canvas. It also mixes very easily.

The on-site study for this painting was done with watercolor and India ink.

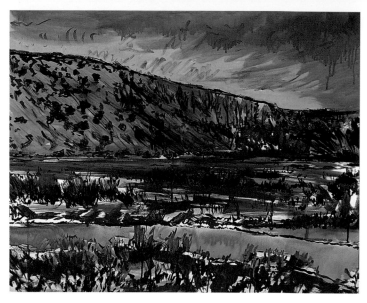

2. The gouache underpainting is in place. I used reds in the foreground vegetation as well to sit underneath the greens. I thinned the acrylic gouache with enough water to make it slightly transparent, and it is possible to see the airbrush color lines of the sketch.

1. I sketched out the composition with black airbrush acrylic, thinned with alcohol for fluidity and to accelerate drying time, using a long-handled #3 round sable brush.

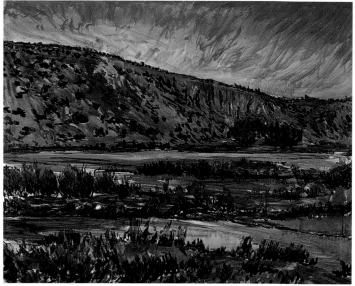

3. This is the initial oil layer. At this stage I applied layers of oil thinned with Turpenoid. When layering traditional oils, it is important that the leanest (or least oily) layers be applied first and the "fattest" (most oily) layer last. Much of the underpainting and the sketch are visible. When applying thinned oil, be sure the strokes of paint follow the contour of the shapes that you are describing. I use hog-bristle brushes to make loose strokes with traditional oil color.

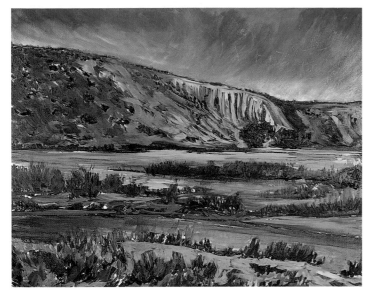

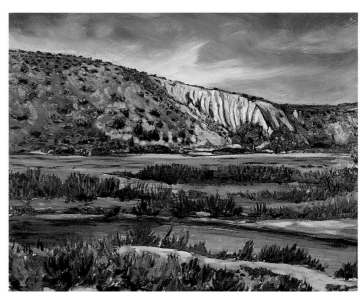

4. This is the second oil layer. The paint is a little thicker, more opaque. I decided to add some brighter reds to the cliffs. I added some of the yellow-green in the pasture, which lies in front of the cliffs. There are more solid, brighter blues in the sky. Notice how the water of the river has become greenish.

5. For the third oil layer, I added some premixed traditional painting medium. Oil painting medium is normally comprised of turpentine, damar varnish, stand oil, and sometimes a dryer, and it increases both fluidity and transparency. The painting has most of its final color. I added clouds to the sky and light hitting the central cliffs. I added more vegetation to the hillside on the left side of the painting. The plants in the middle and foreground now have the darks necessary to ground them. The land in front of the river is more solid. For the shadow areas I used mixtures of sap green, Prussian blue, and cobalt violet.

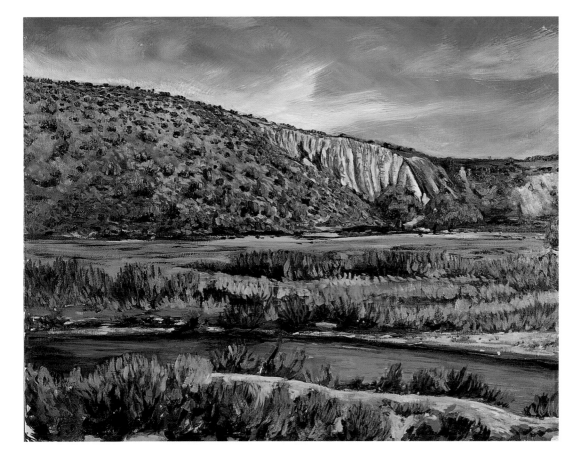

Third oil layer, detail

Sean Dye, **Cliffs and Arroyo Near Pilar, New Mexico** (2003)
Oil, airbrush color, and acrylic gouache on linen, 24 x 30 in. (61 x 76.2 cm).
Collection of the artist.

Water-Soluble Oil

During the last few decades, artists have become aware of the dangers inherent in long-term use of many art materials, including toxic solvents such as turpentine traditionally used to thin oil paints. One alternative to traditional oil colors is oil that can be thinned with water, and in the last decade of the twentieth century, a few different manufacturers accepted the challenge of developing a line of artist-quality water-soluble oil paints. After six years of research Max Grumbacher produced the first water-soluble oil line in the mid-nineties; their formula involves slightly altering the molecular structure of the paint so that it can be thinned with water. Other manufacturers found different solutions, and only after experimentation with the various paints will you be able to decide which products are best for your work.

WATER-SOLUBLE OIL AND MIXED MEDIA

Water-soluble oil has most of the visual properties of traditional oils. Traditionally, however, it was considered unsafe to mix any water-soluble medium with oil color. Recently, Holbein has developed a water-soluble oil, Duo, which is mixed with linseed oil and which they claim reproduces the characteristics of traditional oil color, yet can be used in mixed-media works with watercolor, gouache, and acrylic for a variety of different results. In my own work, I have successfully used water-soluble oil with other water-soluble mediums, but each layer of the water-soluble oil must be thoroughly dry before another layer is applied. This takes approximately 24 hours, depending on thickness.

Sean Dye, **Love, Death, Hope, and Faith Take a Walk in Provincetown** (2003)
Water-soluble oils, egg tempera, and acrylic gouache on panel, 15 x 30 in. (38.1 x 76.2 cm). *Collection of the artist.*

For this painting I invented clothing, hairstyles, body types, etc., that would go with my thematic archetypes. I painted many of the subtle details—e.g., the tie-dye colors on Death's T-shirt and the menu board in front of the lobster joint—with a mixture of water-soluble oil and Winsor & Newton's Oil Painting Medium for Water-Mixable Oils.

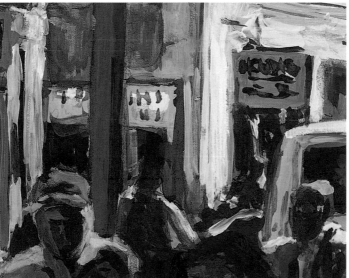

Provincetown Afternoon, Detail

Sean Dye,

Provincetown Afternoon

Water-soluble oil, India ink, and acrylic gouache on Gessobord, 18 x 24 in. (45.7 x 61 cm). *Collection of the artist.*

In this painting (another in my Provincetown Series), I painted the entire background with bright orange acrylic gouache. I left much of the orange between the figures and other objects to give the viewer the feeling that light was coming from within the painting as well as illuminating it.

WATER-SOLUBLE OIL, VINE CHARCOAL, CASEIN, AND WHITE CARBON ON GESSO- AND ACYLIC-PRIMED PANEL

On a recent trip to New Mexico, my wife and I visited the famous Ghost Ranch, where Georgia O'Keeffe lived and painted for 50 years. The light and landscape were inspiring.

To capture the multitextured, rich beauty of the landscape, I planned to use a variety of different mediums. I also decided to make the length of the painting twice its height, to capture the panoramic quality of the scene.

I prepared a ½-inch MDO panel with three layers of white gesso. I added a mixture of Winsor & Newton's Clear Gesso Base with red oxide acrylic paint, which gave gave me a rich, slightly textured surface. Casein is a good choice for use with water-soluble oils, as it eventually dries to a matte finish that is almost completely water-insoluble.

1. All the dark values have been put in with black vine charcoal and the light values with Holbein's white carbon sticks. The mid-values are the red ground showing through. When the sketch was complete, I sprayed the entire surface with a light spray of workable fixative, which prevents the sketch from being disturbed, but does not completely seal the surface; much of the absorbency of the support is retained.

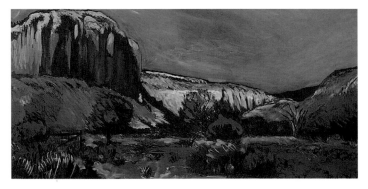

2. The casein underpainting is complete. I used firm nylon brushes to apply the casein, which I had thinned with a bit of water. The visual domination of the cliff has been tempered by giving other areas some dramatic visual interest. I painted the deep shadows in the cliffs with cooler red-violets. I added some lightened raw sienna and Naples yellow to the highlighted areas. I also made the sky more orange and most of the larger trees bright red, to provide a contrast with the oil layers.

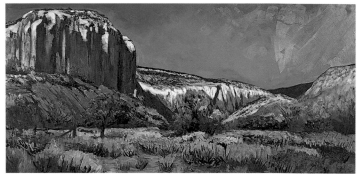

3. Once casein has dried thoroughly, it cannot be reactivated and reworked, and the addition of gouache, watercolor, or water-soluble oil will not change the appearance of the casein layer. It is, however, still slightly absorbent, and the first strokes of a water-soluble medium may soak in and appear flat. Subsequent layers will have more and more of the luster that is typical of oil color. I painted much of the vegetation using greens, blues, and zinc or permanent white. I cooled down the foreground sage with ultramarine blue. I added more reds to the slope below the big cliff to make it more solid. The sky is painted with a variety of blues. At this stage, all of the water-soluble oil layers have been laid down and are dry.

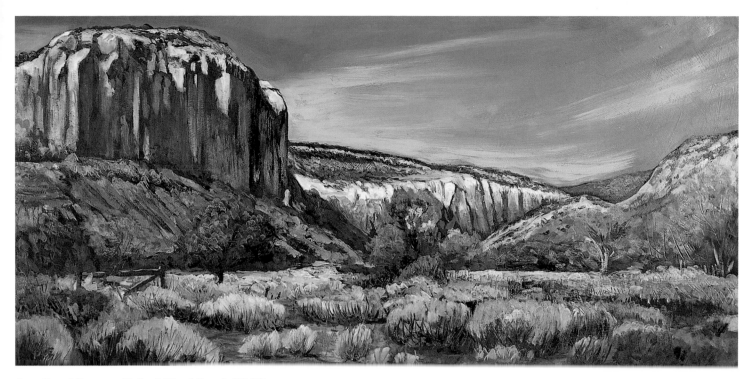

Sean Dye, **Afternoon Walk at Ghost Ranch** (2003)

Water-soluble oil, casein, vine charcoal, and white carbon on gesso- and acylic-primed panel, 24 x 48 in. (61 x 122 cm).

Collection of the artist.

To finish the painting, I reworked the sky and added light to the top of the plant life. I added a bit more detail in the shadows of the cliffs. The dramatic contrast of warms and cools in this scene is faithful to the actual visual experience one has upon visiting this spectacular natural wonder.

Afternoon at Ghost Ranch, Details

Left: To create texture and to expose the base layer, I scratched into the oil color with the handle of my brush. *Right:* This extreme detail shows how strong the original red oxide color still is. The brushstrokes from the clear gesso base can also be seen in contrast to the marks in oil color.

DEMONSTRATION

WATER-SOLUBLE OIL, TEMPERA, AND WALNUT INK ON COLD-PRESSED PANELLI A GESSO

I encountered this view on the way to Bandelier National Monument near Santa Fe to see some of the cliff dwellings. I liked the way the cool colors in the sky contrasted with the warm red and orange hues of the Southwestern landscape.

For my support, I chose the Panelli a Gesso wood panel that simulates a cold-pressed watercolor sheet because it seemed right for this highly textured landscape. This surface also accepts ink readily, with little dripping. I needed a non-flexible support because I planned to use egg tempera, which dries to a water-soluble matte finish which works nicely as an underpainting for water-soluble oils but which tends to flake or peel on canvas. For the sketch, I used walnut ink, which is warmer than India ink, and it seemed a good choice for the warm colors in the scene.

2. The tempera underpainting is complete. I used greenish colors for the sky to keep it warm but also to add some unusual color. I put purple washes into the distant mountains and added reddish and orange browns to the hillsides and canyons. The panel was still quite absorbent at this stage, so I applied the tempera as thin washes.

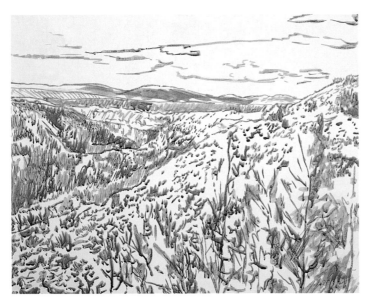

1. The walnut ink sketch is complete. Walnut ink is still somewhat water-soluble when dry, so I sprayed the surface lightly with workable fixative before continuing. After the ink and fixative were dry, I decided to knock back the white of the panel with a warm wash of Indian yellow tempera (not shown).

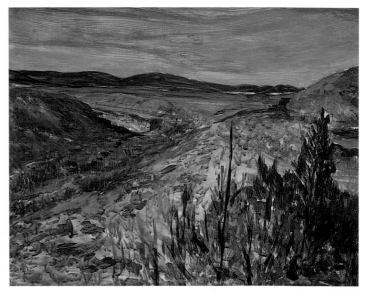

3. The first water-soluble oil layer is complete. I decided to go right into the sky and add a fairly thick layer of blue-green. I darkened the distant mountains. Next, I added thin layers of brownish orange on the land just beyond the canyon.

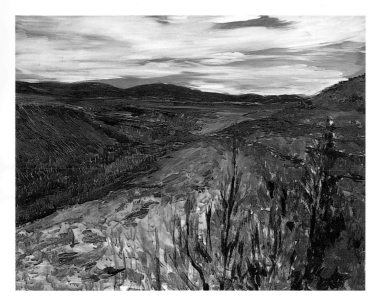

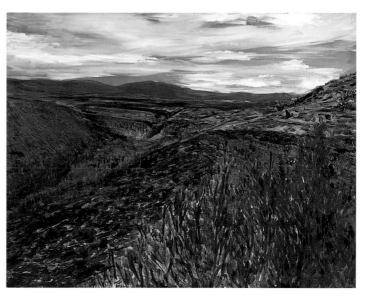

4. This is the end of the second water-soluble oil stage. Before beginning to paint, I added Artisan oil painting medium to make the paint glaze over the previous layer. I have made the sky much bluer and added milky clouds. I added light reds and earth colors to the middle ground.

5. For the third layer, I put a thin scumble of lighter blue-violet and white over the distant mountains; introduced greens to indicate the many trees and shrubs in the scene; varied the colors and values of the sedimentary layers of soil and stone; and worked in textures in the left foreground.

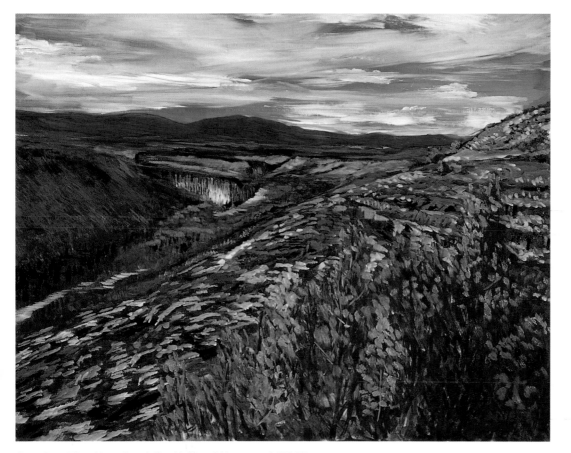

Finished Painting, Detail
The broadest brushstrokes are in the foreground; they get progressively narrower as objects recede into the background. This helped me to achieve the deep perspective I wanted.

Sean Dye, **View Near Bandelier National Monument** (2003)
Water-soluble oil, tempera, and walnut ink on wood panel, 16 x 20 in. (40.6 x 50.8 cm). *Collection of the artist.*

I added highlights to the cliffs and hillsides, a very light reflection to the river, which until then was not really visible as water, and more greens and light yellow-greens to the foreground trees.

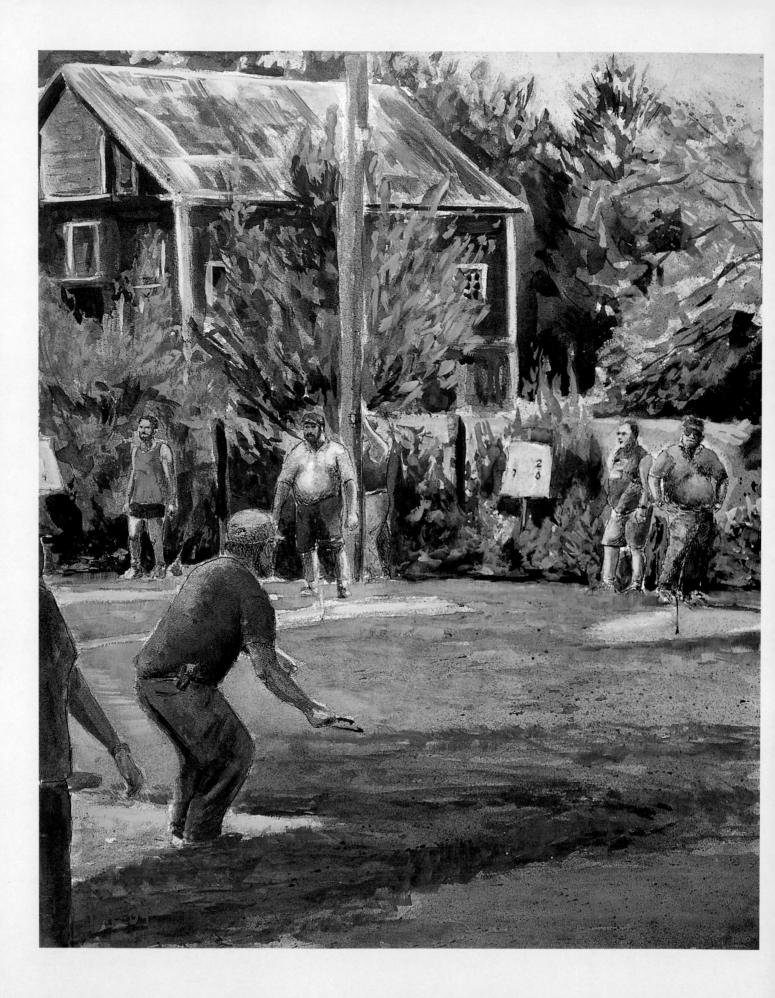

6 WATERCOLOR

Although often described as a "transparent" medium compared to acrylic or gouache, water-color can be relatively opaque depending on the color and on how diluted the pigment is, and watercolor can be combined with almost any combination of other mediums to achieve a variety of subtle effects.

Sea Dye, **Horseshoes at the Fair, Waterford, Maine** (2004) Watercolor, graphite, India ink, gouache, and acrylic airbrush color on rag paper, 28 x 22 in. (71.1 x 55.9 cm). *Collection of the Artist.*

The progression of stages for this work were detailed pencil sketch; India ink, using a brush and pen; light mist of reddish-black acrylic airbrush color sprayed on the entire piece for added texture; opaque gouache color, to add mid-tones and highlights to the figures, vegetation, and barn.

A Brief History of Watercolor

Water-soluble paints have been around for thousands of years, but the growth of watercolor—as distinct from tempera, gouache, and fresco—as a preferred medium for painting is inextricably linked with the invention of paper and, later, with the use of sizing for coating paper. (Although a number of different kinds of paints are soluble in water, the term *watercolor* in this book refers to today's artist-grade paints consisting of pigment dispersed in a medium the main ingredients of which are gum arabic and glycerin plus another water-retaining substance such as corn syrup or honey.) During the first century CE Chinese and Japanese artists applied watercolor to handmade paper and silk, creating landscapes and practicing fine calligraphy. In the sixteenth century German painter and engraver Albrecht Durer (1471–1578) made extensive use of watercolor to do full renderings of subjects that he later painted in oil. Other European artists who used watercolor for drawing and for preliminary studies were the Flemish masters Peter Paul Rubens (1577–1640) and Anthony van Dyck, and, in France, Jean Honoré Fragonard (1732–1806). Watercolor became a significant means of expression in Britain in the early 1800s, and in 1855 England sent 114 watercolors to the World's Fair in Paris. The Englishman Joseph M. W. Turner (1775–1851), who influenced the French impressionists, is most famous for his marine watercolors, which glow with light and color.

Austrian expressionist Egon Schiele (1890–1918) spent much of his short career creating psychologically and spiritually charged figures using watercolor, gouache, and pencil. Abstract expressionist Mark Rothko (Latvian/American, 1903–1970) did a lot of his work in watercolor, especially during the 1940s. He sometimes painted with watercolor, gouache, and tempera, then added India ink while the paint was still wet to create a soft, flowing effect. Abstract paintings created by the great Russian-

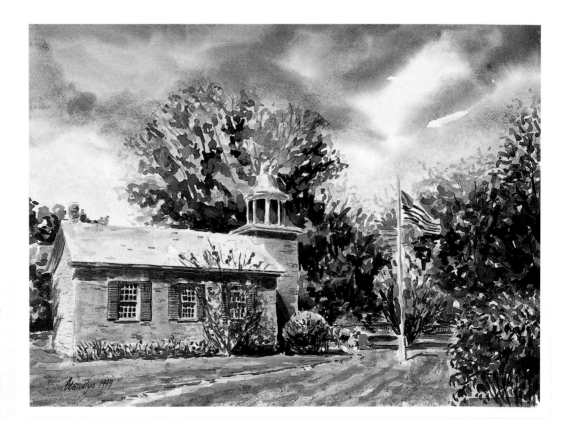

Sean Dye, **School House at Shelburne Museum, Shelburne, Vermont** (1999)
Watercolor, gouache, and graphite on 140-pound cold-pressed paper, 18 x 24 in. (45.7 x 61 cm). *Private Collection.*

Before applying any pigment I made a detailed pencil drawing to establish the composition. I decided to invent some movement in the sky to counteract the strong angles of the building and the path leading to it.

Sean Dye, **Maine Tugboat at Twilight**
Watercolor, gouache, and graphite on 300-pound cold-pressed Lana watercolor paper, 22 x 30 in. (55.9 x 76.2 cm). *Collection of the artist .*

Here I wanted to capture the light one sees just moments before sunset. After applying the watercolor layers, I used the more opaque gouache for the tugboat, which helped establish scale and a clear center of interest.

born artist and theorist Vasily Kandinsky (1866–1944) helped change the way the world looked at art. Kandinsky often used watercolor, and in one of his paintings, *Into the Dark* (1928), he applied the color with an atomizer spray, masking different areas to achieve the effects he wanted. Paul Klee (Swiss, 1879–1940), an associate of Kandinsky, often used watercolor as one of the ingredients in his unique mixed-media art.

Winslow Homer (American, 1836–1910) painted wonderful watercolor works from the 1870s through the early 1900s (see pages 13 and 36). Other important American watercolorists whose work helped to elevate the status of watercolor as a serious medium in the mid to late ninteenth and early twentieth centuries were Thomas Eakins, John Singer Sargent, and Maurice Prendergast. Charles Demuth (1883–1935), an early American abstract painter, worked with pencil, watercolor, and charcoal on thin paper so it would crinkle, adding texture. Realist American painter Edward Hopper (1882–1967) created many of his explorations of Americana in watercolor. New Yorker John Marin (1870–1953), who worked primarily in watercolor, created

vibrant abstract landscapes and cityscapes painted with loose, fluid brushstrokes, which sometimes included charcoal and cut paper. Georgia O'Keeffe, although not known primarily as a watercolorist, painted extensively in that medium between 1916 and 1919.

WATERCOLOR AND MIXED MEDIA

The main thing to keep in mind when using watercolor in a mixed-media work is that the support used must be absorbent enough for the paint to soak into the surface a bit. If the paint beads up on a surface, it is a good sign that the surface is not suitable for watercolor. In addition, if you want this transparent medium to show up as a distinct element in the finished work, the surface must be relatively light.

Watercolor can be used on panels if they are absorbent enough. Gessoed panels, white Pastelbord, Claybord, or panels prepared with absorbent ground will all accept watercolor well. Commercially made canvas primed with acrylic is a good example of a nonreceptive surface. If you want to use canvas, it is better to hand-prime it yourself with gesso, adding a small amount of marble dust. Golden's Absorbent Ground will make almost any surface absorbent enough to accept watercolor.

You can use graphite, charcoal, and India ink under or over watercolor. If you use charcoal, spray the charcoal layer lightly with workable fixative before putting down the watercolor. Watercolor will not disturb marks made with India ink, as it dries waterproof. You may also choose to use water-soluble inks, in which case the watercolor will blend with and soften the ink passages.

Gouache, which is an opaque water-soluble medium, is bound with gum Arabic, as is transparent watercolor, and they work well together in a mixed-media work. Water-soluble gouache is often used to heighten light areas. If you use acrylic gouache underneath watercolor, you can later lift off or scrub away the watercolor, leaving the acrylic gouache layer undisturbed.

Oil and soft pastel sit well on top of watercolor, especially on rough paper. If oil pastel is used first, it acts as a resist: the watercolor will adhere only to the places not covered with oil pastel.

DEMONSTRATION

WATERCOLOR, INDIA INK, AND WATER-SOLUBLE PENCIL ON MDO PANEL PREPARED WITH GESSO AND GOLDEN'S ABSORBENT GROUND

When I made the small watercolor study for this painting, I realized that it had a suggestion of movement that was much stronger than most of my other abstract paintings, which tended to focus on pure composition and surface texture. I titled the piece *Wrecking Ball* so that the viewer would key in on the main action right away. The wrecking ball is a symbol of the stresses and complications of our often-frantic twenty-first-century lives, which can destroy all that we have strived for if we don't manage things carefully.

I wanted the rigidity of a panel but also needed the absorbency of paper, so I used a "found" piece of MDO board. I primed the paper-faced surface with three coats of Holbein's S smooth gesso and two coats of Golden's Absorbent Ground. All gessoes are not created equally. I have found that some of the bargain brands tend to flake, crack, or become powdery. There is also a difference in covering, or sealing, power between the high-end and budget brands.

When I began this piece, I had both the intimate mixed-media works of Paul Klee and the detailed draftsmanship of Rembrandt in mind. I wanted the drawing stage to maintain its presence in the finished work, so I decided to use pen and India ink, which would show through, and not be disturbed by, the watercolor.

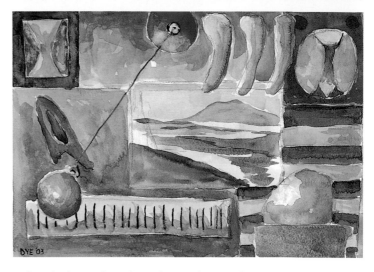

1. I made this study with wet layers of watercolor over a pencil sketch. My palette was influenced by the colors used by early Italian Renaissance artists. Most of the shapes are floating near the picture plane. The major exception is the rectangle that appears to be a window into a landscape. This "landscape window" is a reference to my main body of work. The shape in the upper right originally entered my visual vocabulary as a ladybug. Ladybug images in my work refer to my daughter, who is fond of the insect.

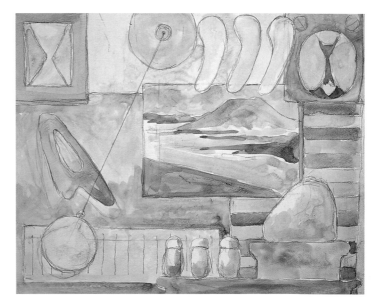

2. I sketched out my composition next, making several minor changes to the original design. I added light watercolor washes to delineate the different shapes.

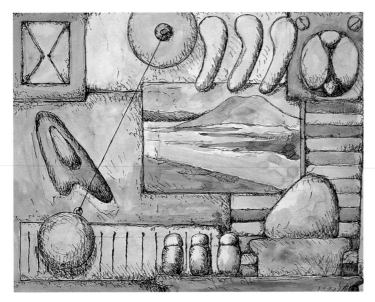

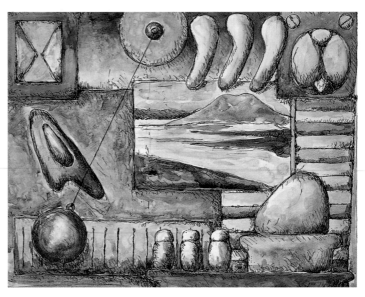

3. I used a metal quill pen to apply India ink, to strengthen the shapes and suggest shadow. I employed a variety of ink strokes, including: long, linear strokes, cross-hatching, and small dots.

4. With the second watercolor application I introduced a richness of color. It is possible to have many layers of watercolor visible at the same time because of its transparency. At this stage the shapes maintain their original colors, but there are now a variety of hues for each. After initially darkening the wrecking ball, I lightened its center by scrubbing it with a soft, wet cloth.

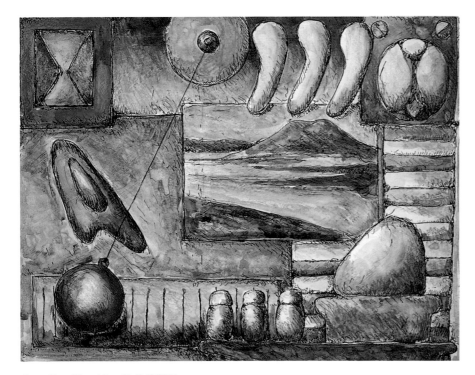

Sean Dye, **Wrecking Ball** (2003)

Watercolor, pen and ink, and water-soluble pencil on gesso– and Absorbent Ground–prepared MDO board, 12 x 15 in. (30.5 x 38.1 cm). *Collection of the artist.*

After the watercolor- and ink-layered painting had been in my studio for a while, I decided it was missing something, and late one evening I popped it out of its frame. I had two new sets of water-soluble pencils by Cretacolor that I had not tried yet. I used them to change the intensity of the colors and to add a grainy quality to the surface.

Wrecking Ball, Detail

The watercolor, ink, and water-soluble pencil work together to create the final, "worked" surface.

DEMONSTRATION

WATERCOLOR, EBONY PENCIL, AND PASTEL ON WATERCOLOR PAPER

Today's car owners nonchalantly trade in their vehicles every two or three years, long before the fabled "bond" between human and machine can be established. Many of my neighbors, however, are farmers, and most of their tractors have been in use for years—some for many decades! When I saw this tractor, a couple of miles from my home, I imagined how many hours the farmer—and perhaps his father—must have sat in the driver's seat or tinkered with the working parts of this ancient machine.

I chose 300-pound cold-pressed watercolor paper because of its sturdiness and pronounced texture. Many traditional watercolorists prefer not to use soft, dark graphite, like Ebony pencils. Here I decided to use them because I wanted to make a strong statement with the drawing.

I also think pastel can be a perfect complement to watercolor, no matter which is the dominant medium. I skim the pastel over the raised surfaces of the coarse paper, allowing the watercolor to shine through in the depressions of the paper.

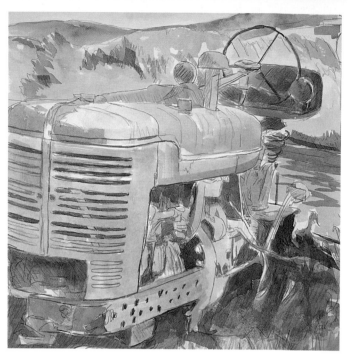

2. This is the first watercolor layer. In traditional watercolor painting, all of the light areas are added first. For this tractor, I decided to block in my shadows early on to help establish some three-dimensional form.

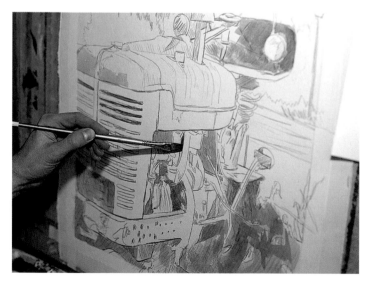

1. In this photo I am adding the darkest shadows with watercolor washes of mixtures of Prussian blue, sepia, Paine's gray, and burnt umber. I used long-handled ¹/₂-, ³/₄-, and 1-inch flat watercolor brushes.

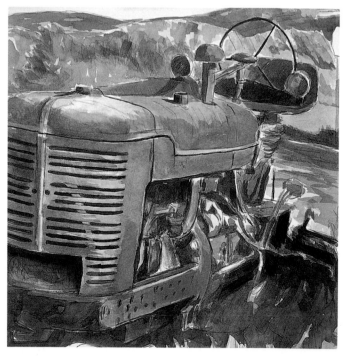

3. The tractor has much of its body color. The shadows are still rather light. The Ebony pencil shows up strongly.

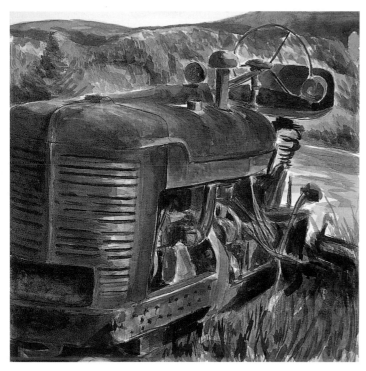

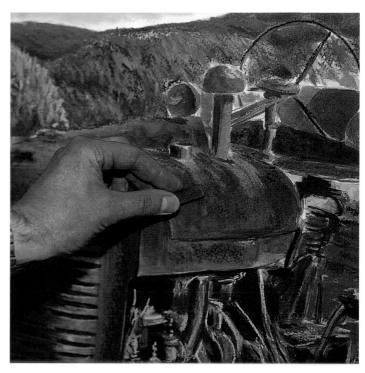

4. The third watercolor layer is complete. All of the lights and darks have been planned and executed. I've added rusty textures to the metal surfaces of the tractor. The colors in the background have become richer and the foreground grasses suggested.

5. A watercolor painting on cold-pressed paper can be a very inviting surface for pastel. Such was the case with this one. Here I am gently gliding a firm pastel over the coarse paper to leave pigment on the raised surfaces.

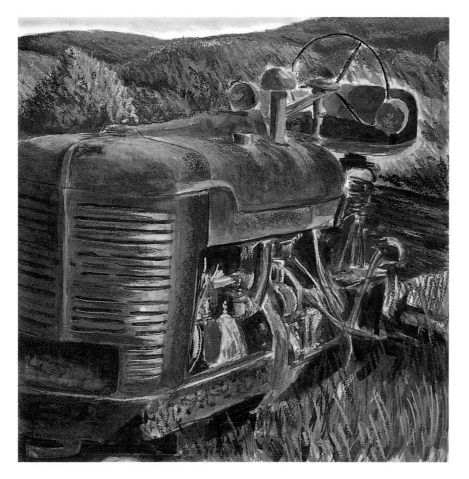

Sean Dye, **An Old Friend** (2003)
Watercolor, graphite (Ebony pencil), and pastel
on watercolor paper, 20 x 20 in. (50.8 x 50.8 cm).
Collection of the artist.

The pastel added some additional textures to the weathered surface of the tractor, as well as helping me define the mechanical parts of the engine area. The pastel strokes for the grasses push the shadows back, adding more depth to the foreground. The vivid pastel colors in the background landscape—now dreamlike, with an almost whimsical quality—provide a sharp contrast with the realistic tractor, on which the watercolor layers are more prominent.

7

GOUACHE

Nicholas Battis, **Shimmer** (2003)
Gouache, iridescent gouache,
and glitter on paper, 15.5 x 11.5 in.
(39.4 x 29.2 cm).

In *Shimmer*, Nick Battis exploits
gouache's versatility as an
opaque and a transparent medi-
um. He also plays with the idea
of soft and hard focus working
together on the same planes.

During the Middle Ages gouache was one of the
mediums used to embellish illuminated manu-
scripts, but until the early nineteenth century, only
a few European masterworks were painted with
gouache alone. Today, gouache is a popular medium
with fine artists, commercial artists, and illustrators.
It is also widely used for mixed-media works,
combining as it does opacity and brilliance of color.

Introduction to Gouache

Gouache, from the Italian *aguazzo* ("mud"), is a water-based paint that can be manufactured by using naturally opaque pigments or made opaque by the addition of white pigment or precipitated chalk. There are some outstanding extant examples of gouache and gold leaf works created in India and Turkey in the sixteenth and early seventeenth centuries. Later works in gouache include some of Albrecht Durer's nature paintings; a series of pantings by Gaspard Dughet (Poussin, French, 1615–1675); and a few paintings by Paul Klee. Many artists, however, including Georges de La Tour, Edgar Degas, and Francois Boucher, painted mixed-media works with gouache and watercolor.

Gouache differs from watercolor in several respects. In addition to opacity and matte finish, it is thicker than watercolor and its use creates smooth, brilliant, light-reflective color areas that are vivid even on the darkest of backgrounds.

It is generally lightened by the addition of white rather than by adding water. Although gouache brushstrokes are not easily blended, smooth blending can be achieved by using an airbrush.

Holbein Art Materials introduced the first acrylic gouache in 1986. Acrylic gouache has the same brilliance of color and matte finish found in traditional gouache, but it is not true gouache because it is made with an acrylic polymer binder rather than a gum Arabic binder. Acrylic gouache is waterproof after it dries, and at the same time is more flexible than gum-based gouache.

Some gouache paints on the market have been prepared with too much low-quality white filler or too much chalk, resulting in pale, powdery colors that resemble poster paint. M. Graham, Holbein, Sennelier, and Winsor & Newton all manufacture gouache with rich, vibrant colors made by

Frank Federico, **Big Sound**
Ink and gouache on panel with freely prepared underpainting.

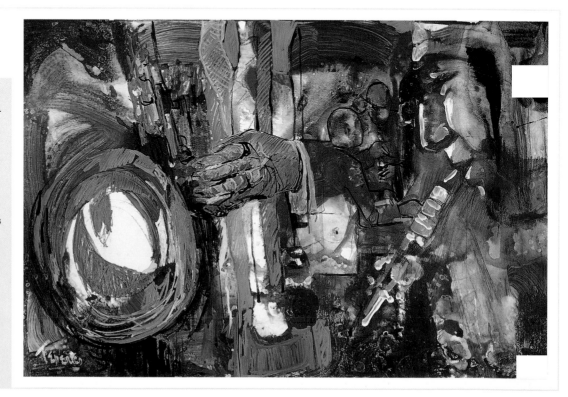

This painting is part of Frank Federico's Jazz Series. The feeling of great jazz sound is unmistakable. At first glance the painting appears to be a beautiful collection of abstract shapes and textures. The viewer, however, very quickly begins to see musicians, instruments, and a deep space created with overlapping areas of color and variations in size. Notice the various thicknesses of pigment, from washes to totally opaque layers. There is also an incredible variety of brushstrokes.

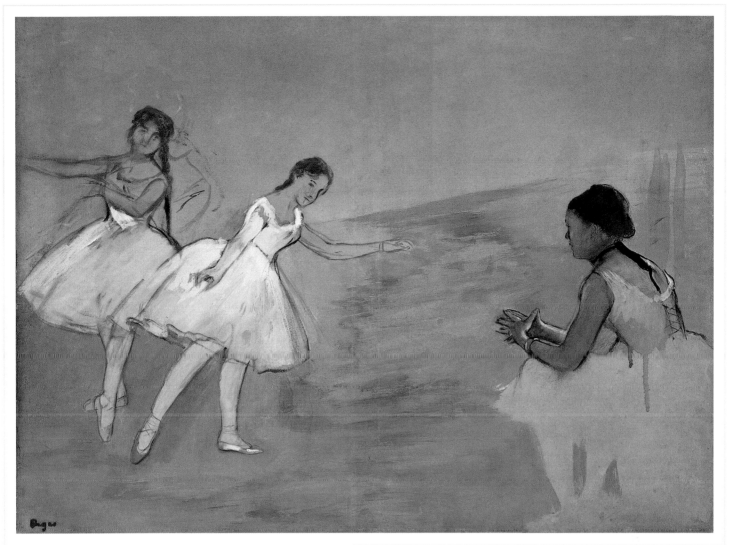

Edgar Degas, **Ballet, Three Dancers** (c. 1873)
Essence and gouache on paper mounted to fabric, 18 ¼ x 24 ½ in.
(21 x 61 cm). *The Norton Simon Foundation.*

In this study, different areas of the painting have been rendered with various levels of completion. The arms and hands of the seated figure at the right are finely detailed while the lower portion of the same figure is merely blank paper, which becomes the color of the floor. The details of the two dancing figures fall somewhere in between.

increasing opacity through adding pigment. Some gouache lines were developed specifically for the brightness qualities desirable in illustrations that are to be photographed for magazine pieces, where permanancy is not always a requirement. These paints, sometimes called "luminous" colors, should be avoided by fine artists. The permanancy of any paint, including gouache, depends on how lightfast, or resistant to the damage caused by ultraviolet light, the paint is. The American Society of Testing Materials (ASTM) recognizes three lightfastness categories: I, excellent lightfastness under all normal lighting conditons; II, good lightfastness, suitable for all applications other than prolonged exposure to ultraviolet light (e.g., an outdoor mural); III, poor lightfastness. If the brand/color you want to use does not have a lightfastness rating on the label, check with the manufacturer. If that brand/color has not been tested, don't buy it.

GOUACHE AND MIXED MEDIA

Gouache adheres better to somewhat porous surfaces than watercolor does. It is more opaque than watercolor, and its colors are not affected by the colors of background layers. A single layer of gouache is fine for underpainting purpose, but I do not recommend using multiple layers. Traditional gouache is bound in gum Arabic and may have matting agents added, making it slightly brittle and, in general, not a good choice for canvas because the flexible canvas is likely to cause cracking or flaking. Gouache can be used as an underpainting on linen if the linen is first mounted on a rigid surface.

Acrylic gouache is inherently more flexible than traditional gouache and better suited for canvas. It should be used on acrylic-primed surfaces rather than their oil-primed counterparts. On a heavily toothed surface, if the gouache is not thinned with water, some texture may be lost.

White gouache used as an underpainting for watercolor adds brightness. White gouache can also be used under specific areas of a painting, for the same purpose. Gouache is often used to heighten light areas of a watercolor painting as well as add physical texture to the surface.

Gouache may be combined with nearly all drawing mediums in any order of application. Oily or waxy pencils will act as a resist in most cases if applied first. Gouache dries to a vel-

Sean Dye, Big Tree at Shelburne Farms
Gouache, watercolor, and pencil on 140-pound Imperial cold-pressed watercolor paper, 9 x 12 in. (22.9 x 30.5 cm).
Collection of the artist.

This view is one of the most beautiful approaches to majestic Lake Champlain not far from my home. Most of the top layer of the painting is gouache. Some of the washes in the sky are watercolor.

vety matte finish, and many artists find it ideal for underpainting with soft pastel and oil pastel.

Gouache makes an excellent underpainting for oil color. It dries quickly, and the oils soak into the absorbent surface, creating a stable mechanical bond. Gouache, which is water-soluble, can be corrected, but will not be disturbed, by mineral spirits. If you use more than one layer of gouache, you run the risk that the lower layer or layers will absorb the moisture from the top layer or layers, making them brittle and prone to cracking. Some artists prevent this by adding a few drops of gum Arabic solution to the paint, but one has to be careful about proportions. Too much gum Arabic will make the paint both shiny and sticky. Some artists who work with gouache add a small amount of matte acrylic medium to the gouache to make it more flexible. Acrylic medium does, however, darken some colors, and all combinations must be tested before use.

Jonathan Young,
New Mexico Hello
Acrylic gouache and watercolor,
15 x 22 in. (38.1 x 55.8 cm).

Jonathan Young captures the essence of Southwestern light in this painting. He uses a few confident, broad strokes to indicate the sun-blasted cliffs. The polymer acrylic–based gouache works well with the watercolor, which has soaked into the paper.

New Mexico Hello, Detail

Sarah Neith,
Tea Reflections (2003)
Acrylic gouache, acrylic, and
water-soluble oil on Gessobord,
20 x 16 in. (51 x 40.6 cm).

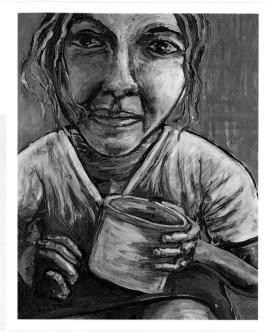

Tea Reflections, Detail

Vermont painter Sarah Neith
has been exploring new ways to
represent the figure in her
recent work. In this painting, a
self-portrait, she has deliber-
ately distorted the figure to
draw attention to the facial
expression. The easily manipu-
lated oil color works well on
top of the loose, solid strokes of
acrylic gouache and acrylic.

Nicholas Battis, **Dot Org** (2003)
Ink, gouache, iridescent gouache,
and watercolor, 10 x 11.5 in.
(25.4 x 29.2 cm).

Brooklyn Artist Nicholas Battis
creates works on paper that uti-
lize a variety of materials. His
abstract work often suggests
structures and rhythms found
in nature. In this piece the early
washes dictate the initial flow of
the painting, while the collec-
tions of circles seem to dance
and mingle in their respective
groups. There is a nice contrast
between the shiny iridescent
gouache circles and the rest
of the painting's matte surface.

DEMONSTRATION

GOUACHE, WATERCOLOR, INDIA INK, AND GRAPHITE ON BUFF PRINTMAKING PAPER

At the top of the Parliamentary Tower of the Canadian Parliament in Ottawa there is a wonderful view of the Parliamentary Library rooftop, and behind it is a beautiful, expansive view of the city. I knew I wanted to use gouache and watercolor for the paint mediums, so I chose printmaking paper for the support. Printmaking paper has much less sizing than watercolor paper, making it very absorbent. I knew that when I added transparent watercolor to the absorbent surface, much of the pigment would be pulled into the paper, allowing me to apply many thin layers without much color buildup.

1. My initial sketch was done in HB pencil on the printmaking paper. I then went over the pencil lines with thinned India ink. This is the inked-in sketch.

This studio shot shows the finished ink study. At the upper right is the digital photo that I took at the same time that I did the initial sketch and which I used to make sure my structural details were correct. I had a palette with wells for thinning the ink, and a paper towel handy for blotting the brush and for catching any drips.

Gouache layer, detail
I used the gouache layer to add color to the copper roofing, suggesting its patina and discoloring due to weather.

2. I introduced color subtly, using transparent watercolor. The India ink and the loose watercolor strokes work together to suggest the complicated window structure and buttresses.

3. The thin layers of gouache are more opaque and slightly grainier than the watercolor layers.

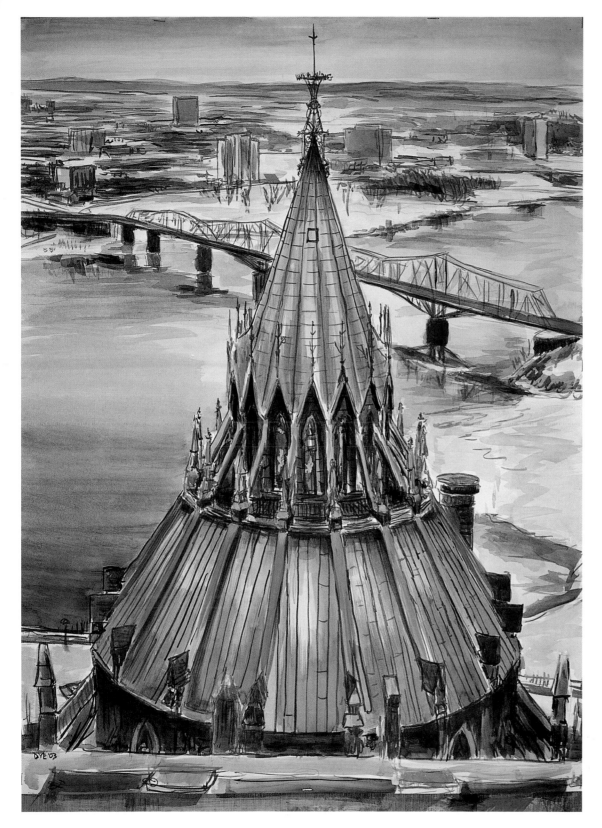

Sean Dye, **Library Rooftop, Canadian Parliament, Ottawa** (2003)
Gouache, watercolor, India ink, and graphite on buff print-making paper, 22 x 30 in. (55.9 x 76.2 cm).
Collection of the artist.

For the final gouache layer, I added gray clouds over the warm horizon to make the day feel colder and darker. I decided to make the river look frozen, and I put some snow on the ground. I added light but opaque color to the top edges of the architectural elements to make them more three-dimensional.

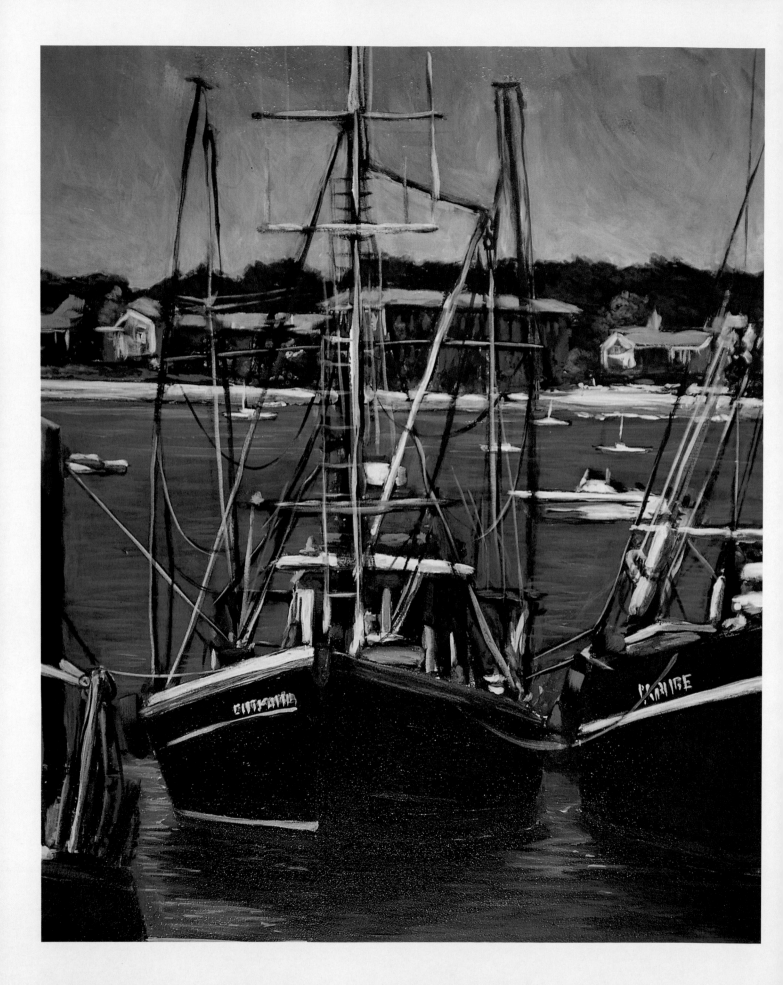

ACRYLIC POLYMER EMULSION

Sean Dye, **Afternoon Boats, Provincetown, Massachusetts, Detail**
Acrylic polymer emulsion, acrylic gouache, and India ink on canvas, 36 x 48 in. (91.4 x 122 cm). *Collection of the artist.*

This work was painted especially for a show under a tight deadline. In most cases I would paint a work this size in oil. Because of the time constraints, I decided to use the faster-drying acrylic. I used Golden's gel medium and glazing medium to mimic the effects of oil color. At the exhibition this painting hung next to one of my oils of the same size and a similar subject. While there were subtle differences, the paintings worked well together.

Acrylic polymer emulsion artists' paints, which have been around only since the mid-twentieth century, are widely used by contemporary artists. The colors are intense and the paints can be applied with brush or airbrush, or dripped, poured, or splattered. Acrylic also dries relatively quickly, a definite advantage for mixed-media works.

Acrylic for Artists

A TWENTIETH-CENTURY INVENTION

Acrylic resins were discovered in the late nineteenth century by the Swiss chemist W. A. Kahlbaum. In 1915 Otto Rohm, in Germany, patented the process for making acrylate, a form of acrylic used as a substitute for drying oils in industrial paint. Rohm and Haas marketed polymethyl methacrylate in the late 1920s, and acrylics were first sold in the United States as substitutes for glass (Plexiglas and Lucite). In 1949 Bocour Artists Colour Inc. marketed Magna, a solvent-soluble artists' paint. Rohm and Haas introduced Rhoplex, the first acrylic emulsion specially designed for paint (latex), in 1953; Rhoplex was meant to be used for house paint, but the process for making it became the base for the artist acrylic emulsions marketed today.

Very soon after their introduction into the art field, acrylics made possible new forms of contemporary art, perhaps most notably the large-scale "hard-edge" paintings that began to appear in the 1960s. Acrylic dries much more rapidly than oil, and artists can mask off already-painted areas to achieve perfectly straight lines without pulling up the dried paint. Well-known American artists who have made extensive use of acrylic include Morris Louis (1912–1962), Helen Frankenthaler (b. 1928), Roy Lichtenstein (1923–1997), and Frank Stella (b. 1936). Some of English artist David Hockney's best-known works were painted with acrylic (b. 1937), as were many of the later paintings of Russian-American Mark Rothko (1903–1970).

Although acrylic is often used as an alternative to oil color, there are some important differences. Not even the best acrylic polymer emulsions can match the luminous transparency of oil. Oil paint is more viscous than acrylic, and the creamy texture of oil paint retains brushstrokes so perfectly that the marks of individual bristles can be discerned. The properties of acrylic paint can be altered by adding gels or mediums, but even with those additives, the brushstrokes tend

Frank Hewitt, **Franklin County** (1991)
Oil stick and acrylic on linen, 72 x 72 in. (183 x 183 cm).
Courtesy of Karen Hewitt. Photo by Ken Burris.

The two mediums and the texture of the linen support in this painting make independent statements yet come together to form a cohesive, unified whole. By overlapping layer after layer of thinned paint, Frank Hewitt creates a deep, breathing space. The viewer is pulled back to the flat surface of the painting by the thick, opaquely painted shapes that actually protrude slightly from the painting's surface.

to flatten out and become smoother as the paint dries. The downside of acrylic's quick drying time is that it is more difficult to achieve smooth transitions than it is with oil.

ACRYLIC POLYMER EMULSION AND MIXED MEDIA

Acrylic polymer emulsion is an extremely versatile medium, making it a natural for mixed-media works. It can be painted on

nearly any clean, nonoily surface, and there is no need to first add a barrier ground. It can be thinned like watercolor. It can also be used for thick impasto passages without losing its flexibility. Its nonyellowing and adhesive properties—small objects, fabric, sand, and other materials will adhere to a thick acrylic layer—making it an ideal choice for collage.

Some of the many possibilities for the use of acrylic polymer emulsion in mixed-media works are as follows:

• As a layer or layers over watercolor or gouache, with the caveat that if too much water is used to thin the acrylic, it may disturb early paint layers.

• In very thin washes on absorbent surfaces, as an underpainting for oil color. It is best to stick to acrylic gouache or colored acrylic gesso for oil paintings.

• As an underpainting medium for oil pastel. The oil pastel sticks easily to the surface and can be built up on the bumps of the acrylic brushstrokes. Acrylic is not suitable under soft pastel because its semigloss finish does not provide enough tooth.

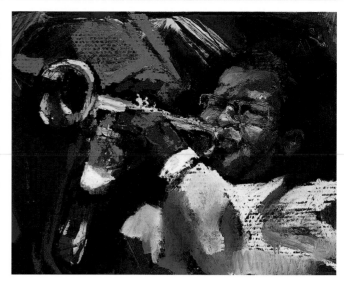

Frank Federico, **The Big Horn**
Oil stick over acrylic on black canvas

In this painting, the oil stick glides over the acrylic layers, allowing many of the brushstrokes to remain. Notice the similarity of this palette with that of Frank Hewitt's *Franklin County*, on the opposite page.

Sarah Neith, **Portrait of a Modern Man** (2003)
Acrylic and water-soluble oil on canvas, 48 x 48 in. (122 x 122 cm).

The flat, posterlike background in this painting is suggestive of graphic design. The head is rendered in thin, translucent monochromatic layers, which allow the warm yellow underpainting to come through. The bright red outlines work to reinforce the two-dimensional quality of the painting. This technique was often used by painters in the second half of the twentieth century, perhaps most notably by Andy Warhol.

Portrait of a Modern Man, Detail

ACRYLIC, WALNUT INK, AND PVA GLUE ON MAPLE ARTBOARD

This farm lies at an intersection of two country roads in the middle of corn and hayfields. The Green Mountains offer a wonderful backdrop to the south. I decided to work on natural maple panel because I felt the wood grain would help convey the rough textures I wanted. At the same time, the smooth surface would allow me to build up many transparent layers.

I sealed the wood with PVA glue, a modern, stable replacement for traditional animal glue size, making the surface less absorbent and slick enough to allow the brush to glide over it. The walnut ink gave me a subtle, transparent sketch that added warmth at the same time. With a bit of workable fixative the acrylic does not disturb the ink. I chose acrylic polymer emulsion because it dries quickly, allowing me to apply a multitude of layers in a relatively short time, so I could get the deep sense of space I needed.

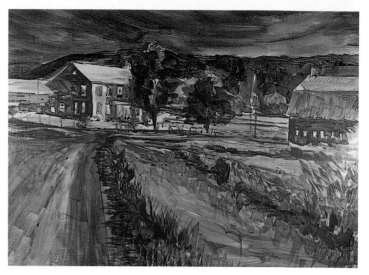

2. For the first acrylic passages, I used a limited palette of cool colors: blue-green, blue, blue-violet, and violet with a hint of red. I added Golden's satin glazing medium to all of the colors so that I could build them up slowly.

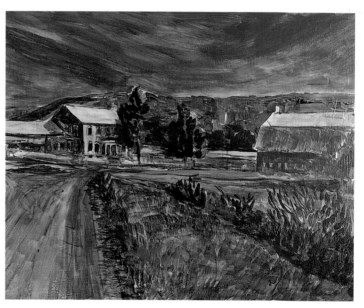

3. I added a layer of blue to the sky and lighter green to the mountains. I put greens and warm yellows into the foreground field and added warm yellow-oranges to the house, the road, and the top of the barn. The strokes are loose and free.

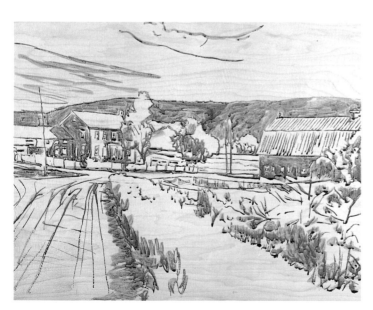

1. This is the walnut ink sketch, done with a #6 sable brush. Walnut ink is not waterproof, so I gave it a light spray of workable fixative.

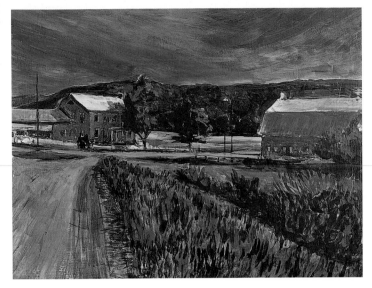

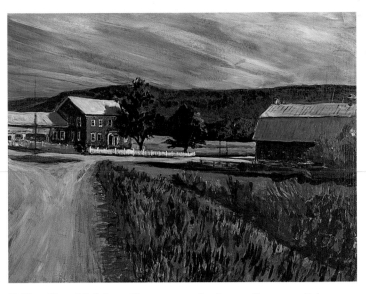

4. I added manganese blue to the sky and brought the reflection into the roof of the barn. I put bright brick reds and oranges on the house and added much more green to the foreground field.

5. Here I've added the milky summer clouds as well as some light glazing on the distant hills. I shaded the side of the barn and the left side of the house with deep blue-violets. I added purple shadows in the grass and on the road.

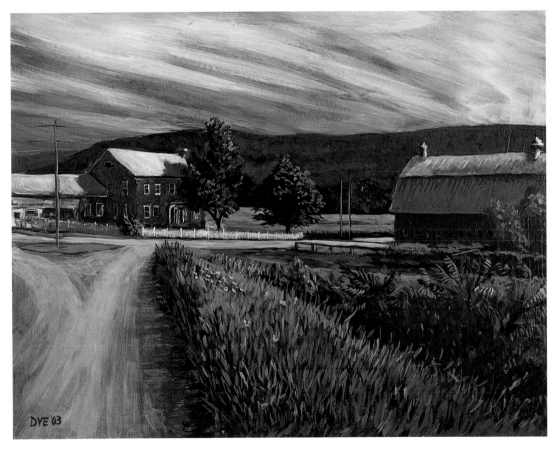

Sean Dye, **Hinesburg Corner Farm** (2003

Acrylic, Walnut ink, and PVA glue on maple panel, 16 x 20 in. (40.6 x 50.8 cm).

Collection of Gary and Susan Stewart.

The final acrylic layer has been applied. The passages of walnut ink provide a warm brown undertone. Because the acrylic and walnut ink are both relatively transparent, the soft, neutral yellow of the ungessoed maple also contributes color. At this point it is possible to identify some of the flora by species (for example, the sumacs) and not simply as masses of color. The trees in the middle ground have highlights, making them more three-dimensional. I added wild flowers to the field and detail to the flora in front of the house. I added violets to the shadows cast by the trees onto the house. With a small brush I added a few loose details to indicate the trim on the house.

DEMONSTRATION

ACRYLIC, COLORED DRAWING INK, INDIA INK, AND CHARCOAL ON ACRYLIC-PRIMED LINEN

This scene is near Arroyo Seco, a quirky little town just north of Taos, New Mexico. The country road, which heads northeast out of town, leads into the Carson National Forest. The road seems to go on forever, revealing spectacular views at every turn. Right from the start I decided to use panoramic dimensions, and did my initial sketch on an 8- by 20-inch sheet of paper.

For the reasons outlined in the previous demonstration, I wanted to use acrylic polymer emulsion as the dominant medium, and so had to prime the canvas with acrylic. Oil primer is designed for oil color; acrylic polymer emulsion will not adhere to it well.

I planned to apply the acrylic paint with a painting knife to take advantage of the random, natural grain of the Belgian linen. To make the paint more viscous, and thus more able to retain such heavy strokes, I added acrylic matte gel to the paint.

1. The underpainting has been layered over the sketch, on acrylic-primed linen stretched over an 18- by 48-inch heavy-duty stretcher. Previously, I had applied a layer of Holbein's M gesso, a bright white medium which has a lightly sanded finish. I did my sketch in vine charcoal. I used Higgins colored drawing ink and black India ink for the underpainting. The colored ink provides vibrant, expressive strokes right out of the bottle, and doesn't need thinning. The India ink provided the darker values. India ink is completely opaque when used straight, and I thinned many of these strokes with water. The thin ink layers do not cover up the texture of the linen. After the ink was dry I gave it a spray of workable fixative to prevent smudging and running.

2. All of the acrylic paint in this work was applied with a painting knife, using the same technique one would use to frost a cupcake. This is the first layer. I added Golden's matte gel mediums to the paint in both "soft" and "heavy" viscosities, depending on the effect I wanted. Soft gel adds luminosity and transparency, but has only a slight effect on viscosity. Heavy gel adds luminosity and transparency and at the same time makes the paint more viscous, so that individual brushstrokes will be much more evident. I added bright, loose reds, blue-greens, and earth tones.

3. For the second acrylic layer I lightened the sky and the road and delineated the different color areas in the fields and hills more clearly. The colors in the sky are now far more complex; the blues have now been enhanced by blue-gray and gray. The greens in the field have now been mixed with reds and oranges to make them more natural-looking.

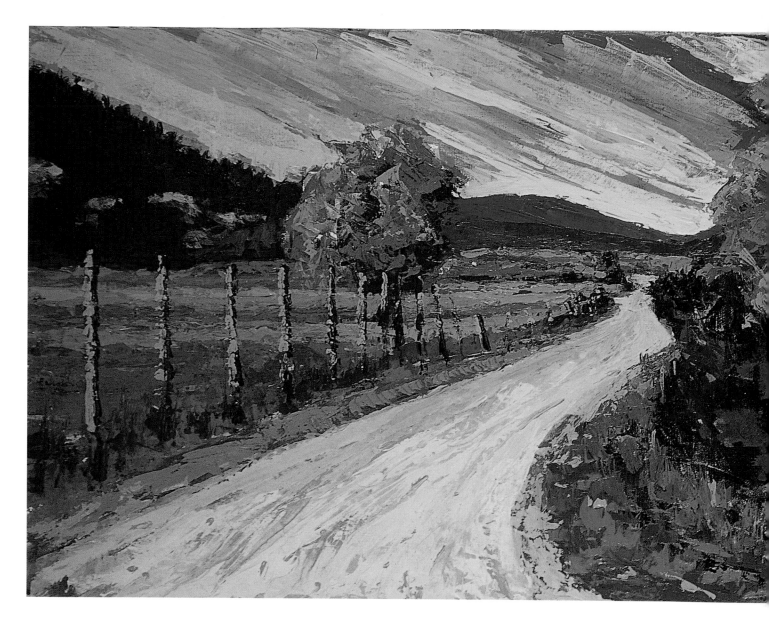

Sean Dye, **Country Road Near Arroyo Seco, New Mexico** (2003)
Acrylic, colored drawing ink, India ink, and charcoal on linen, 18 x 48 in.
(45.7 x 122 cm). *Collection of the artist.*

To complete the painting I tried to fine-tune the knife strokes without
losing too much of the spontaneity. I brought more light into the left
side of the trees. I left a lot of the red coming through the greens.
The multiple layers of acrylic create a three-dimensional paint history
as they stack up on the surface of the linen.

Painting Knife Application, Detail
I am dragging the paint underneath the tip of a top-quality knife with
a rounded point (my favorite shape). Painting knives vary greatly in
quality. It is better to invest in one good all-purpose knife such as this
one than to buy a whole set of cheap ones.

Country Road Near Arroyo Seco, Detail

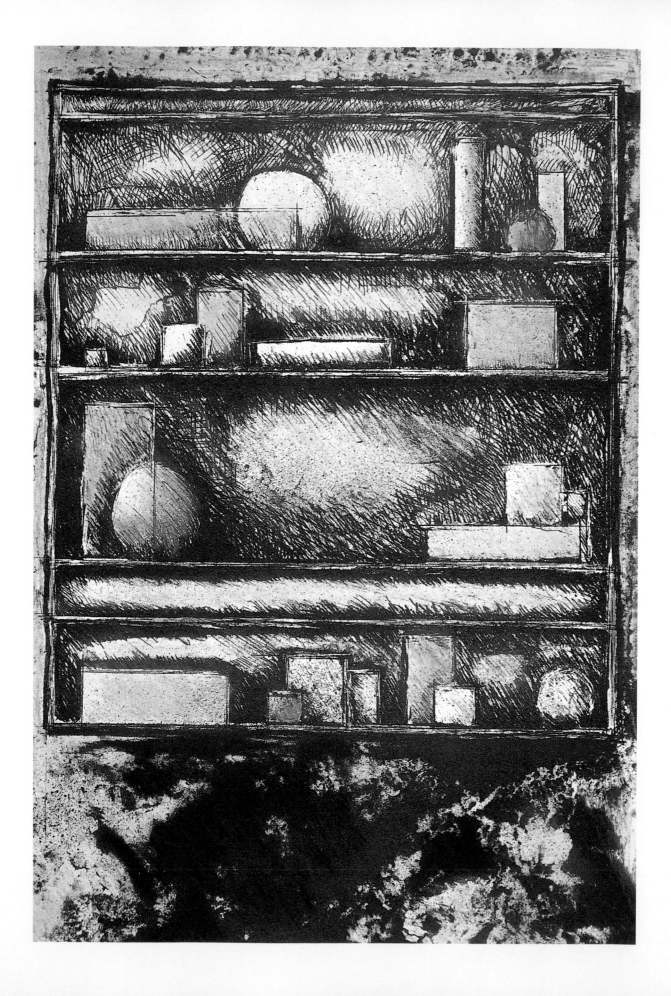

9

PRINTMAKING

Sean Dye
Shelf Series # 4 (1989)
Lithograph with pastel on paper,
9.5 x 14 in. (24 x 35.5 cm).
Collection of the artist.

The original drawing for this
work was made with graphite,
tusche, and graphite powder on
frosted Mylar. I exposed the
image onto an aluminum litho-
graphic plate. The print was
hand-pulled on a traditional
lithography press. Shortly after
printing I decided to hand-color
the image using a very light
touch with soft pastels.

Printmaking is different from all the other tech-
niques covered in this book in that rather than
applying pigment directly to paper, canvas, art-
board, etc., the artist creates the work on any one
of a variety of surfaces, then impresses or stamps
the images into a support, usually paper or fabric.
This chapter starts with a brief history of print-
making, then demonstrates two techniques that are
particularly appropriate for mixed-media works:
monotype and drypoint.

An Introduction to Printmaking

The major types of printmaking are relief printing, intaglio, lithography, serigraphy, and monotype.

RELIEF PRINTING

Relief printing methods, which include woodcuts, wood engrav-ings, and linocuts (linoleum cuts), all involve creating a raised design on a surface by carving away background areas.

Woodcuts emerged in China sometime between 25 and 220 CE, and artists in the Far East were transferring woodcut designs to paper by the seventh century. In the nineteenth

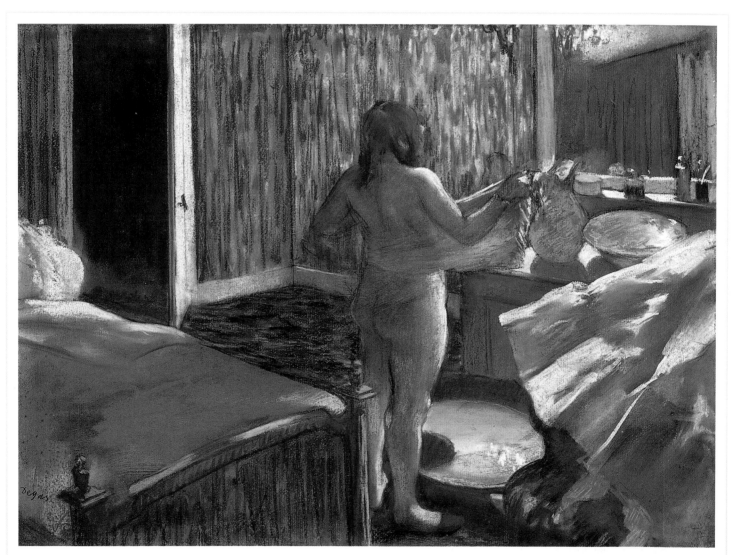

Edgar Degas, **Woman Drying Herself after the Bath** (1876-77)
Pastel over monotype on paper, 18 x 23.75 in. (45.7 x 60.3 cm).
The Norton Simon Foundation.

One way that Degas maintained freshness over a series of paintings with the same subject was to use different techniques. In this painting Degas has used monotype as a substructure to which he introduced color with pastel. The composition, with its creative cropping and strong diagonals describing the bed, floor, and vanity, is masterful.

century in Japan, Ando Hiroshige and Katsushika Hokusai perfected the art of making multicolored woodcuts, and today's Japanese printmakers remain faithful to relief printing on a very sophisticated level.

In Europe during the late Middle Ages, woodcuts were used to decorate textiles. Once paper became widely available, about 1400, many European masters adapted the technique to fit their own unique style, including Albrecht Durer (German, 1471–1528), Lucas van Leyden (Dutch, 1494–1593), and Titian (Italian, 1490?–1576). Nineteenth- and twentieth-century European and American artists who created notable relief prints include Pablo Picasso, Winslow Homer, and Helen Frankenthaler.

INTAGLIO

Intaglio, including engraving, etching, mezzotint, drypoint, and aquatint, is the reverse of relief printing: the areas that are to be printed are the ones carved out of the surface. The earliest intaglio engravings were made on medieval armor; in the fifteenth century the basic technique was used to print on paper. Lines of the design are incised into copper or zinc plates and ink is rubbed in the incisions. The top of the plate is then carefully wiped clean and a sheet of damp paper placed on top. The plate and paper, surrounded by felt blankets, are then run between two rollers through a press.

The basic tool for intaglio engraving is the burin, a sharp V-shaped instrument that can cut a range of line widths. Drypoint prints are made using a strong steel needle that scratches across the surface raising a thin ridge called a burr, which holds the ink. For etching, soft-ground etching, and aquatint, the artist first applies an acid-resistant *ground* to the surface, draws on the coated plate with a needle, then dips the entire plate into acid to "bite" the image in. Form and value in early engraving and drypoint were often achieved by laborious cross-hatching. Mezzotint, unlike engraving and drypoint, which scratch one line at a time, creates value by scratching multiple lines with one tool.

LITHOGRAPHY

Lithography was invented in the late eighteenth century by Alois Senefelder. The artist draws on a flat printing surface with an oily crayon, the image is fixed with acid, and the entire surface is soaked in water. When the surface is inked, the ink adheres only to the areas that were drawn in with the grease-based crayon. Senefelder used perfectly smooth Bavarian limestone as a surface. Today, lithographs are printed on either limestone or metal plates.

SERIGRAPHY

To make a serigraph, or screen print, the artist blocks out the design on a finely meshed surface (silk or synthetic fiber) by covering or plugging the holes that are not meant to print, places the mesh over paper, then forces paint or ink through the unplugged holes onto the paper. Serigraphy is ideally suited for creating works with multiple colors. Artists who specialize in serigraphs may need to make as many as 30 to 40 separate mesh sheets, one for each color.

MONOTYPE

Monotype is so named because it is used to make a single print rather than a plate which can be used to make multiple copies. The artist paints on a smooth surface such as glass, Plexiglass, zinc, copper, or frosted Mylar. A moist paper is laid on top of the plate. Together they are either run through an etching press or hand-rubbed with a large spoon or a baren. The one-of-a-kind image is then pulled from the plate. The process yields unique effects that could not be achieved by simply painting on paper. Edgar Degas made hundreds of monotype prints.

PRINTMAKING AND MIXED MEDIA

Printmaking was first conceived of as a method by which an artist or writer could distribute many copies of an image or text. Many experts believe that printmaking came into its own as an expressive medium in the 1630s in the work of the Dutch master Rembrandt van Rijn. It is generally accepted that before Rembrandt, printmaking in art was used as an affordable means to copy paintings of the great masters in order to get the work into the hands of the common people. Rembrandt, on the other hand, used a variety of printmaking techniques, including etching, dry point, and aquatint, to create original works that expressed imagery and ideas independent of his paintings. Some of Rembrandt's etchings are as

small as the palm of your hand, yet these tiny images are as masterful and visionary as the artist's monumental canvases.

Two centuries after Rembrandt's revolutionary prints were conceived, Degas and Henri Toulouse-Lautrec took the process one step further. They used hand-pulled prints as a substructure on which the image could be developed with other mediums such as pastel, gouache, or essence.

In the mid to late twentieth century, printmaking came into its own as an important element of mixed-media works. American artists such as Robert Rauschenberg and Andy Warhol used printmaking processes to apply images or text to canvas. These printed passages could stand alone or work together with paint and other materials.

I first started combining printmaking with other medi-

ums in 1983. I had been working on a series of lithographic portraits printed from traditional Bavarian limestone, combining images of friends, family members, and long-deceased ancestors with sketchy gridwork. A few years later, I decided to go back into some of them with artist-quality oil pastel. Bang, I was hooked on printmaking for multimedia. I continued using lithography/oil pastel for several years and eventually began using soft pastel as well. Most printmaking paper is sized very lightly, leaving its surface open and rather porous, and soft pastel can be rubbed in such a way that the pigment is forced into the surface of the paper. It wasn't long before I began experimenting with a variety of printmaking–paint medium combinations. The following two demonstrations are only two of the almost limitless possibilities.

Frank Hewitt,
Ostwald's Dream (1989)
Screen print, oil, and acrylic on linen, 60 x 60 in. (152.4 x 152.4 cm). *Private collection. Photo by Ken Burris.*

Much of Frank Hewitt's work was driven by his vast knowledge of color theory. This painting is an homage to the great German scientist and color theorist Wilhelm Ostwald (1853–1932), who won the Nobel Prize for chemistry in 1909. In *Ostwald's Dream*, Frank Hewitt incorporates screen-printed diagrams of Ostwald's "Color Solids" as well as sections of those solids.

DEMONSTRATION

MONOTYPE WITH OIL, MONOTYPE WITH WATERCOLOR, AND PASTEL ON BUFF-COLORED PAPER

In the early 1990s, I acquired a small etching press. I had come to the realization that my attraction to printmaking was not due to its capacity to provide multiple copies but rather its ability to create distinctive marks and images. Eventually, I began to experiment with monotype, and most of my mixed-media works that use printmaking processes involve one-of-a-kind monotype prints, which have nuances and textures that could never be produced by painting or drawing on paper.

My press is tiny, so my mixed media printmaking works are also small. But the size of an image has little to do with its success visually. I enjoy working at this scale because it forces me to "think big" on a small scale.

I have used a variety of surfaces for monotype plates, including Plexiglas and frosted Mylar, and created images on these plates with numerous materials including etching ink, oil color, water-soluble oil, watercolor, monoprinting colors, lithographic crayons, water-soluble crayons, pencils, and pastel. Many printmakers run a print through the press several times using different colors to complete the image. I generally prefer to make a monochromatic print and bring in color with other mediums.

The selection of what kind of plate and which mediums to use is always somewhat subjective. However, I chose Plexiglas for this piece because I wanted to be able to use my preliminary sketch as a road map for painting the oil layer plate. Monotype is an immediate printmaking process that is the closest to painting. The oil color moves easily on the plate, offering the artist a painterly experience. The paint stays wet for such a long time that the image can be worked and reworked many times. The smooth Plexiglas surface allows the paint to be applied additively and subtractively with brushes, knives, or soft rubber tools.

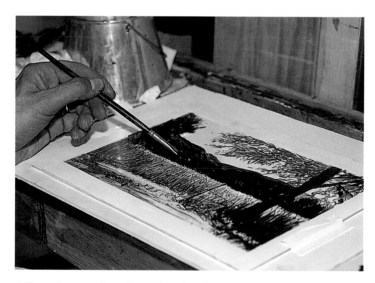

1. I made this pencil study on Fabriano Uno 140-pound cold-pressed paper as a way to explore my subject before painting it onto the monotype plate. It is the same size as the print: 7 x 10 inches.

2. I taped my study and my Plexiglas plate onto a piece of foam board. Using my study as a road map, I used sepia and burnt sienna oil color to paint the monotype plate.

The watercolor layer only affects the areas that have not been touched by the previous oily layer. Its passages are transparent and allow the light color of the paper to come through. The watercolor seems to sink into the absorbent paper, while the oil color sits closer to the surface.

3. Here I am carefully removing the monotype print from the plate. The paper is Lana Gravure, which I dampened before placing it onto the plate, then ran both through my small, lightweight press. The plate still has plenty of color on it. At this point I could pull another, lighter image or repaint the plate and print a slightly different image.

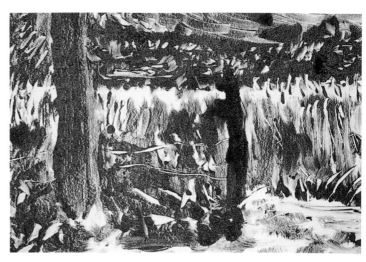

4. This is a detail of the first monotype image. Notice how different it is from my study. The etching press forces the paint into the paper in ways that could not be achieved by simply painting directly on the paper. The distinctive textures seen in this detail are partly due to the fact that after I had painted on the plate with brushes, I pushed, pulled, and scraped the paint with a color shaper. Color shapers have a paintbrush-style handle with a soft rubber tip in place of bristles.

5. For my second plate, I painted watercolor onto paper. I painted light washes of color, because I wanted only a little of this color to transfer to the print. I remoistened the monotype print, placed the two papers front to front using a lightbox for registration, and ran them through the press together.

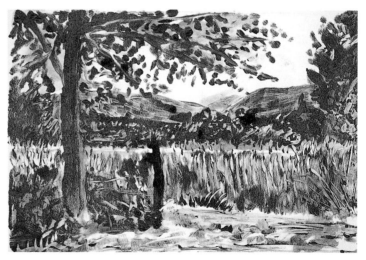

6. The print now has subtle hints of color.

The soft pastel works well with the oil-based print. There is plenty of tooth on the printmaking paper to hold the pastel if one uses a light touch. The pastel layer is the only time that the artist can see the work while pigment is being applied. This is an opportunity to make minor adjustments as well as to add a spontaneous, hand-made quality to the image.

The combination of mediums—oil, watercolor, and pastel—and substrate—buff-colored paper—seemed to me the best choices for conveying the subtle complexity of both the scene itself and the atmosphere. It was a hot, humid summer day in New England with a pale, milky sky and hazy atmospheric effects, yet many deep, vibrant colors were present.

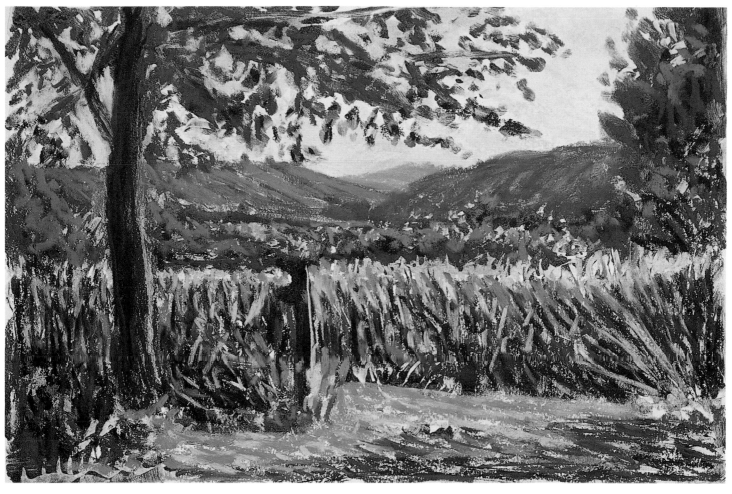

Sean Dye, **Hinesburg Meadow View** (2003)
Monotype with oil, watercolor, and pastel on buff paper, 7 x 10 in. (17.8 x 25.4 cm). *Collection of the artist.*

The pastel layer gives this piece all of its vivid colors, but some of the watercolor and buff of the paper are also visible.

In these details, one can clearly see my use of "broken color." I applied the pastels with short, unblended strokes. I was careful not to cover the monotype completely as I wanted its unique textures to play a role in the final image.

DEMONSTRATION

DRYPOINT, MONOTYPE,
AND OIL PASTEL ON PAPER

The inspiration for this printmaking demonstration was *Afternoon at Ghost Ranch,* the painting on the front cover. I decided to use a light drypoint print first, to serve the same purpose as a sketch would in one of my paintings. It is an intaglio process that does not require the harsh chemicals used for etching. It provides a structure and a value plan on which to build color. I wanted only one good print for this project, so I didn't need a permanent plate. Plexiglas, which is relatively inexpensive, was a logical choice.

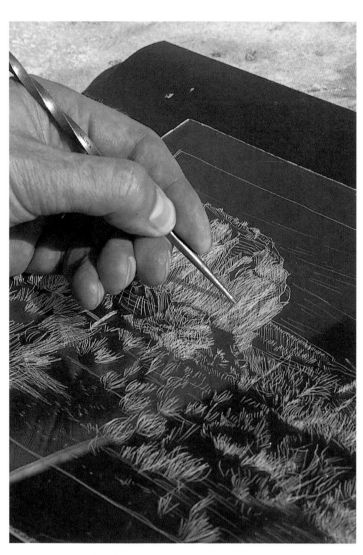

1. I am scratching into the Plexiglas plate with an etching needle. I have placed my drypoint plate onto a piece of black paper so I can see the lines as I scratch them.

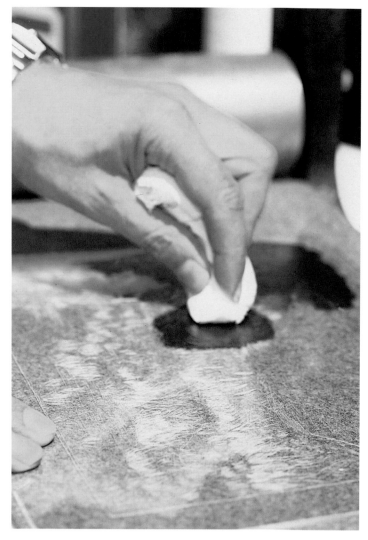

2. Here I am using a cloth dauber to ink the plate with Graphic Chemical's sepia oil-based etching ink. After covering the plate with ink, I wipe it off with clean, soft rags. The ink remains in the tiny scratches to be transferred to the paper. I will next lay moistened printmaking paper onto the plate and run it through the etching press, then carefully remove the print and let it dry.

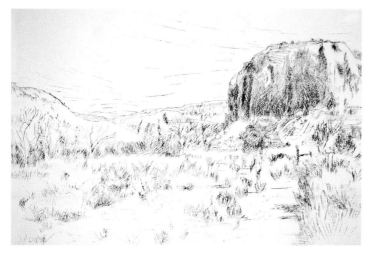

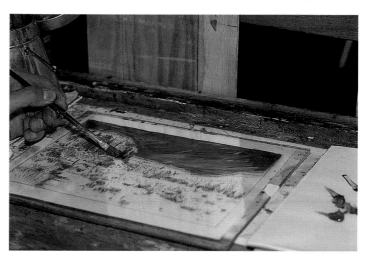

3. This subtle drypoint print has given me my layout and some value information. The scratches in the plate have tiny burrs, which make the lines rather soft and fuzzy.

4. I left some etching ink on my drypoint plate so I could see the lines. I taped a second, new plate onto it and placed both of them on a piece of white paper. Using oil color plus a bit of stand oil to help preserve the paper, I painted initial colors for my image.

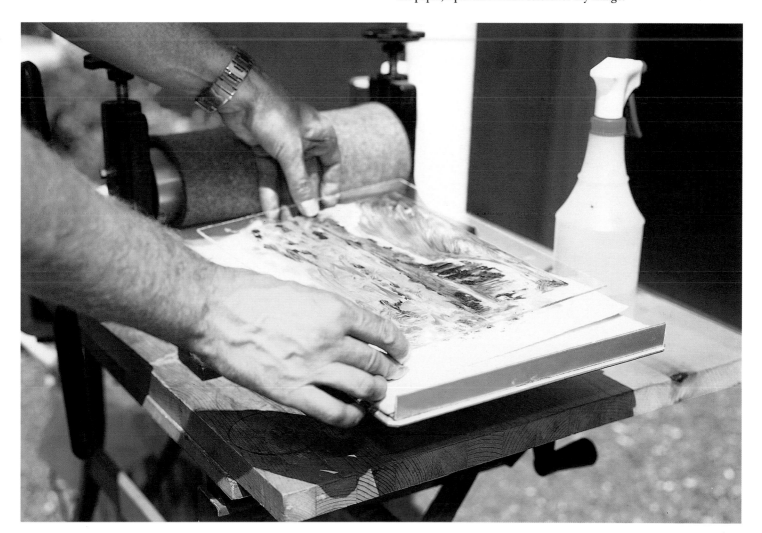

5. I carefully placed the monotype plate face down onto the drypoint print, flipped them over so the paper would be on top, and ran them through the press. I removed the print and let it dry.

6. The image is starting to come to life here with the addition of color. The loose, fluid strokes in the sky, made possible because the surface of the Plexiglas plate is slick, add motion to the piece. The drypoint lines are still prominent, but they have been enhanced by the painterly strokes of the monotype.

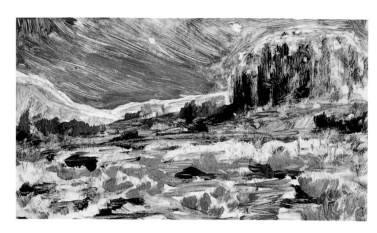

Afternoon at Ghost Ranch II, Detail

In this closeup all three layers are visible. The drypoint is the subtlest layer. The monotype layer shows the initial color and the unique brushstrokes that were forced onto the paper by the pressure of the etching press. The oil pastel layer seems to float on top of the print-making passages.

Sean Dye, **Afternoon at Ghost Ranch II** (2003)

Drypoint, monotype, and oil pastel on paper, 7 x 10 in. (17.8 x 25.4 cm).
Collection of the artist.

I used a light touch to complete the color with the oil pastels. I added more red to the New Mexican soil and pale greens to the sage. I added some subtle color to the cliffs and distant hills as well as a hint of wispy clouds in the sky.

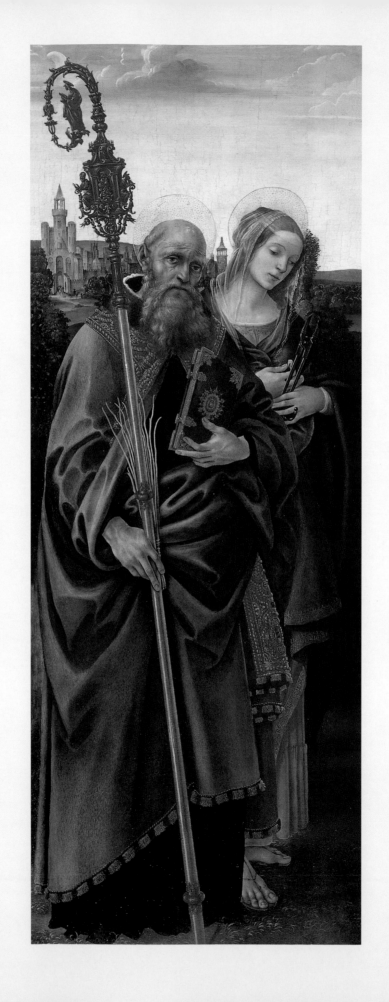

10

EGG TEMPERA
& CASEIN

Filippino Lippi, **Saints Benedict and Appollonia** (c. 1483)
Tempera glazed with oil on panel,
62 x 23 ⅝ in. (157.4 x 60 cm).
The Norton Simon Foundation.

The colors on this beautiful painting are as clear and vibrant as if the artist had applied them to the panel last year, rather than 500 years ago.

Up until the fifteenth century, when artist-grade oil paint became widely available, both casein and egg tempera were popular mediums. Egg tempera was used to create some of history's greatest murals and wall paintings. Casein came into its own as a medium for fine art in the twentieth century, and can be used to create a variety of effects in mixed-media works.

Egg Tempera

The revolutionary Italian painter Giotto di Bondone (c. 1260–1337), who made many advances in the techniques for mixing and applying tempera, is considered by many to be the first modern European artist (see page 12). Cennino Cennini (c. 1390), in his book *The Craftsman's Handbook,* advised using egg yolk tempera for panel painting and whole egg tempera for fresco, a means of painting on plaster or gesso while it is still wet. In the late fifteenth century, Sandro Botticelli (c. 1445–1510) painted a number of tempera masterpieces, including *Primavera* (c. 1482) and *Birth of Venus* (c. 1485).

Once oil paints became widely available, egg tempera lost much of its popularity as a medium for painting on panel and canvas because oil is more flexible than tempera, and can be applied in broad strokes. Tempera was still used for fresco due to its sturdy, water-resistant surface. By the seventeenth century, artists had all but abandoned fresco and, with it, egg tempera. The last of the great eras of fresco painting took place during the early twentieth century. Most of the artists responsible for the revival of interest in fresco were Mexican, but the American artist Thomas Hart Benton (1889–1975) also painted fresco murals. Mexican artist Diego Rivera (1886–1957) painted enormous fresco murals in public buildings that portrayed complex sociopolitical themes.

A few well-known twentieth-century artists have used tempera extensively, including Ben Shahn, Andrew Wyeth, Jacob Lawrence, and Isabel Bishop.

EGG TEMPERA IN MIXED MEDIA

Egg tempera paints dry to a hard, waterproof surface, and can be used to create crisp, hard edges. The quick drying time and hard finish, however, make blending difficult. Artists usually build up many thin layers of color until the desired effect is achieved.

Egg tempera is a translucent medium, less transparent than oil and watercolor and not nearly as opaque as casein or gouache. Its translucency can be increased by adding egg tempera medium to the mixture. It works best on rigid, absorbent supports, such as panel, or heavy watercolor paper, which can be primed with gesso to reduce absorbency.

Egg tempera works well with charcoal, India ink, and walnut ink. It is relatively quick-drying and does not have a glossy finish. It can also be used to advantage as an underpainting for soft pastel.

Sean Dye,
Forgiveness (2003)
Egg tempera and oil color on
panel, 18 x 36 in. (45.7 x 91.4 cm).

Isabel Bishop, **Waiting** (1938)
Oil and tempera on gesso panel,
29 x 22.5 in. (73.7 x 57.2 cm).
Collection Newark Museum,
New Jersey. Purchased 1944,
Arthur F. Agner Memorial Committee.

Isabel Bishop spent much of
her career as a printmaker. She
studied and taught at the pres-
tigious Art Students League in
New York. A Social Realist in
style and sensibility, Bishop
was a member of New York's
14th Street School, where she
maintained a studio until
1984. In this painting Bishop
depicts a contemporary scene
using the ancient combination
of oil and tempera with meth-
ods she learned from studying
Baroque and Renaissance art.

DEMONSTRATION

TEMPERA AND WALNUT INK MIXED WITH INDIA INK ON TEXTURED CLAYBORD

Our home in Vermont is surrounded by hundreds of acres of wilderness that we use for hiking, backcountry skiing, snowshoeing—and painting. I found this interesting little scene about a mile from my house. We were experiencing a spring thaw, and the receding snow had exposed some of last fall's leaves that were still full of color.

Claybord in some ways mimics the plaster-covered walls used for fresco painting. Its initially porous surface becomes less and less absorbent as subsequent layers of pigment are added. Ampersand's Claybord Textured is a $\frac{1}{8}$-inch hardboard panel coated with a soft absorbent kaolin clay that is designed to simulate the texture of cold-pressed watercolor paper. I chose the textured Claybord for this piece because of the rugged nature of the subject matter.

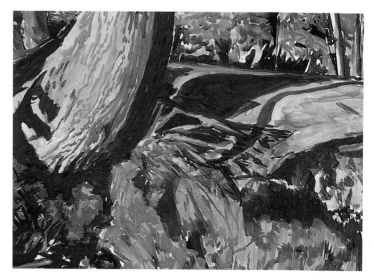

2. For the egg tempera underpainting, I used various densities of the three primary colors—red, blue, and yellow—which I obtained by thinning them with water. The walnut ink sketch is still visible in many areas.

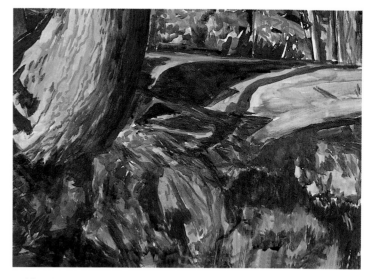

1. The ink sketch is complete. I darkened the walnut ink slightly with India ink; I knew that the mixture would become lighter as it soaked into the surface, and walnut ink alone might have been too light.

3. The Claybord was still absorbing so much color that I decided to go back into the initial tempera layers to darken them with more walnut ink.

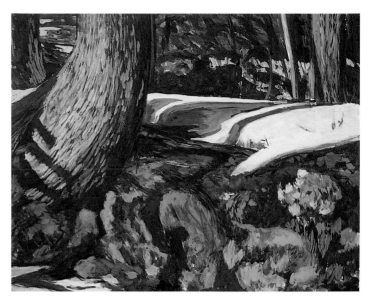

4. At this stage, I have established many of the final colors. The shadows on the snow are blue now, rather than the earlier purple. The snow has been coated with some very pale red near whites. I've added pale blue grays to the rocky outcroppings and given a fine bark texture to the tree trunk. I used a fair amount of raw sienna and Indian yellow to create warmth on the ground.

5. More layers of tempera have been added. I used olive greens to suggest the mosses on the rocks and incorporated some deep blues into the darkest shadows. I added even more texture to the tree trunk. Tempera dries very quickly, and the only way to achieve the look of a blended surface is to use many small strokes. Note that the ink passages have receded, but the original texture of the panel is still very visible.

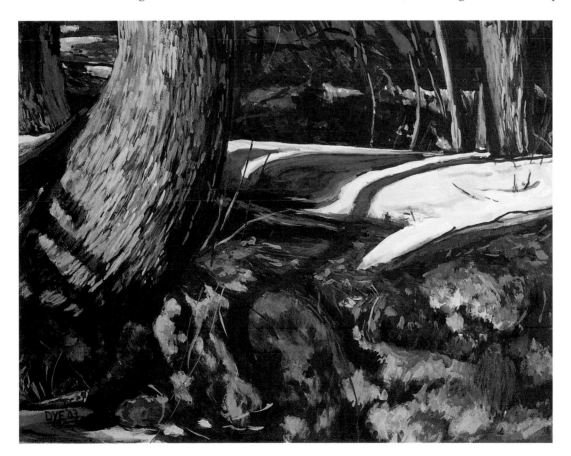

These wispy twigs were added with a small round brush. The texture of the Claybord can be seen in the blue shadow.

Sean Dye, **Signs of Spring** (2003)
Tempera and walnut ink mixed with India ink on textured Claybord, 16 x 20 in. (40.6 x 50.8 cm).
Collection of the artist.

Casein

Casein is a complex protein found in milk that is used for glue as well as a binder for pigment. It is a quick-drying, versatile, and durable medium that was originally produced by reacting curd or skim milk directly with an alkali, first lime and later ammonia. Because of its adhesive strength, lime casein was used for bonding wood in ancient Egypt, Greece, Italy, India, and China. Its use as a painting medium in Europe dates back to the twelfth century, when it was used for panel painting. Ancient Hebrew texts allude to the use of casein for house paints and for a decorative coating in fine arts. In the nineteenth and twentieth centuries casein tempera was widely used for industrial and commercial purposes.

Casein paint was first sold in tubes in 1933 by Ramon Shiva for professional artists' use. Illustrators liked the medium because of its quick drying time and velvety matte finish, which photographs well, but it declined in popularity after the advent of acrylic, which is more flexible and less difficult to apply than casein. Artists who want to use casein are encouraged to develop a feel for the medium by starting with thin layers, then slowly building up the water-resistant layers to opacity. Today Shiva, the only casein commercially produced, is manufactured by Jack Richeson & Co., Inc.

Sean Dye, **Water Trail in a Hinesberg Field** (2004)
Casein, oil pastel, and India ink on museum board,
24 x 18 in. (61 x 45.7 cm).

I applied two coats of Golden's Absorbent Ground to off-white, four-ply 100% rag museum board, then washed over the whole surface with yellow-orange casein. I sketched the entire composition including value references with India ink, then painted over much of the ink with casein colors. Finally, I ran loose strokes of oil pastel over the casein to refine the texture of the vegetation and reflections in the water.

CASEIN IN MIXED MEDIA

Casein is a versatile medium that can be applied to most rigid, nonoily surfaces, such as paper, plastic, Masonite (hardboard), canvas, linen mounted on a rigid surface, and illustration board. I especially like working with casein on heavy watercolor paper, gessoed panels, or Claybord.

It can be applied in opaque layers or thin washes for a variety of effects. Because it dries to a matte finish, I think it looks best with other matte-finish mediums. It can be made more translucent by adding casein medium, and buffed to a satin finish or varnished for a glossy finish.

Casein is thinned with water and is fully compatible with other water-based mediums. If you use casein on top of acrylic, it should be an acrylic wash, which will not seal the paper or board. This way the casein can bond well to the surface.

Casein works well as a medium for complicated subjects because it is easily corrected. It can be lifted like watercolor for the first 12 hours or so. After that it can be erased or removed with a mixture of one part household ammonia to nine parts water.

Toronto landscape artist John Molnar uses casein on top of oil color, but applies varnish to the oil layer first.

DEMONSTRATION

CASEIN AND OIL STICK ON PANEL (PANELLI A GESSO)

This farm is a couple of miles from my studio. I was interested in the way that the farm equipment was nestled in the tall grass in front of the old barn. Scenes like this can easily become a cliché. I decided that a square format and an unusual palette would keep the subject interesting.

To give my board a strong base color, I added precolored gesso. This is a much better solution than trying to add color to white gesso. The titanium white content of white gesso is very high, which means that all mixtures of white gesso and color will have a pale, pastel appearance. The Holbein precolored gesso that I use (it comes in 22 colors) has a uniform, matte finish with excellent absorbency and provides an ideal ground for casein paint.

Casein dries quickly to an absorbent finish that the oil stick will easily adhere to. Both mediums dry to a matte or satin luster, which work well together visually. The casein allows me to be painterly with a brush. I use the oil stick to add drawing elements and some texture.

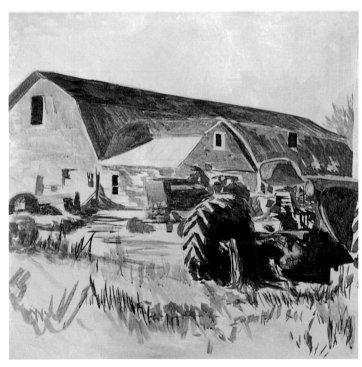

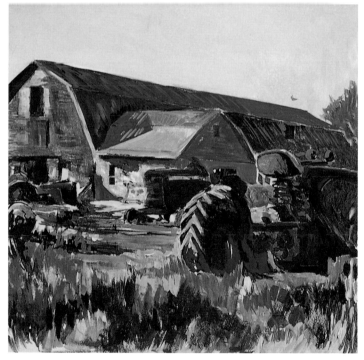

1. I washed the panel with a layer of bright, yellow-orange acrylic gesso and then sketched out my composition in pencil. This shows the gessoed panel and the first casein layer, which I used to establish my values with dark neutrals. I let my paint drift back and forth between cooler blue grays and reddish browns. The paint tended to dry very quickly on the absorbent panel, and I needed to thin it with water so it would brush on easily.

2. Now I am using my casein layers to introduce color to the painting. The yellow ground had a big influence on my color decisions. I was originally going to have a blue-gray hazy sky. Instead, I saw the ground and realized that some type of yellow was going to be the solution.

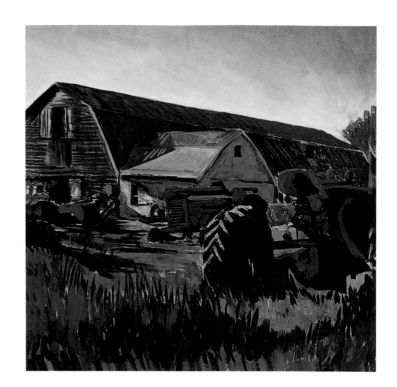

3. I added some subtle orange to the sky and let it fade to a lighter yellow near the horizon. I added more green to the ground and added some bright red to the foreground hay.

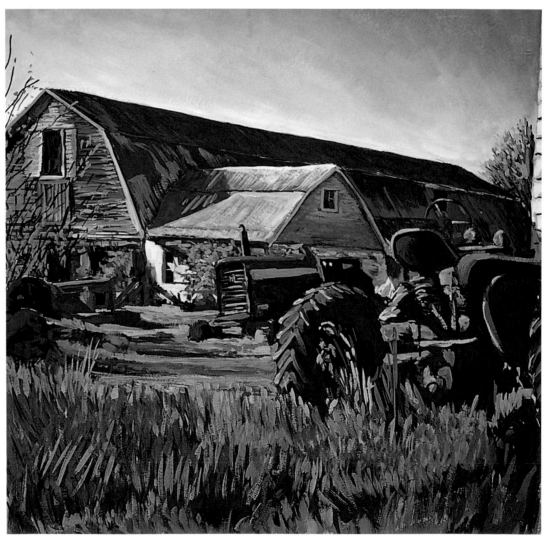

4. At this stage I added much more sunlight to the farm equipment and the barn. I added yellow light coming across the grass and put more warm texture into the tall foreground grasses. I also added a tree in front of the barn on the left side of the painting. Shadows will fall flat if they do not contain color. Here I've added blues, violets, and even red-violets to enliven the shadows.

5. The absorbent surface of the multilayered casein is a perfect ground for oil stick. I wanted to add drawing elements to parts of the painting while leaving the casein passages untouched in others. Skimming the oil stick lightly over the surface allowed me to deposit pigment only on the raised parts of the textured panel.

Sean Dye
O'Neil Farm Equipment
Casein and oil stick on panel (Panelli a Gesso), 30 x 30 in. (76.2 x 76.2 cm). *Collection of David Kirby and Barbara O'Connor.*

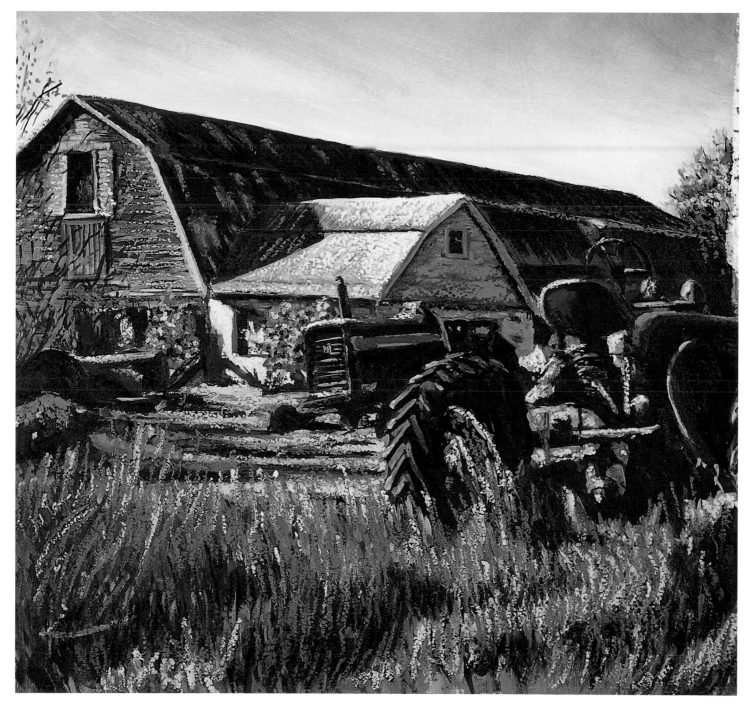

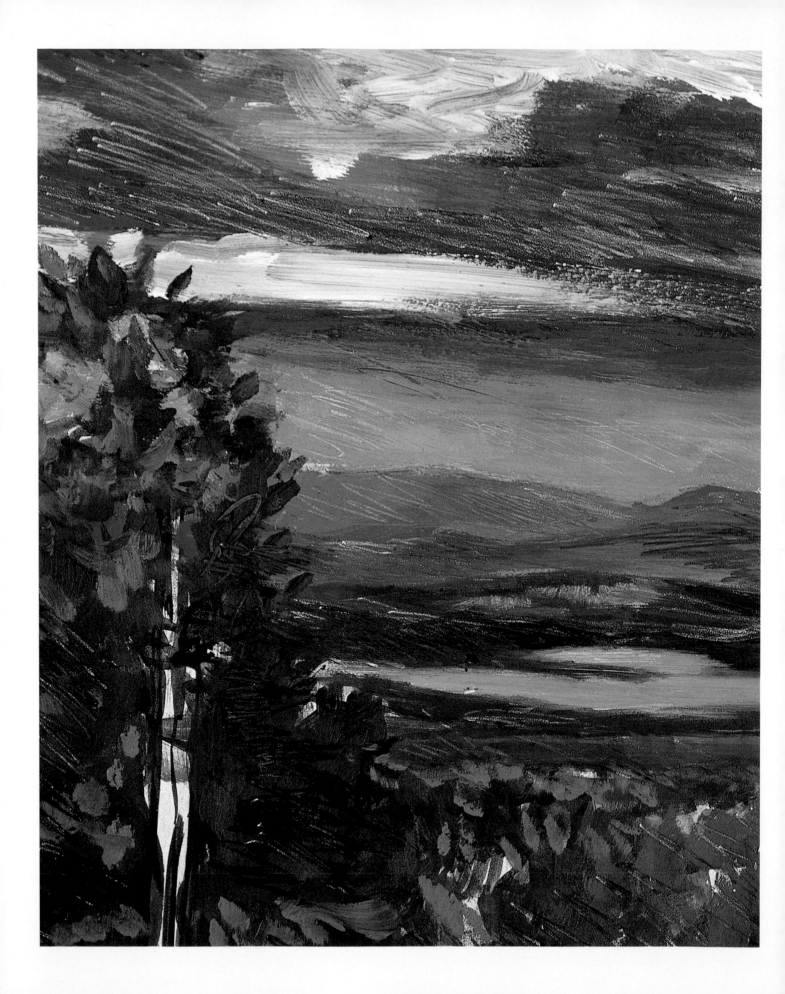

11

ENCAUSTIC

Sean Dye, **Adirondack View from Shelburne, Vermont, Detail**

In this detail from the second demonstration in the chapter, the scratches from my palette knife are clearly visible in the dark areas of the sky, in the trees, and in the foreground grass. I did the scraping after the first application of oil and wax. If I had waited until other layers had been applied, the technique would not have worked as well.

Traditional encaustic is a technique that involves mixing dry pigments with molten wax on a warm palette. The pigment-wax mixture is then applied to a ground or surface, and a heat source is passed over the surface to "burn in" the colors and fuse them to the support. Encaustic, which provides unique textures and luminous effects, is a wonderful addition to any mixed-media studio.

Introduction to Encaustic

Encaustic was used as a painting medium as early as the fifth century BCE. Supports for early encaustic works included panels, most famously the so-called Fayum mummy portraits, which were painted during the first to the third centuries CE in Roman Egypt and inserted into sarcophagi in place of death masks; plaster; baked clay; and marble. The early Christians in Egypt, the Copts, made beautiful, luminous encaustic paintings of holy figures, and encaustic was used as a varnish for frescoes and statues throughout the early middle ages.

In later centuries, encaustic all but disappeared in the West as cheaper and easier-to-work mediums—tempera and oil—became widely available. In the mid-eighteenth century there was a revival of interest in encaustic, beginning in France with artist Joseph-Marie Vien (1716–1809), but the difficulties still outweighed the advantages for most artists.

Hot-wax encaustic painting became easier and more practical at the beginning of the twentieth century with the invention of portable electric heating devices. Today, electrically heated palettes for melting the wax and pigment are available.

Alternatives to hot-wax encaustic are various cold-wax processes. In my own work, I prefer to use a modified cold-wax technique, mixing Dorland's Wax Medium with oil color.

One of the twentieth-century artists who created memorable encaustic masterpieces was Diego Rivera (Mexican, 1886–1957). Rivera, like artists before him, found that even with modern heating techniques, encaustic was not really suited for large murals. Jasper Johns (American, b. 1930) has been a bold and devoted practitioner of the medium. One of his most famous works, *Flag* (1954), is a mixed-media work of encaustic, oil, and collage on fabric-mounted plywood.

ENCAUSTIC AND MIXED MEDIA

The white refined bees' wax for hot-wax encaustic is most commonly supplemented with carnauba wax, which acts as a hardener. A plasticizer is also included and pigments suited for oil paint can be used, usually in small amounts. The product is then

Sean Dye, **Dekalb Avenue** (1989)
Encaustic (oil and wax), acrylic, and charcoal on wood, 24 x 30 x 4 ½ in. (61 x 76.2 x 10.8 cm). *Collection of the artist.*

I painted this piece on a handmade "box" that protrudes a few inches from the wall. painted each shape with many thin layers. The translucency of the oil and wax mixture allows more than one layer to be seen at one time.

kept warm on heated aluminum palettes and applied with either brush or knife. Once applied, it cools, rather than dries. Its adhesive properties make it an excellent choice for collage.

Encaustic has a number of advantages as a painting medium. It is resistant to moisture and doesn't yellow. It has a translucent, matte finish with a soft satin luster. How much underpainting shows through the translucent encaustic layers depends on the medium used. Gouache, for example, will maintain a stronger statement than watercolor.

Encaustic can be applied as a series of glazes or as a thick impasto layer. Encaustic paintings always remain soft and pliable. They can be scratched or incised at any time later to expose other mediums or earlier encaustic layers.

Encaustic works best on panels. Encaustic applied on panels prepared with several coats of gesso or absorbent ground may last indefinitely.

DEMONSTRATION

ENCAUSTIC (OIL AND WAX) AND WATERCOLOR ON CRADLED HARDBOARD

The idea for this painting came to me when I was giving a grid demonstration for my two-dimensional studies class at the University of Vermont. We were exploring symmetry and warm-cool contrast using a limited grid format. My son, whose little league team I was coaching, saw the painting in a half-finished state and said that it reminded him of a baseball game because of the shapes—hence the title, *Stealing Home.*

Cradled hard board (Masonite) is a nice support for a small, square painting like this one. It can be displayed unframed or fitted easily into any frame designed to hold a standard canvas stretcher. It is purchased unprimed, and the artist can design his or her own surface. For this painting I first applied several coats of acrylic gesso to the surface. I changed the direction of my strokes with every layer; the result was an interesting surface that had a random, unplanned quality to it.

Because watercolor sometimes beads on acrylic gesso, I buffed the surface with fine steel wool; the tiny scratches helped to hold onto the watercolor.

I applied the watercolor in thin washes, choosing colors that would provide a contrast with the colors I meant to use for the encaustic layers. Dry watercolor layers are solvent-insoluble, which means they will not be disturbed or picked up by oil and wax mixtures.

The translucent layers of oil and wax allow various amounts of the watercolor layers to show through. They are easily scraped back to expose the watercolor base or earlier layers of the oil and wax. The wax adds a stiffness and body to the paint that eventually creates an interesting texture. For the oil and wax layers, I used a #4 flat brush to help define the sharp edges.

1. I painted the entire Masonite surface with watercolor.

2. For the first layer of oil and wax, I applied a thin coat of the colors I planned to use for the final encaustic layer.

3. More layers of encaustic have been added. As the translucent paint layers build up, the light penetrates the surface in increasingly interesting ways.

Here I am using a flexible palette knife to mix Dorland's Wax Medium with the oil color.

4. This is a detail of the painting after I scraped the early oil and wax layers to add some "wear and tear," or history, to the painting. A stiff palette knife exposed the early layers of watercolor. Subtle hints of these strokes will be apparent in the finished piece.

5. The final encaustic layers have been applied. For paintings like this it is important not to rush. I like to compare it to a good spaghetti sauce. It will be a lot better if it simmers for a long time rather than cooked in a microwave oven. At this stage I am building back up some of the color that was scraped off. Each time I repaint a color, I mix it in a slightly different way, adjusting temperature, intensity, saturation, and value.

Stealing Home, Details

In these details, one can see the many different thicknesses and directions of the brushstrokes.

Sean Dye, **Stealing Home** (2003)

Encaustic (oil color and Dorland's Wax Medium) and watercolor on cradled hardboard, 12 x 12 in. (30.5 x 30.5 cm). *Collection of the artist.*

I wanted this painting to have a more ancient look. I felt that up to this point it appeared too hard-edged and a bit too bright. I painted the final aging and settling layer by using a mixture of Indian yellow, burnt sienna, and sepia for the warm colors. I repainted all of the cool colors with different intensities of the blues, blue-violets, and blue-greens to give those areas more depth.

ENCAUSTIC (OIL COLOR AND WAX), ACRYLIC GOUACHE, AND INDIA INK ON GESSOBORD

This beautiful spot is in Shelburne, Vermont, the town next to mine where my family goes back four generations. From this vantage point, one can see the Adirondack Mountains of New York just beyond Lake Champlain. The painting was done on a breezy, crisp late September day, the beginning of a stellar foliage season in Vermont. The bright, green trees provided a strong contrast to the turning fall colors.

For this piece, I chose smooth-surfaced Gessobord that I toned with a wash of acrylic gouache. Acrylic gouache dries waterproof, allowing me to add multiple, washy layers without disturbing earlier layers.

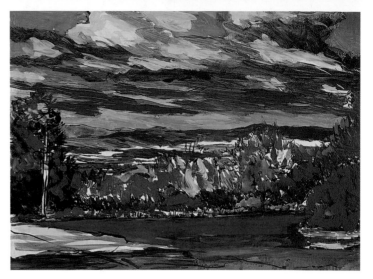

2. For the underpainting, I again used acrylic gouache, which provided the strong, intense, warm colors I wanted. I chose colors that are adjacent to one another on the color wheel: red-violet, red, red-orange, and orange. I kept my brush wet with thinned paint and worked with loose, spontaneous, splashy strokes that dried to a slightly absorbent matte finish and provided an adhesive surface for the oil and wax.

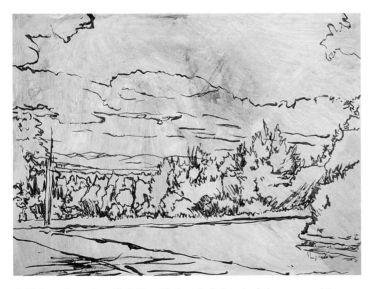

1. Using a long-handled #3 sable brush, I sketched the composition with India ink, which works beautifully on the smooth Gessobord and has a bold, aggressive feel to it. I often establish composition and value at an early stage with dark, permanent marks; this allows me to be more spontaneous during later stages.

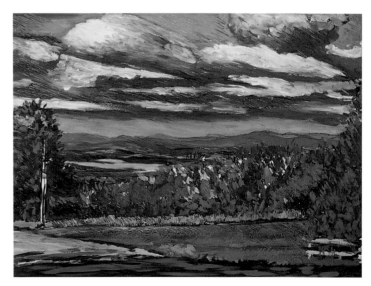

3. For my early layer of oil and wax, I used all cool colors: manganese and cerulean blue in the sky and a variety of blue-violets and violets in the mountains. At this point I decided to show a bit more of Lake Champlain than I had actually seen from my vantage point in order to separate the middle ground from the distant mountains. I added dark greens to the grass and foreground trees. I also introduced some scraping as a way to expose more of my underpainting and add texture.

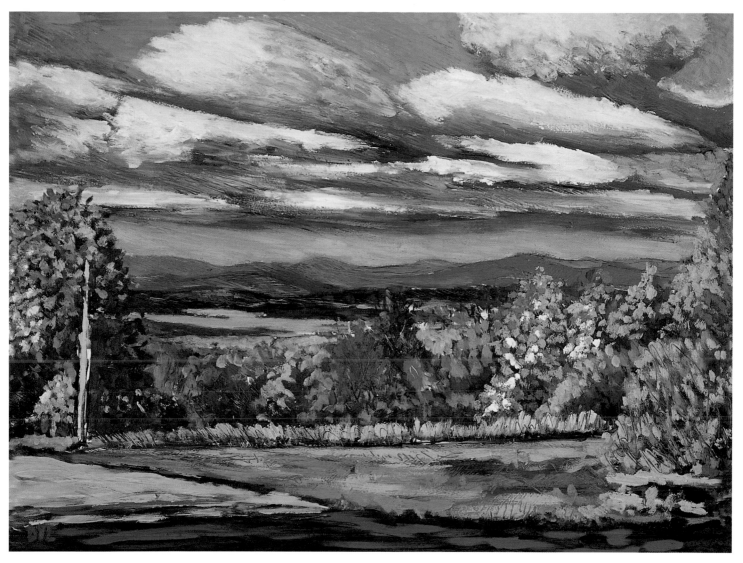

Sean Dye, **Adirondack View from Shelburne, Vermont** (2003)
Encaustic (oil color and wax), acrylic gouache, and India ink on Gessobord, 18 x 24 in. (45.7 x 61 cm).
Collection of the artist.

My original intention was to paint several more layers on this painting. When I got to this stage I determined that there was a freshness that I did not want to mess with. It is a lot less refined than many of my other landscapes but has the feeling of light that I saw on location.

Adirondack View, Detail
The oil and wax, applied in thick, opaque strokes, creates a distinct, three-dimensional texture. The oranges in this brilliantly colored foreground tree thrust the tree forward because it is sitting on top of the cool violets and blue-greens of the background.

Adirondack View, Detail
The textured scraping of the oil and wax can be seen here along the horizon, in the tree shadows, and in the hayfield.

Tips for the Mixed Media Artist

Planning a mixed-media work can be tricky. When you are thinking about the scene you want to portray and what effects you want to achieve you must always take into account issues of compatibility. The support and primer must be compatible with the mediums you want to use; the individual mediums must be chemically compatible; and the chosen combination should be such that each medium contributes its own statement. Over the years, I have found the following tips helpful at various stages of my own mixed-media work.

SUPPORTS
Canvas

+ When stretching canvas, you need to get the tension right. Having the canvas tight enough is especially important when you will use mediums applied in stick form, such as oil stick or oil pastel, on top of oil or acrylic, or when dragging oil or acrylic with a knife over a previously applied medium.

+ Hand-stretched and -primed canvases are generally more absorbent than prestretched canvases, and offer textures with more character.

Paper

+ The correct side of artist-quality paper to use is the one with the manufacturer's logo or watermark in a right-reading orientation.

+ For an archival work, use only heavy (300- to 500-pound) 100% cotton rag paper.

+ Paper to be used as a surface for a mixed-media work, especially if collage elements are to be used, can be glued to some kind of panel with a pH-neutral polyvinyl acetate adhesive.

Panels

+ Before using a natural wood panel as a support, first season it to remove resin and gum (to prevent warping) and then prime it. Unprimed wood is too absorbent to be a good choice for a painting surface; also, the pigmentation of unprimed wood will affect the color of any medium applied to it.

+ For an inexpensive, DIY surface for mixed-media works you can buy furniture-grade birch plywood or Masonite and prime it yourself with gesso.

+ Preprimed commercial panels suitable for mixed media include Ampersand's Claybord (suitable for ink, watercolor, egg tempera, encaustic, and airbrush color), Gessobord (less absorbent than Claybord, and good for oil and acrylic); and Pastelbord (a toothy finish that holds many layers of pastel). A number of other companies offer gessoed panels. You will need to experiment to see what products suit you best.

+ Many commercially prepared panels come in uncradled, cradled, and deep-cradled versions, as well as in an assortment of tinted finishes.

DRAWING MEDIUMS

+ The following drawing mediums are suitable for intermediate or even final layers of a mixed-media work: lithographic crayon for adding dark detail; water-soluble crayons (Holbein, Caran D'ache) for use over watercolor; water-soluble colored pencils (Prismacolor, Cretacolor) to add final texture and richness; ink or soft pencil to outline areas of color, creating a more two-dimensional look.

+ Some acrylic polymer paints will cause an India ink drawing to smudge, so if you plan to use acrylic polymer over India ink, first spray the surface with workable fixative.

+ For an interesting line, you can apply India ink with a "pen" carved from a twig.

+ To prevent colors to be applied over charcoal from darkening, first spray the charcoal layer with workable fixative.

PASTEL

+ If your pastel layer is not working, misting the surface with sepia airbrush color will slightly darken the entire painting, allowing you to reintroduce lighter areas.

+ For early pastel layer(s), don't try to fill every bit of the paper. Leaving open areas gives you more options when you are adding additional pigment, whatever the medium.

+ Golden's Acrylic Ground for Pastel, which contains finely ground sand in a pure acrylic emulsion, provides a coarse tooth for holding pastel or charcoal and can be applied to primed heavy-weight paper, to canvas, or to panels. It is not a particularly

forgiving medium, so be sure to follow the manufacturer's instructions for application.

- Cold-pressed watercolor paper with a watercolor underpainting is a very inviting surface for pastels.
- Most artist-quality papers can be enhanced for pastel use with primers: white or colored gesso plus pumice for an opaque primer; acrylic or latex base plus pumice for a translucent primer that will permit a tinted surface to show through.

OIL

- Oil-primed surfaces are suitable *only* for oil paintings.
- Adding Turpenoid or Gamsol to traditional oil paints makes them suitable for thin washes and also accelerates drying time.
- The first layer of oil color applied over any absorbent layer (casein, tempera, or gouache) soaks in, leaving a rather flat, non-lustrous surface. Adding additional layers will give you the shine that is typical of an oil painting.
- Matte medium thinned with water and acrylic gesso (several coats) are both suitable for priming a surface on which oil paints are to be applied.
- Acrylic gouache and colored gesso both dry quickly to a slightly toothy matte finish and have great bonding properties, making them a good choice for underpainting with oil color.

WATERCOLOR

- Watercolor can be used as an underpainting for any combination of other mediums as long as it adheres to the support.
- Golden's Absorbent Ground, an opaque white medium, will make almost any surface absorbent enough to accept watercolor.
- If you want the transparency of a watercolor underpainting to be evident in the finished work, choose a light surface.

GOUACHE

- Traditional gouache, which is bound with gum Arabic, is slightly brittle and should not be used on a flexible surface.
- A mixed-media work with acrylic gouache as the final layer does not need glass when framing.
- Gouache can be used to heighten the colors in light areas of a watercolor painting and to add texture.
- White gouache can be used under specific areas of a watercolor painting to add brightness.
- Gouache may be combined with nearly all drawing mediums in any order of application.

ACRYLIC POLYMER EMULSION

- Acrylic polymer emulsion can be painted on nearly any clean, nonoily surface; there is no need to first add a barrier ground.
- Small objects, fabric, sand, and other materials will adhere to a thick acrylic paint or gel medium layer, making either of these an ideal choice for collage.

TEMPERA

- Rigid surfaces are best for egg tempera: panels prepared with sanded gesso (traditional or acrylic) or museum board.
- Tempera should not be applied in thick impasto layers. Start with a thin glaze that covers the entire surface. Additional layers can be applied with thin strokes to build up desired areas of color.
- Tempera dries very quickly and cannot be blended the way most other mediums can be blended. You can achieve a "blended" effect by using cross-hatching strokes applied with a relatively dry brush.

CASEIN

- Casein can be applied in opaque layers or thin washes for a variety of effects.
- If you plan to apply casein on top of acrylic, use an acrylic wash; casein will not bond properly to a thick acrylic layer.
- Casein can be lifted like watercolor for the first twelve hours or so. After that it can be erased or removed with a mixture of 1 part household ammonia to 9 parts water.
- Casein can be made even more waterproof by adding one or two drops of acrylic matte medium to the thinning water.

ENCAUSTIC

- Do not mix encaustic with acrylic polymer emulsion paint or mediums. It may be safely used over absorbent surfaces such as acrylic gouache, colored gesso, and well-sanded white gesso, and over watercolor or gouache on an absorbent surface.
- The best support for any work that will incorporate encaustic is a rigid panel—preferably plywood, MDO, or Masonite—prepared with several coats of well-sanded acrylic gesso or absorbent ground.
- To reduce the opacity of encaustic paints, use clear encaustic medium, a mixture of beeswax and damar resin.
- The more resin there is in the medium, the harder the encaustic and the better able you will be to do multiple scratchings or gougings.

BIBLIOGRAPHY

Adams, Laurie Schneider. *History of Western Art.*
New York, McGraw-Hill, 2001.

Arnason, H. H. *History of Modern Art.*
New York, Harry N. Abrams, 1986.

Birren, Faber. *Color: A Survey in Words and Pictures.*
University Books, New Hyde Park, NY, 1963.

Creevy, Bill. *The Pastel Book: Materials and Techniques for Today's
Artist.* New York, Watson-Guptill, 1991.

Elliot, John. *Oil Pastel for the Serious Beginner: Basic Lessons in
Becoming a Good Painter.* New York, Watson-Guptill, 2002.

Eastlake, Sir Charles Lock. *Methods and Materials of Painting of the
Great Schools and Masters.* Mineola, NY, Dover, 2001.

Goldstein, Nathan. *Figure Drawing: The Structure, Anatomy and
Expressive Design of Human Form.* Englewood Cliffs, NJ,
Prentice Hall, 1993.

Howard, Rob. *Gouache for Illustration.* New York,
Watson-Guptill, 1993.

Howard, Rob. *The Illustrator's Bible: The Sourcebook of Tips, Tricks,
Time-Saving Techniques in Oil, Alkyd, Acrylic, Gouache, Casein,
Watercolor, Dyes, Inks, Airbrush, Scratchboard, Pastel, Colored Pencil,
and Mixed Media.* New York, Watson-Guptill, 1992.

Haak, Bob. *Rembrandt Drawings,* London, Thames and Hudson,
1976.

Mayer, Ralph. *The Artist's Handbook of Materials and Techniques.*
Viking/Penguin, New York, 1991.

Mayer, Ralph. *A Dictionary of Art Terms and Techniques.*
Barnes & Noble Books, New York, 1969.

Parramón, José M. *The Big Book of Watercolor.* New York,
Watson-Guptill, 1985.

Rosten, Leo. *The Story Behind the Painting.* Garden City, NY,
Cowles Magazines and Broadcasting, Inc. 1962.

Sayre, Henry M. *A World of Art,* 2nd edition. Upper Saddle River,
NJ, Prentice Hall, 1997.

Stavitsky, Gail. *Waxing Poetic: Encaustic Art in America.* Montclair,
NJ, Montclair Art Museum, 1999.

Turner, Jane (editor). *The Dictionary of Art.* New York,
Grove, 1996.

Wood, James N. *The Art Institute of Chicago: Twentieth Century
Painting and Scupture.* Chicago, Hudson Hills Press, 1996.

Sean Dye,
**Watertrail in a Hinesburg
Field, Detail** (2004)
Casein, oil pastel, and India ink on
museum board prepared with
absorbent ground.

INDEX

Notes:

◆ Page numbers in boldface after an artist's name are pages on which a reproduction of a work by that artist can be found.

◆ When a page number refers to information in a caption or a demonstration step, that is so indicated in parentheses after the page number.